IVERSIT

Drawings A1 to A52 //

Muhanned Cader (MCA1); Chandraguptha Thenuwara (CTA2); Thamotharampillai Shanaathanan (TSA3); Jagath Weerasinghe (JWA4); Muhanned Cader (MCA5); Chandraguptha Thenuwara (CTA6); Thamotharampillai Shanaathanan (TSA7); Muhanned Cader (MCA8); Jagath Weerasinghe (JWA9); Chandraguptha Thenuwara (CTA10); Thamotharampillai Shanaathanan (TSA11); Jagath Weerasinghe (JWA12); Muhanned Cader (MCA13); Chandraguptha Thenuwara (CTA14); Thamotharampillai Shanaathanan (TSA15); Jagath Weerasinghe (JWA16); Muhanned Cader (MCA17); Chandraguptha Thenuwara (CTA18); Thamotharampillai Shanaathanan (TSA19); Jagath Weerasinghe (JWA20); Chandraguptha Thenuwara (CTA21); Thamotharampillai Shanaathanan (TSA22); Jagath Weerasinghe (JWA23); Muhanned Cader (MCA24); Chandraguptha Thenuwara (CTA25); Muhanned Cader (MCA26); Thamotharampillai Shanaathanan (TSA27); Jagath Weerasinghe (JWA28); Muhanned Cader (MCA29); Chandraguptha Thenuwara (CTA30); Thamotharampillai Shanaathanan (TSA31); Muhanned Cader (MCA32); Jagath Weerasinghe (JWA33); Chandraguptha Thenuwara (CTA34); Thamotharampillai Shanaathanan (TSA35); Jagath Weerasinghe (JWA36); Muhanned Cader (MCA37); Chandraguptha Thenuwara (CTA38); Thamotharampillai Shanaathanan (TSA39); Jagath Weerasinghe (JWA40); Muhanned Cader (MCA41); Chandraguptha Thenuwara (CTA42); Thamotharampillai Shanaathanan (TSA43); Jagath Weerasinghe (JWA44); Chandraguptha Thenuwara (CTA45); Thamotharampillai Shanaathanan (TSA46); Jagath Weerasinghe (JWA47); Muhanned Cader (MCA48); Chandraguptha Thenuwara (CTA49); Muhanned Cader (MCA50); Thamotharampillai Shanaathanan (TSA51); Jagath Weerasinghe (JWA52.1 and A52.2).

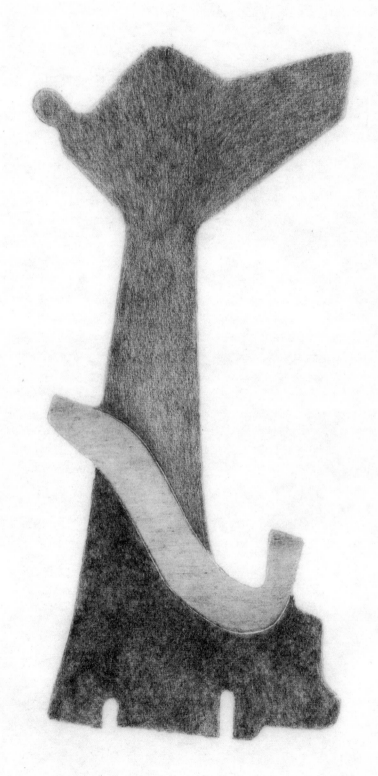

MC A1

MC A1

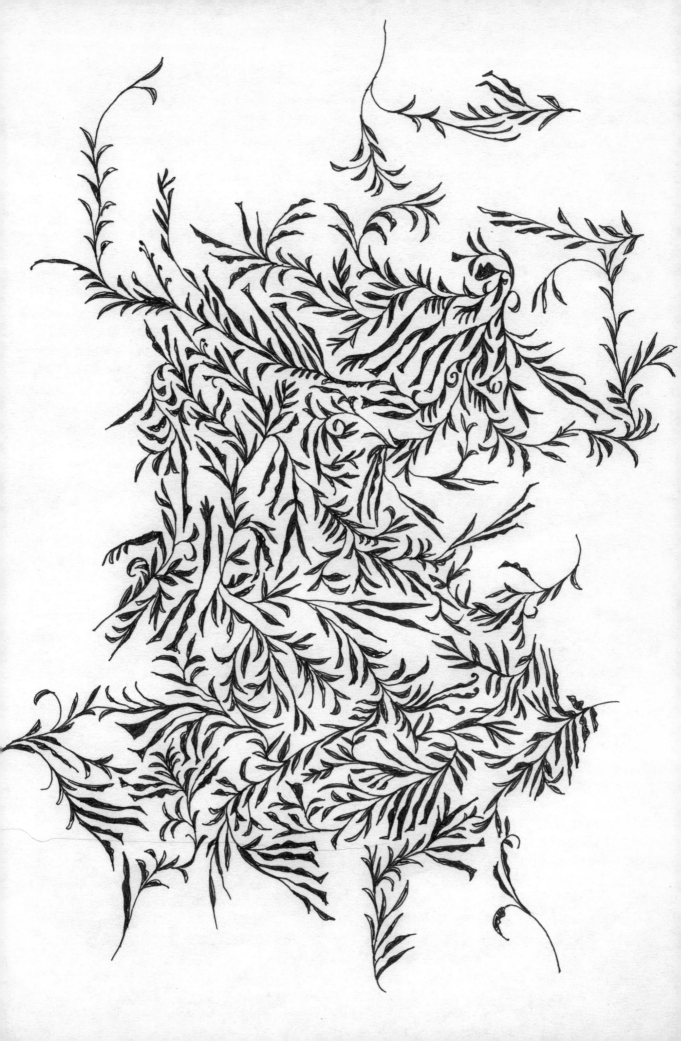

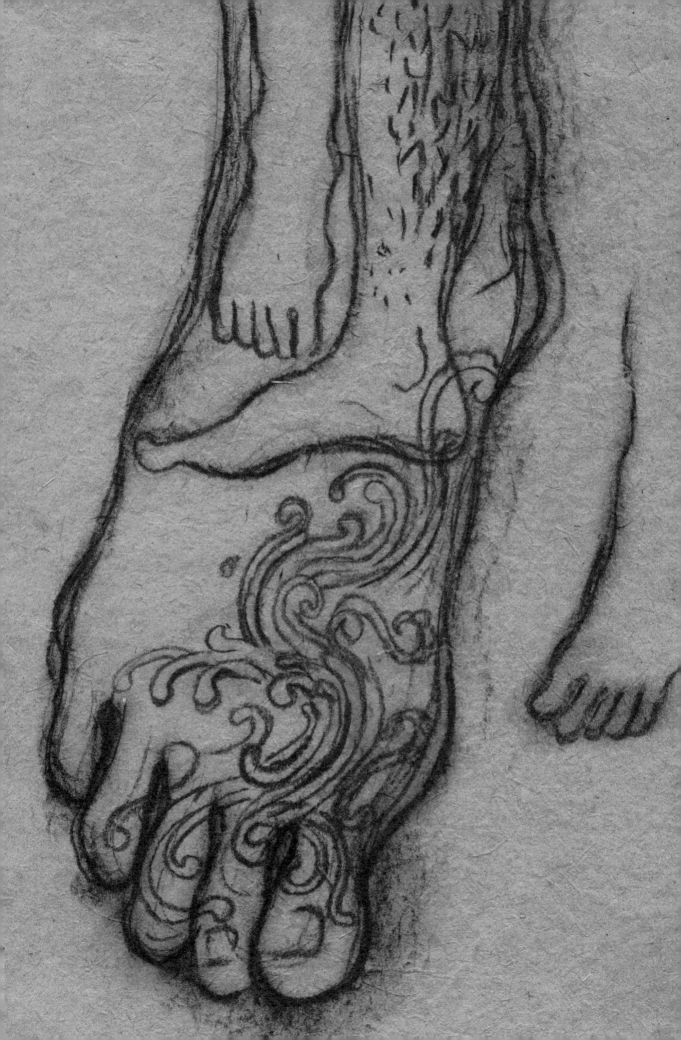

A3

J. Shanahkai

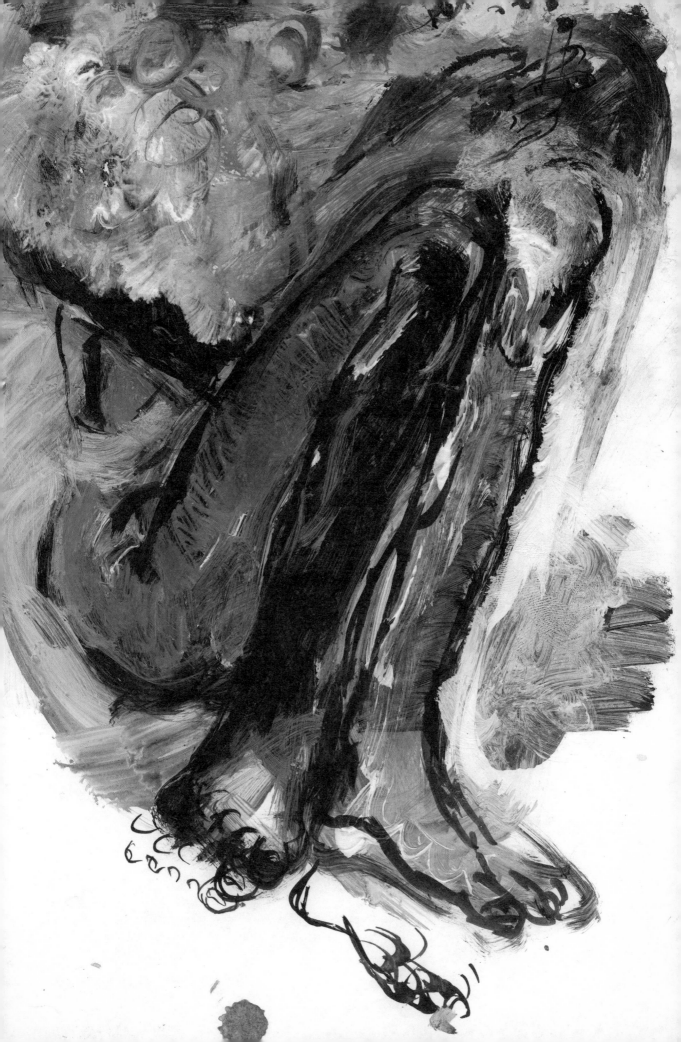

14

J → M

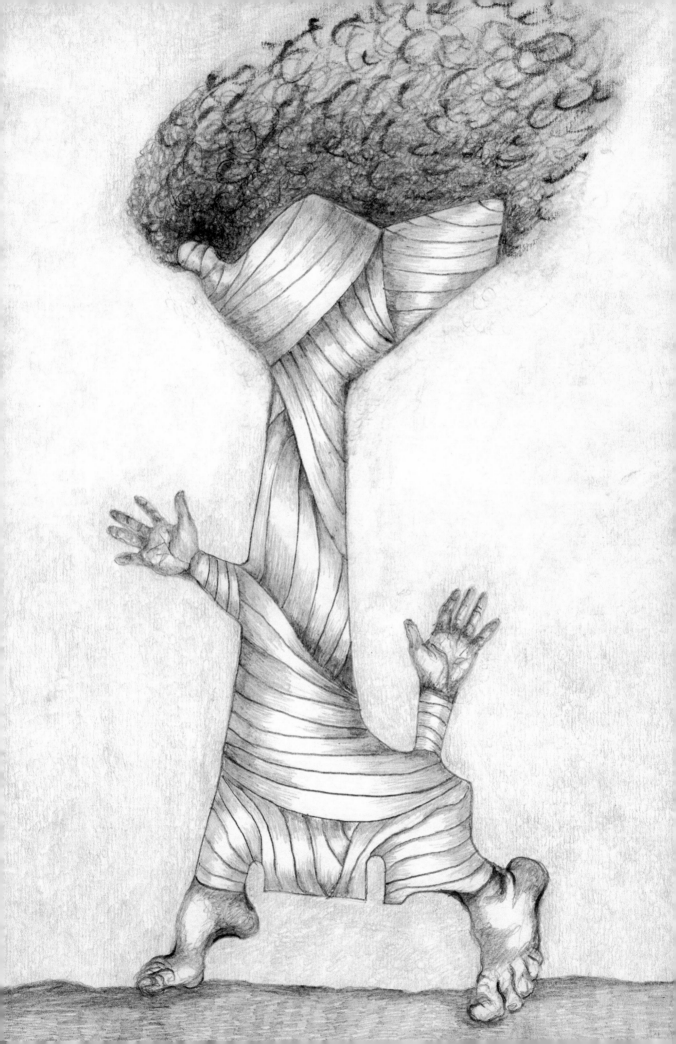

A5-MC

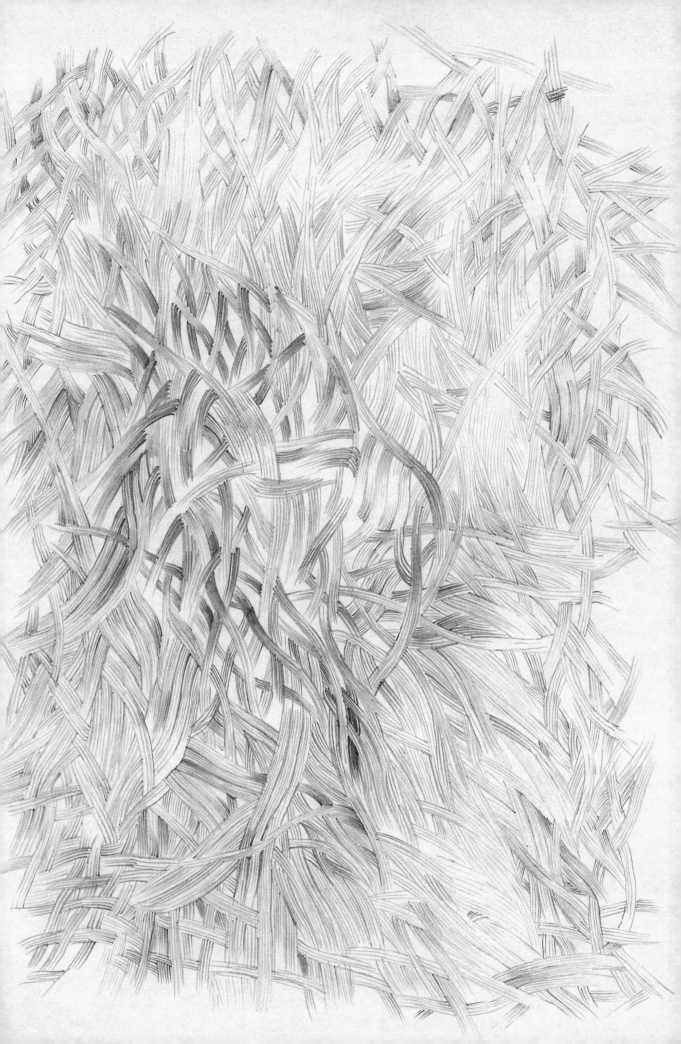

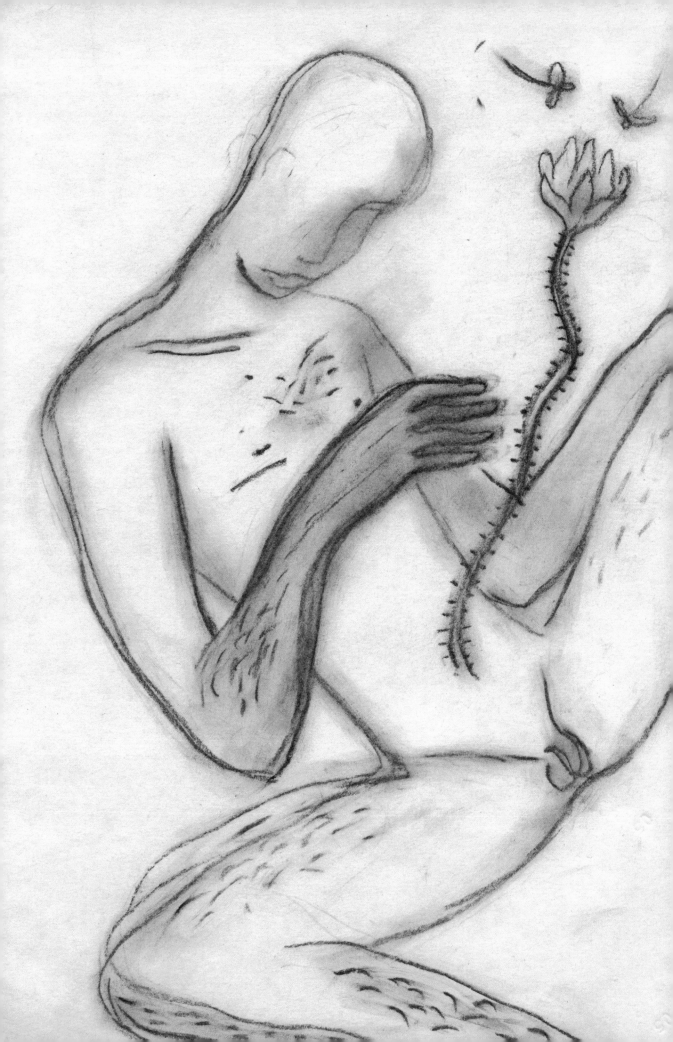

17

I. Stamen

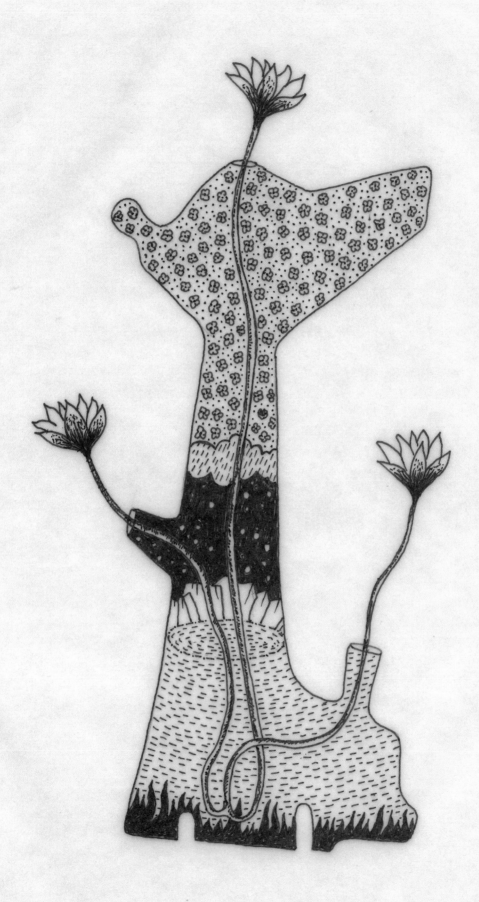

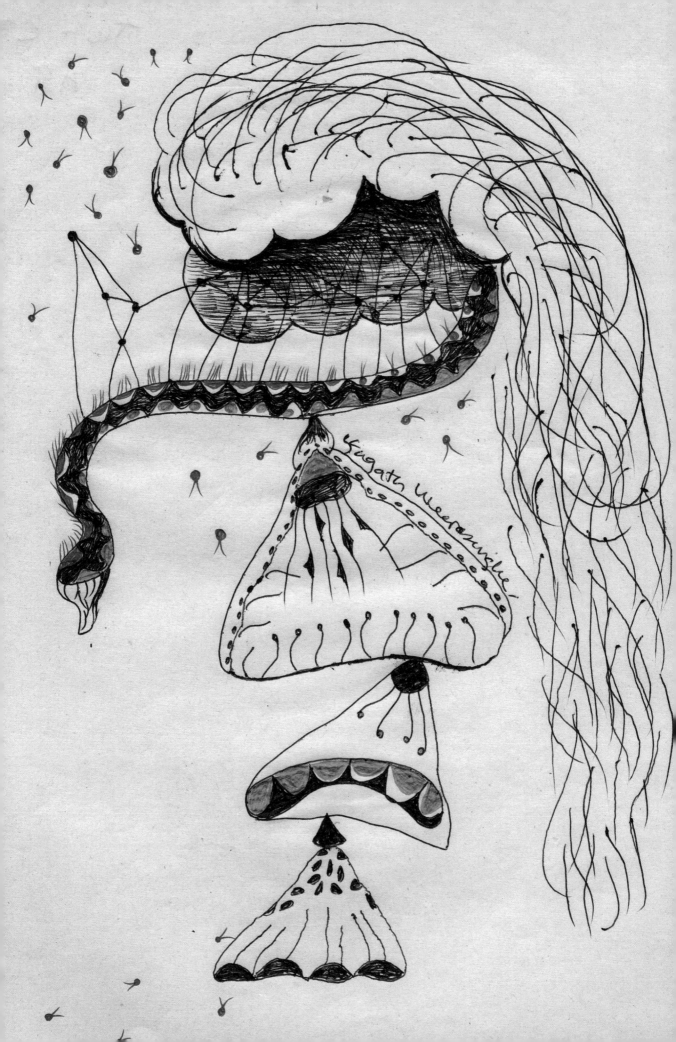

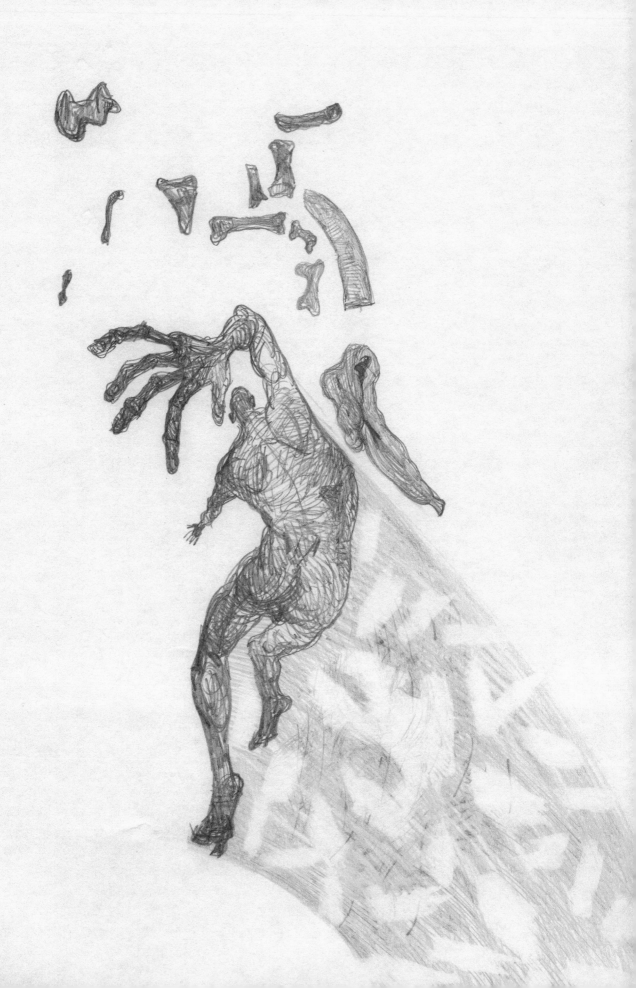

Eskimo . 07.03 A 10

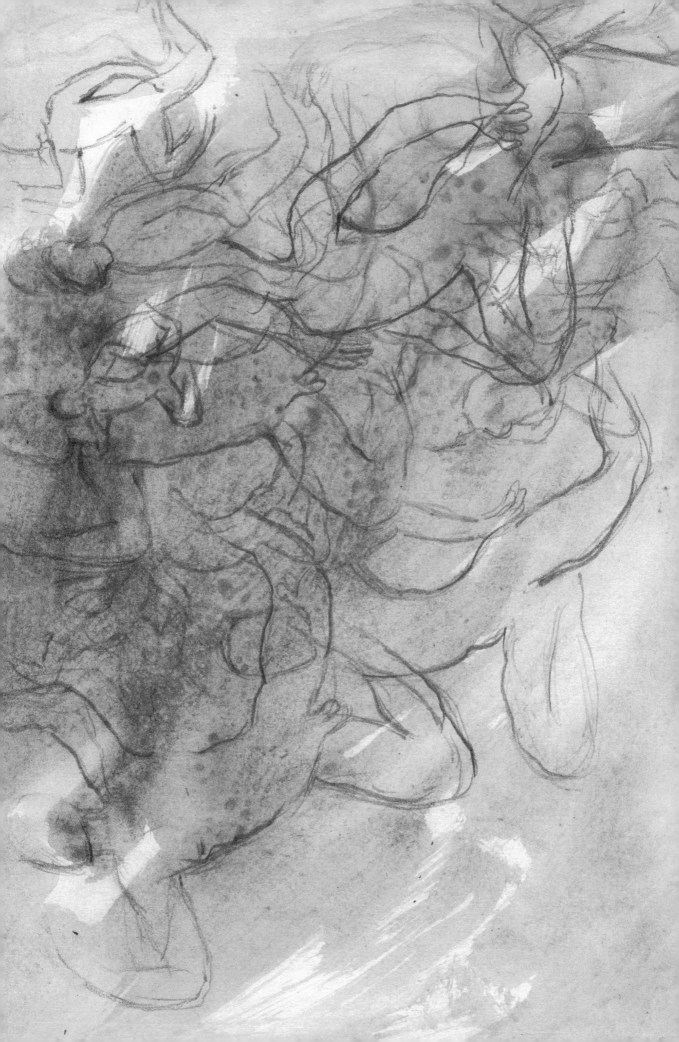

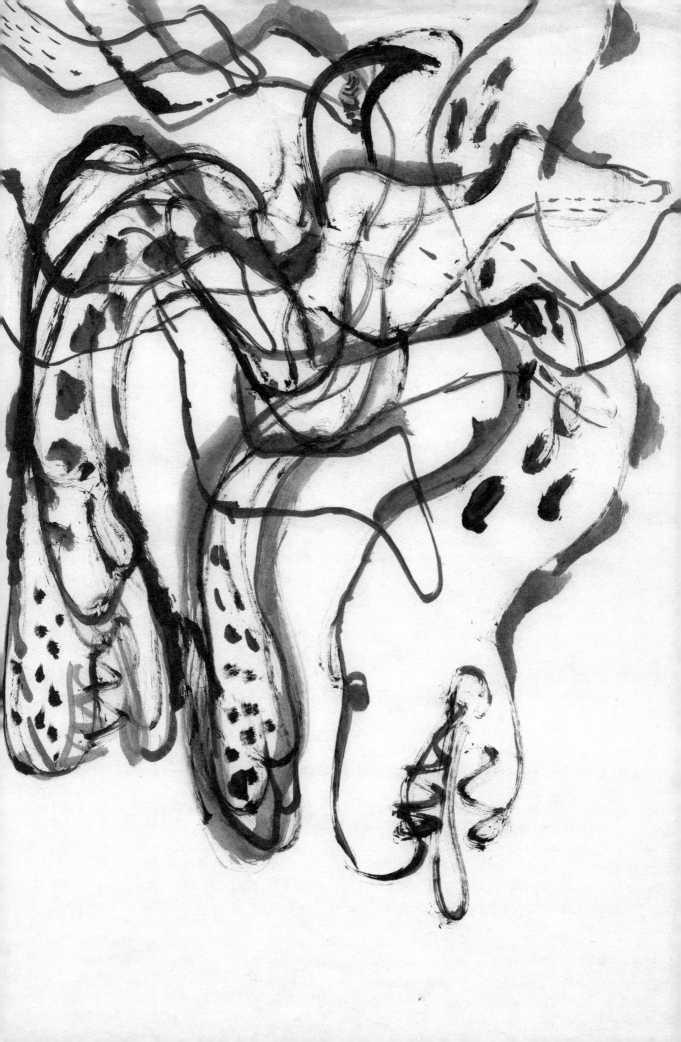

M ⊃ ∩
A12

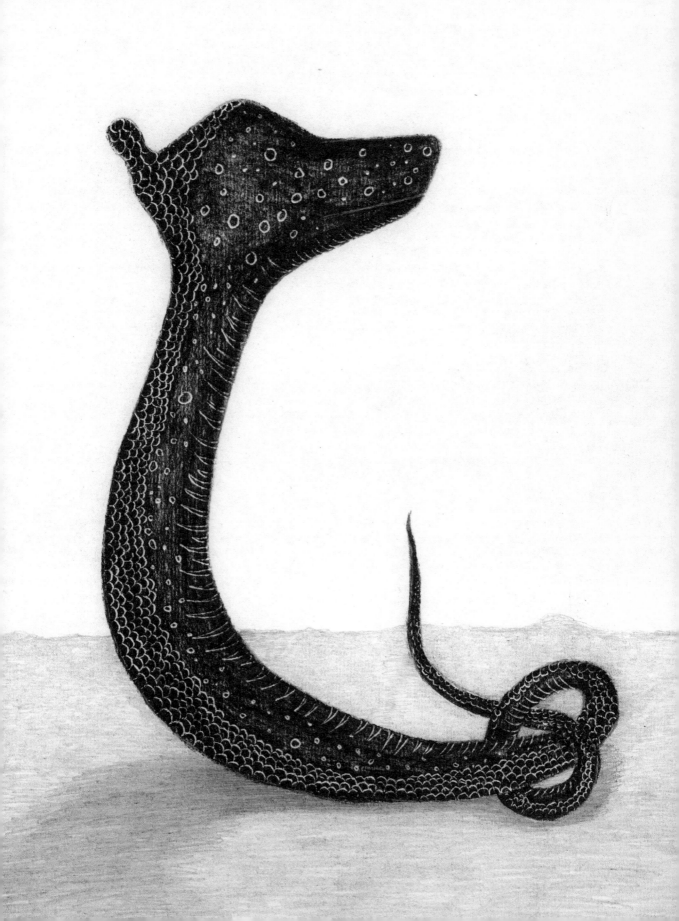

MC - A 13

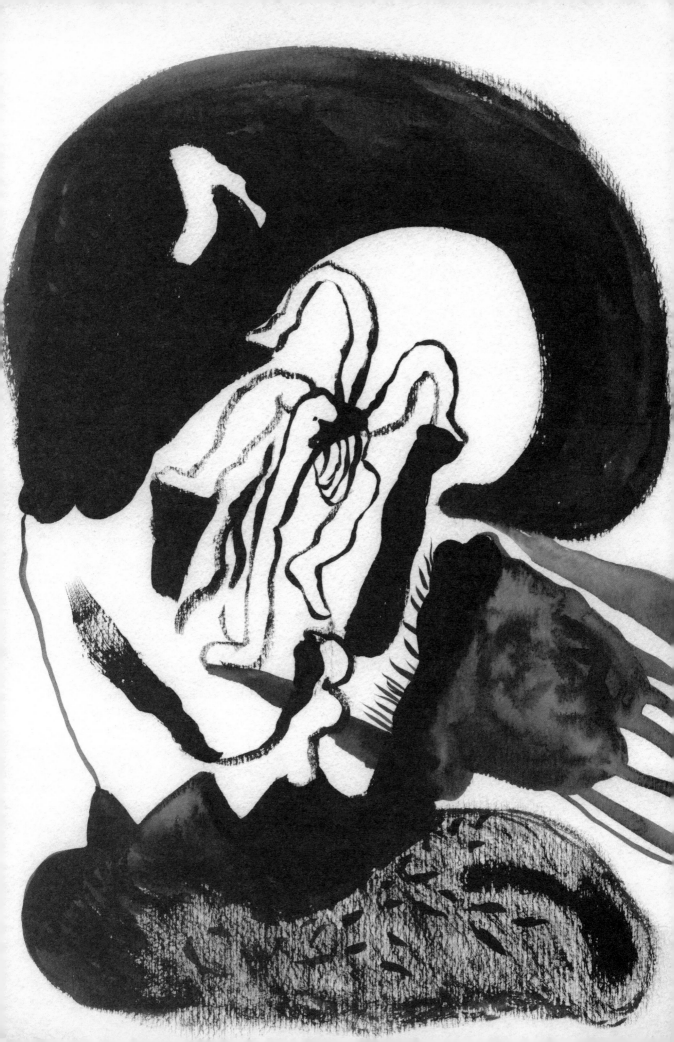

A 14

むしかめ 2005. 09. 07

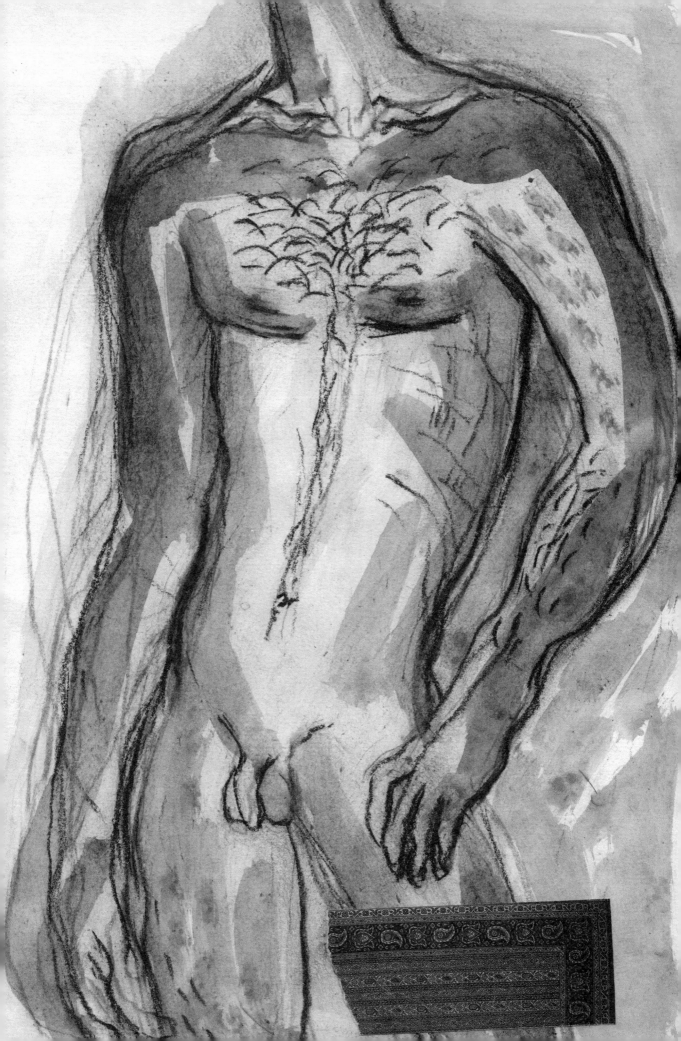

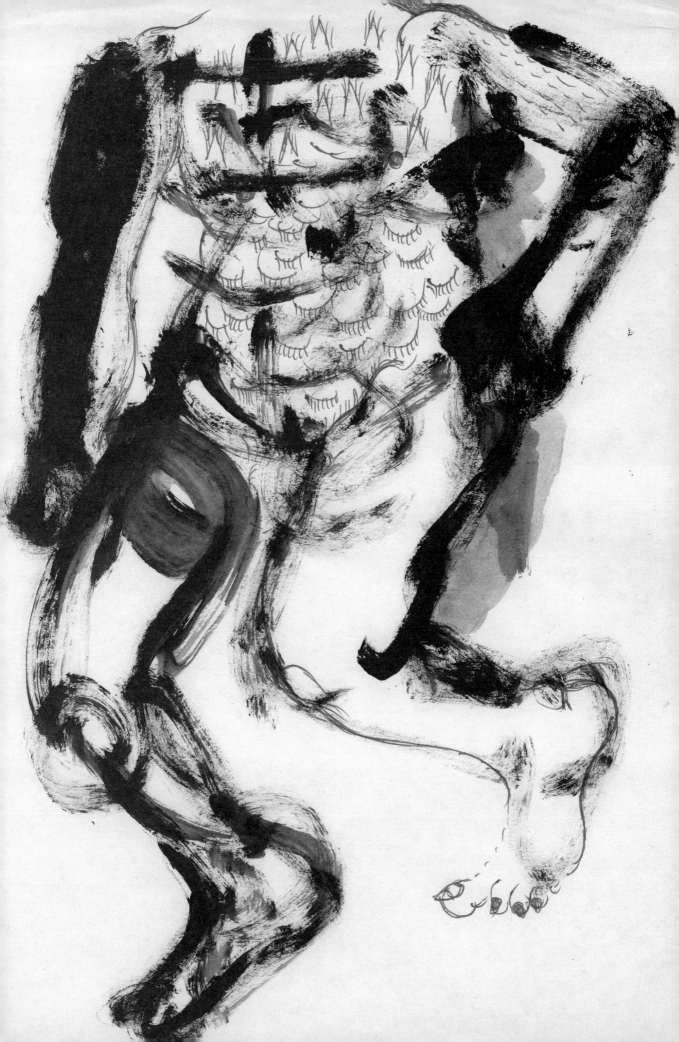

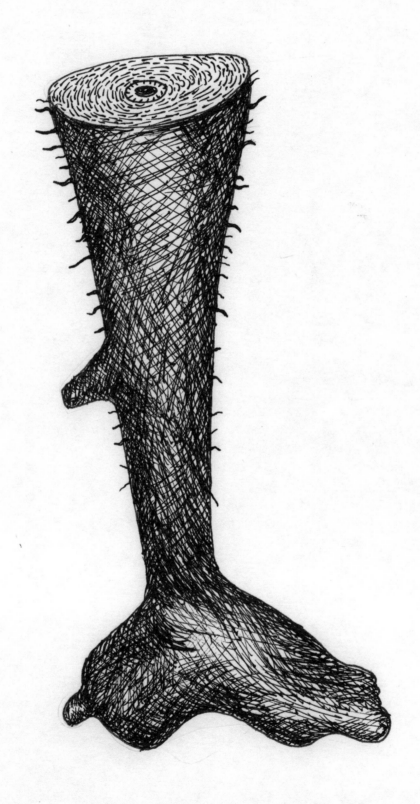

MC-A17

2005.10.31 Lytton A/8

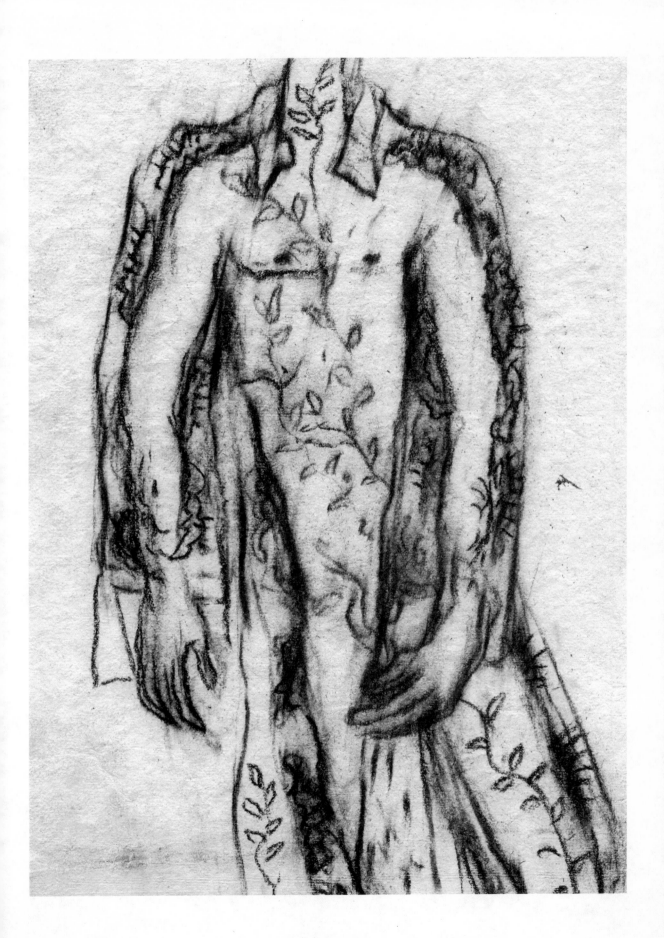

සිතුවම් දැක්ම

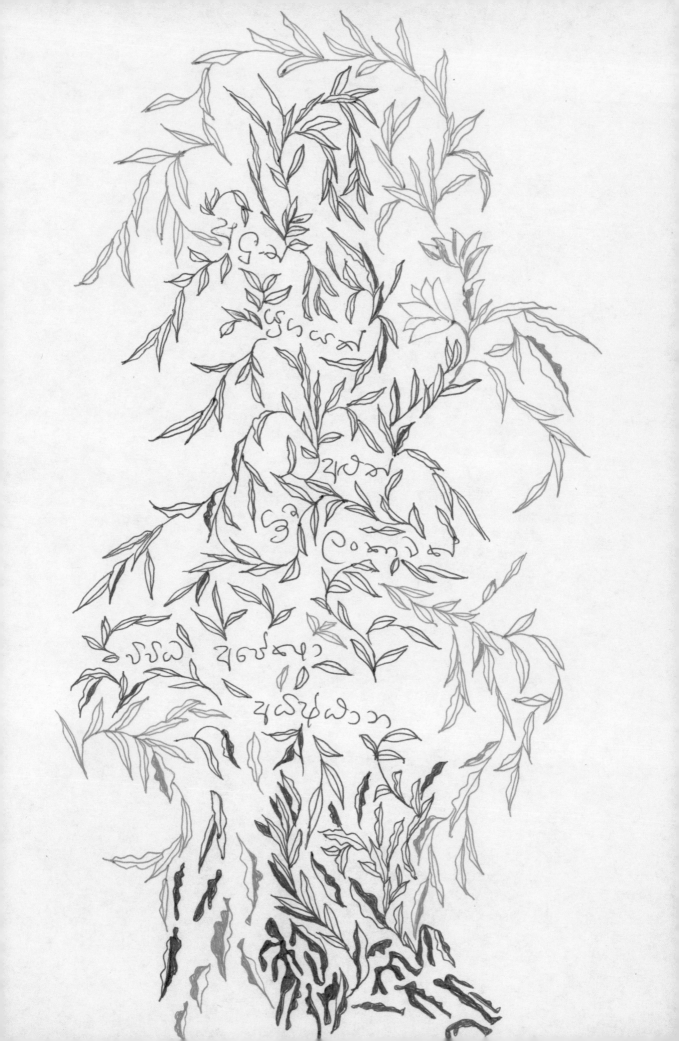

A 21

李禹煥 2005. 11. 20

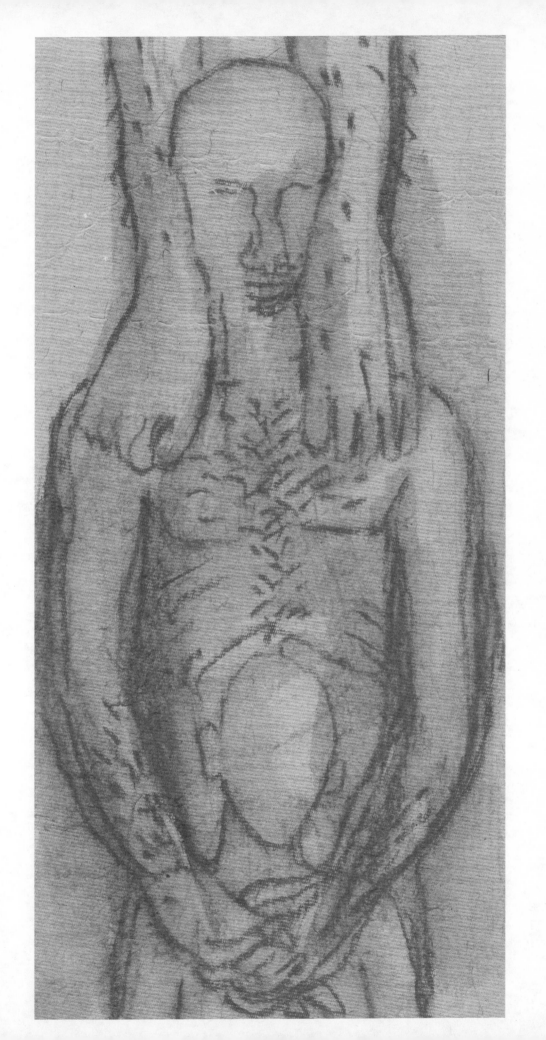

A 22
J. Shanatharam

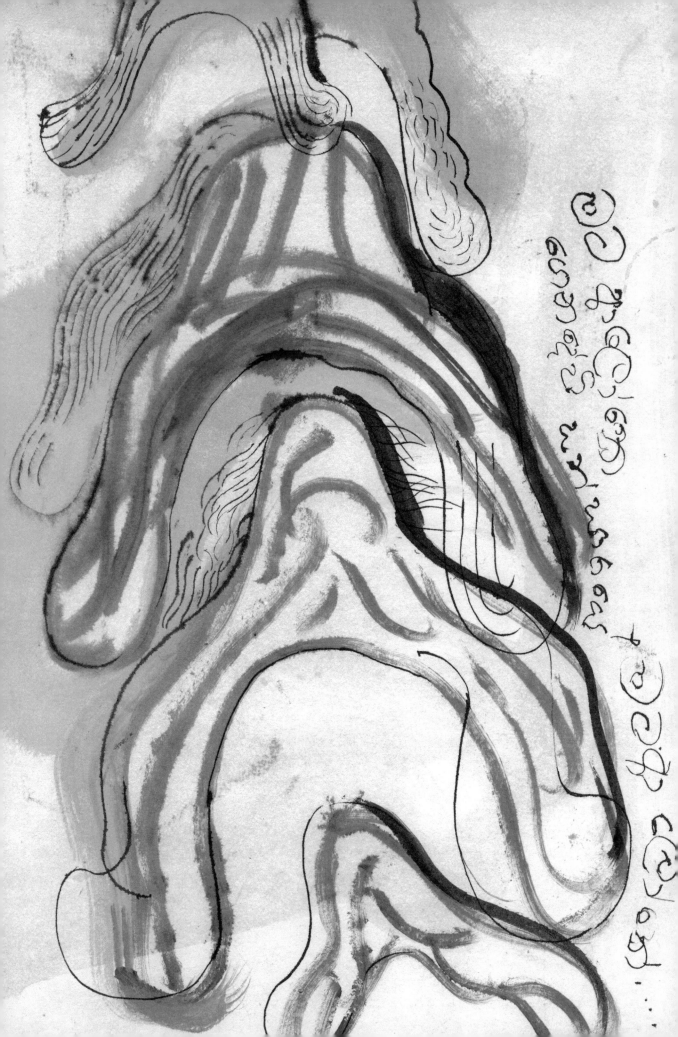

J→M
A23

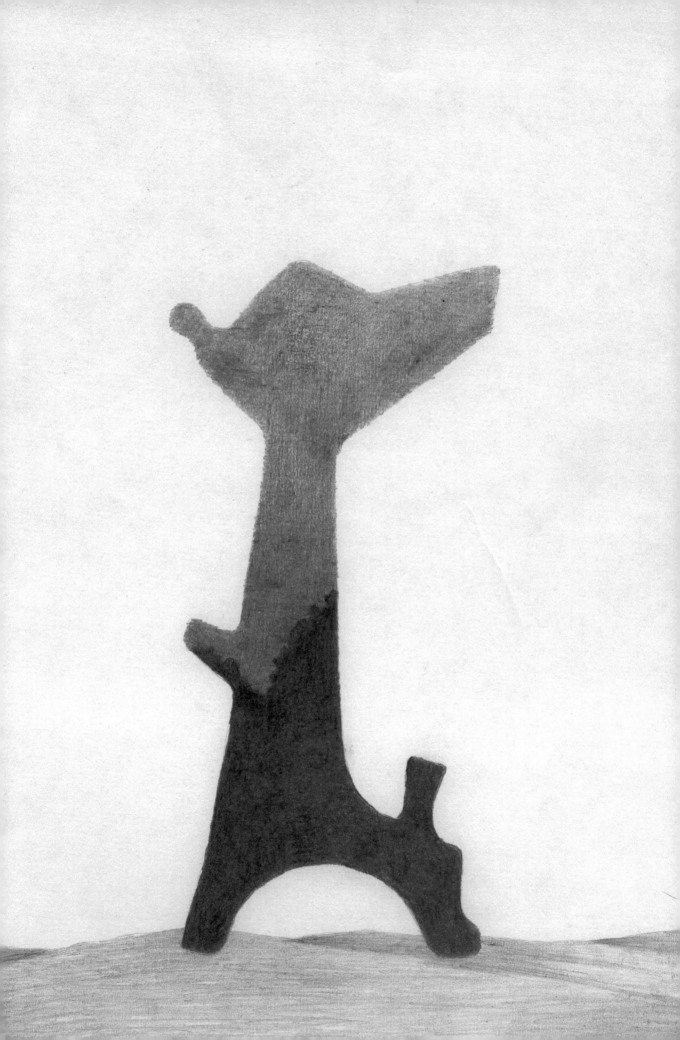

A24-MC

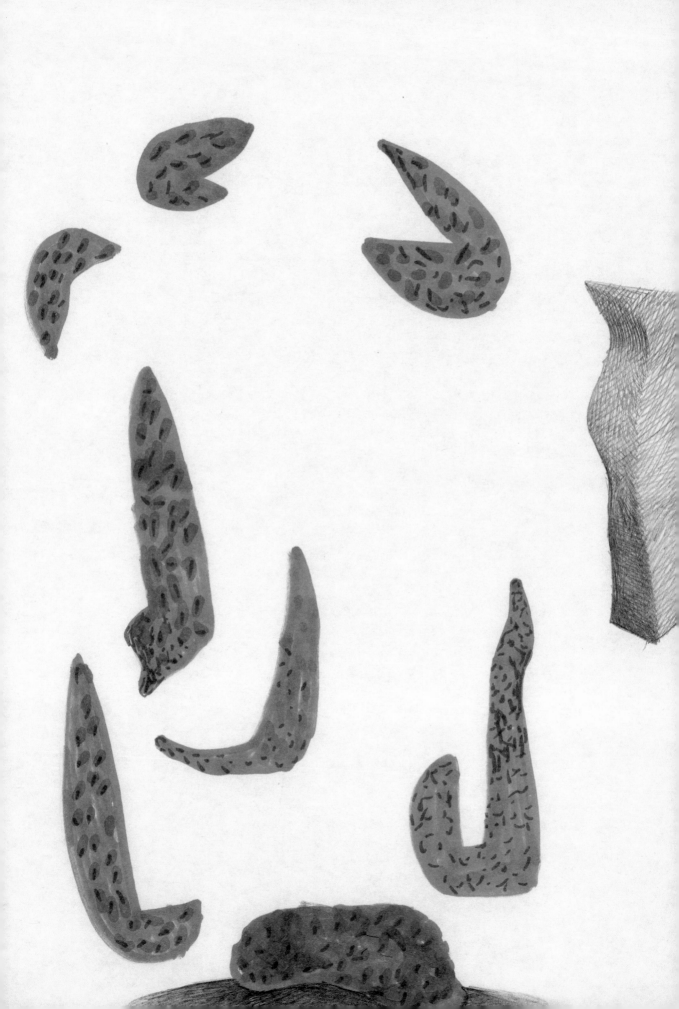

A25

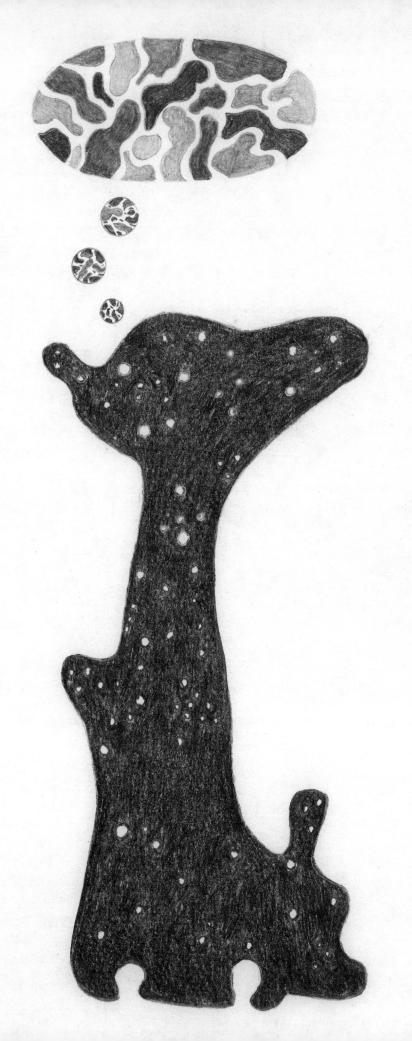

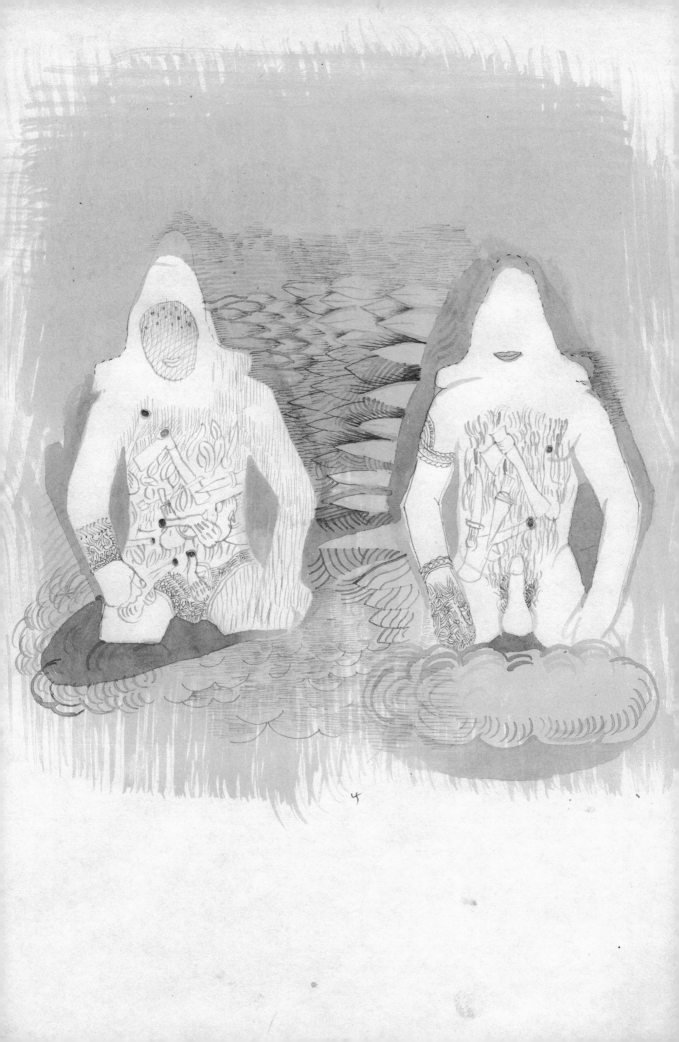

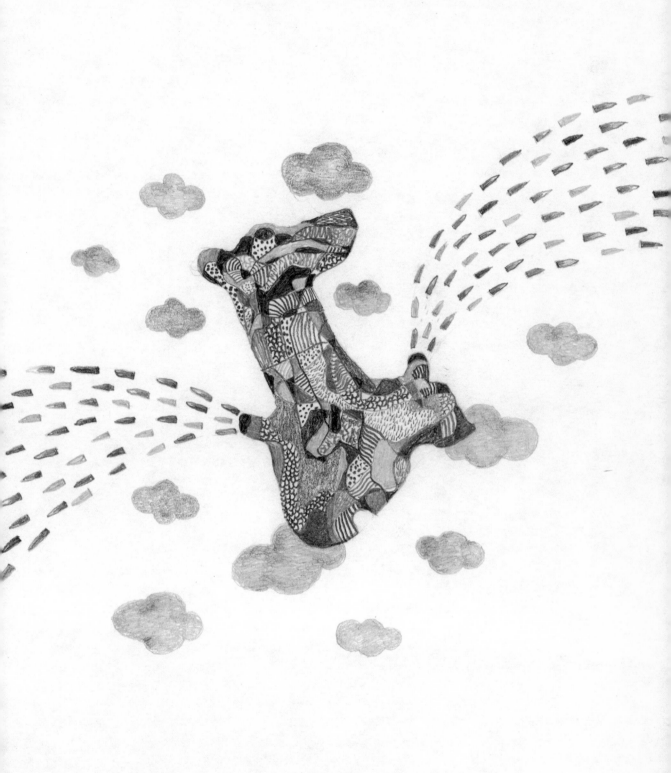

A29.MC

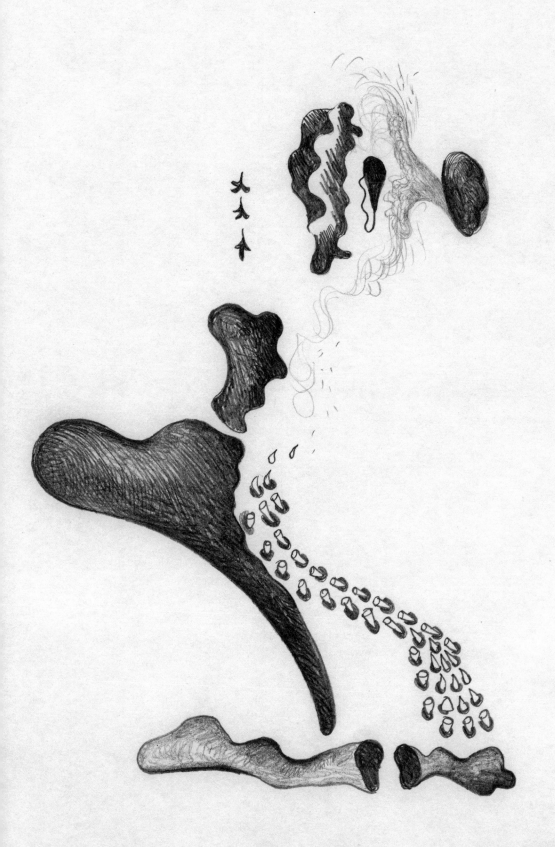

A 30

lyKin 2006. 03. 22

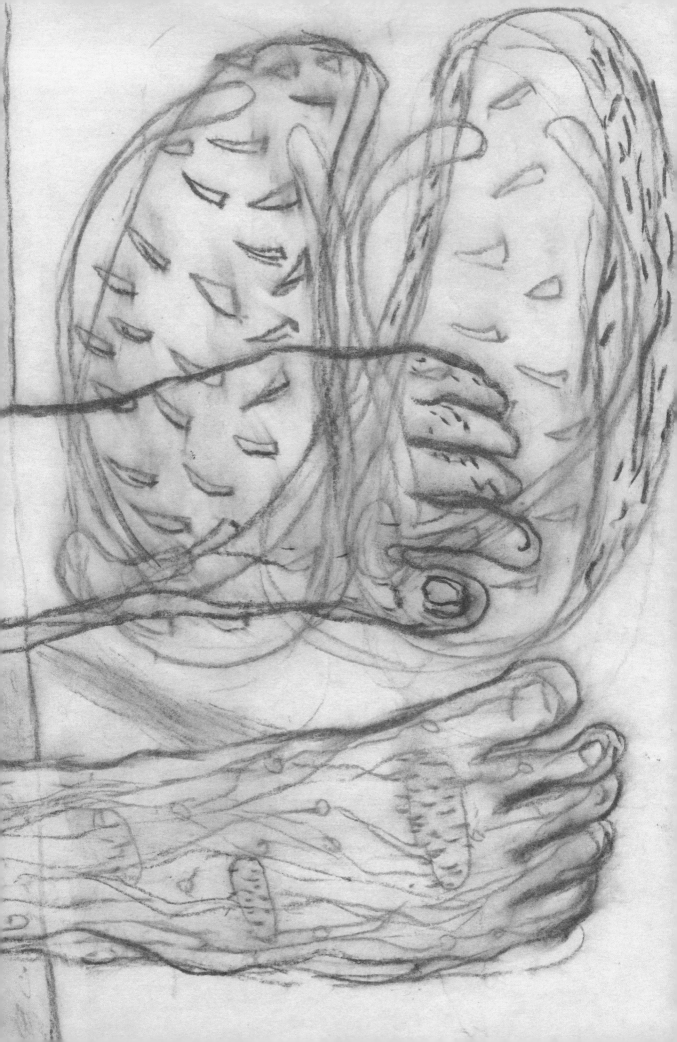

A 31

J. Shanahan -

A3Z-MC

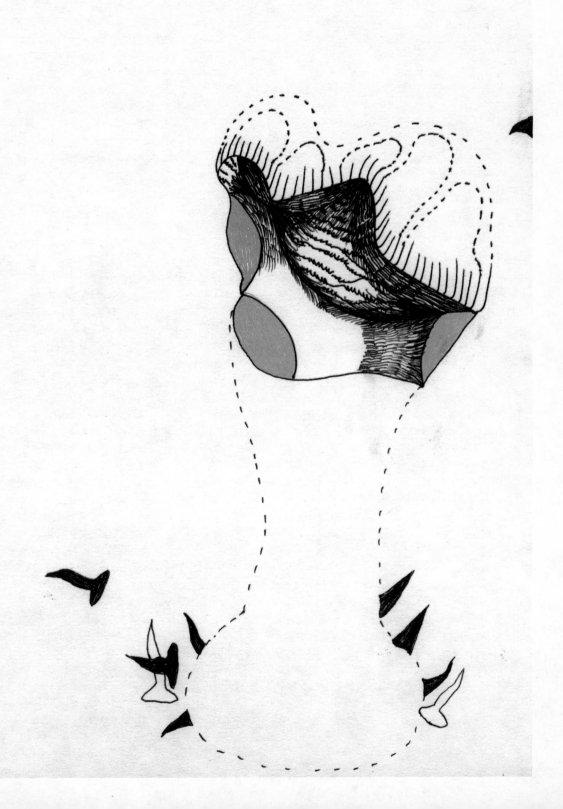

A 33

J → T

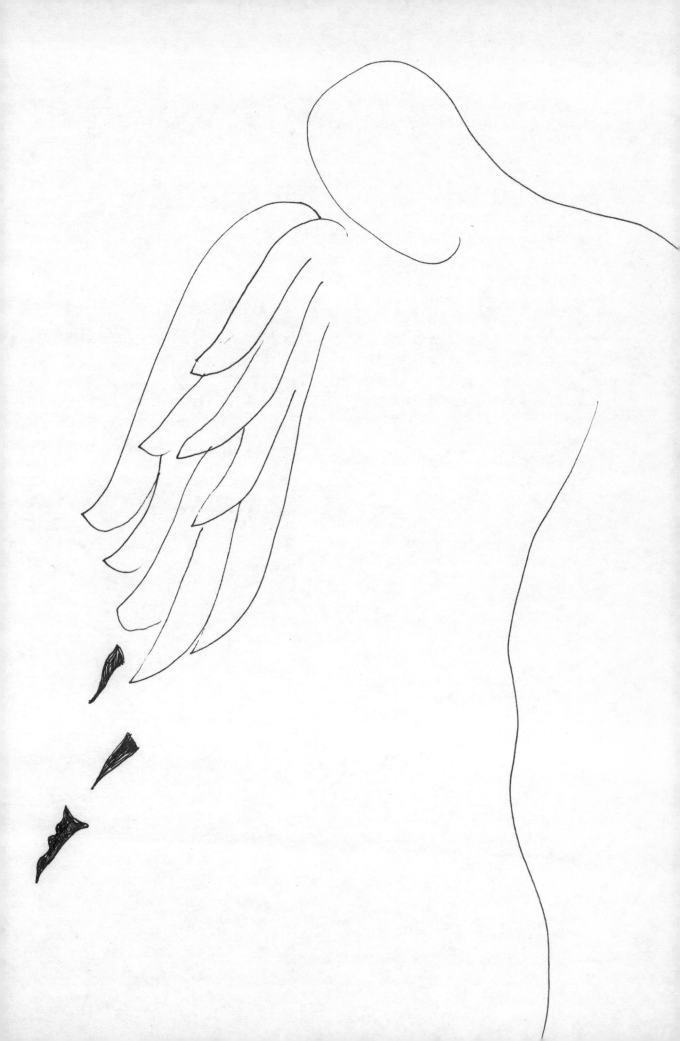

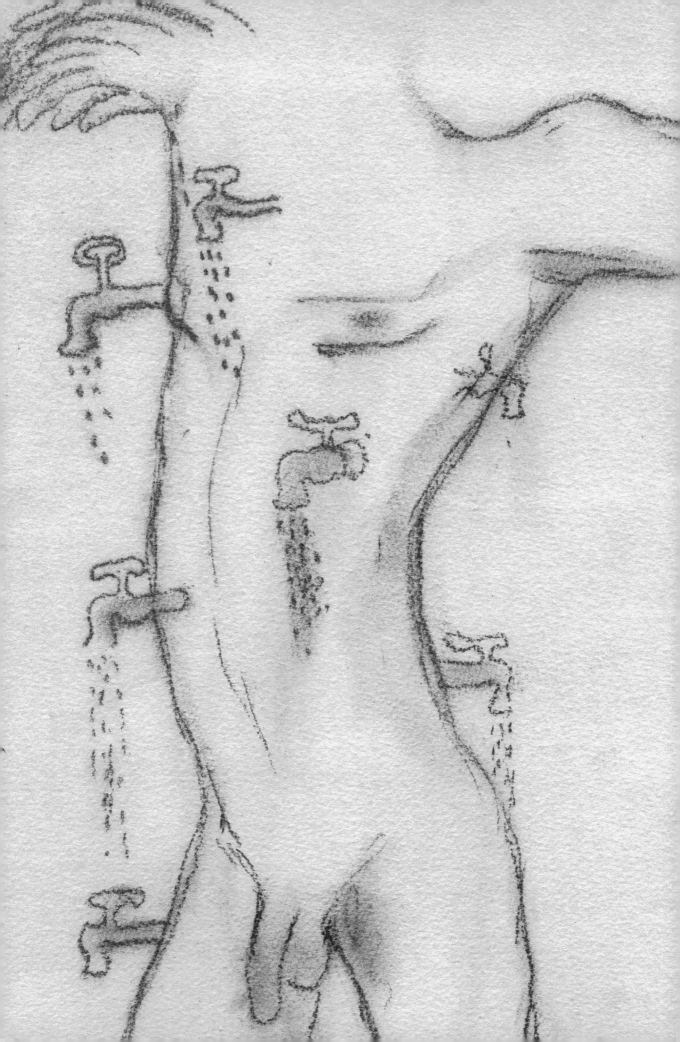

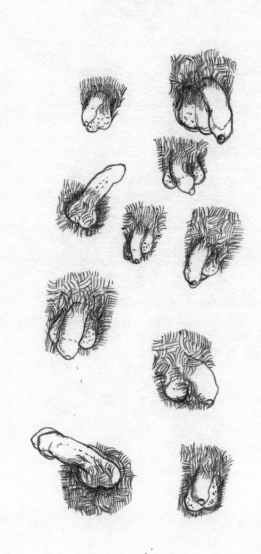

A36

J → M

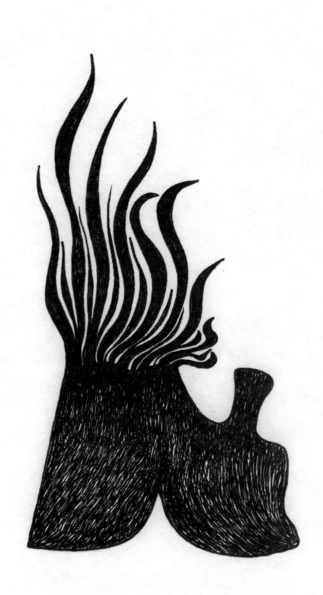

MC- A37

A 38

Lyken 2006. 09. 15

A 39

Smolten

to J

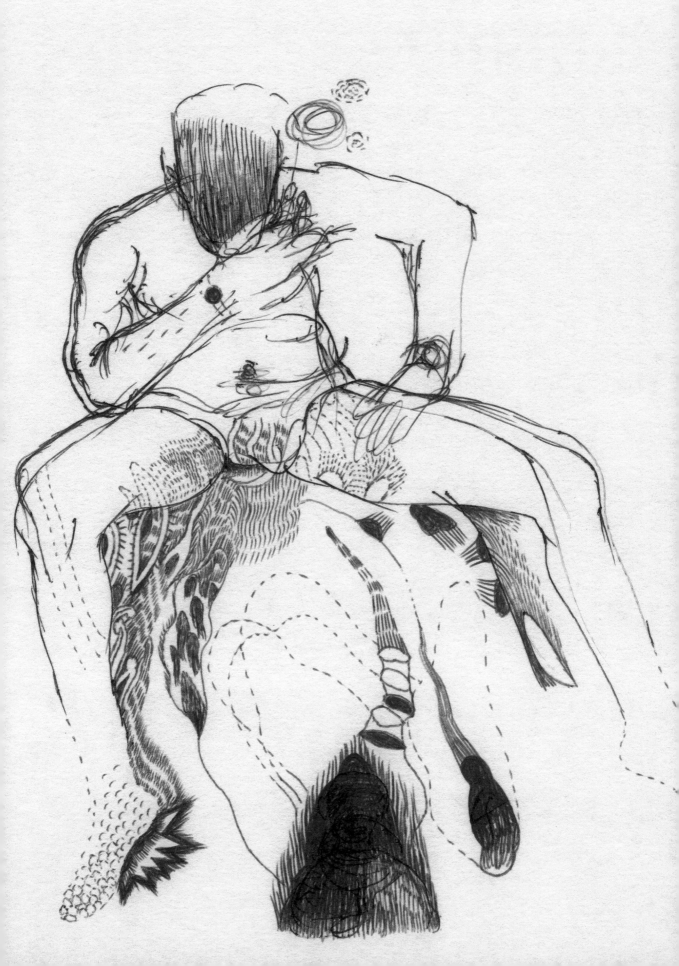

A 40
J → M

A 40
J → M

MC A 41

A - 43

P. Shankarin.

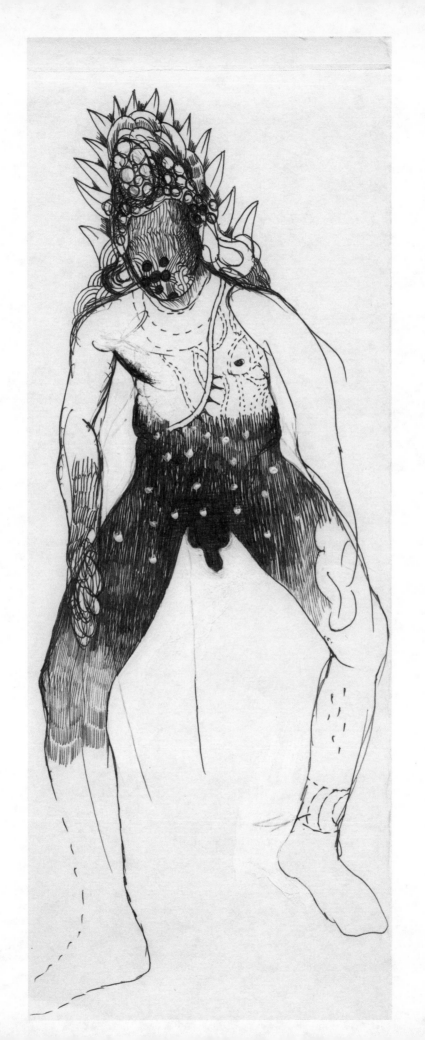

2007 07 26

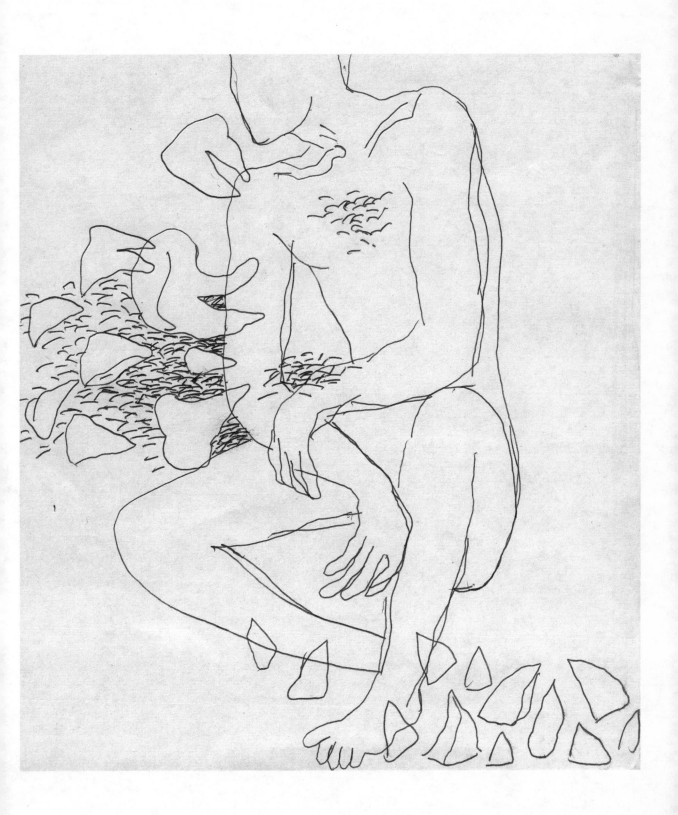

A 46

J. Shaovathie

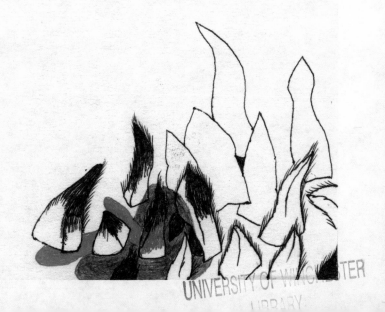

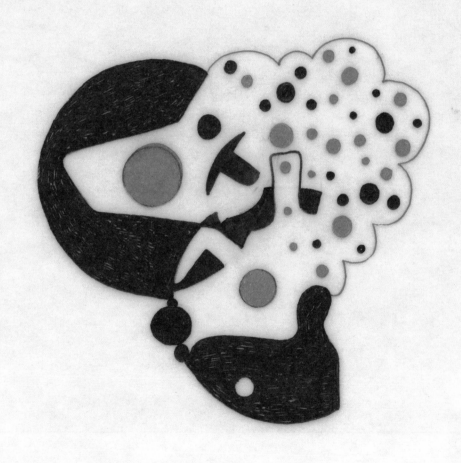

JMC-81 A

A 48 -> MC

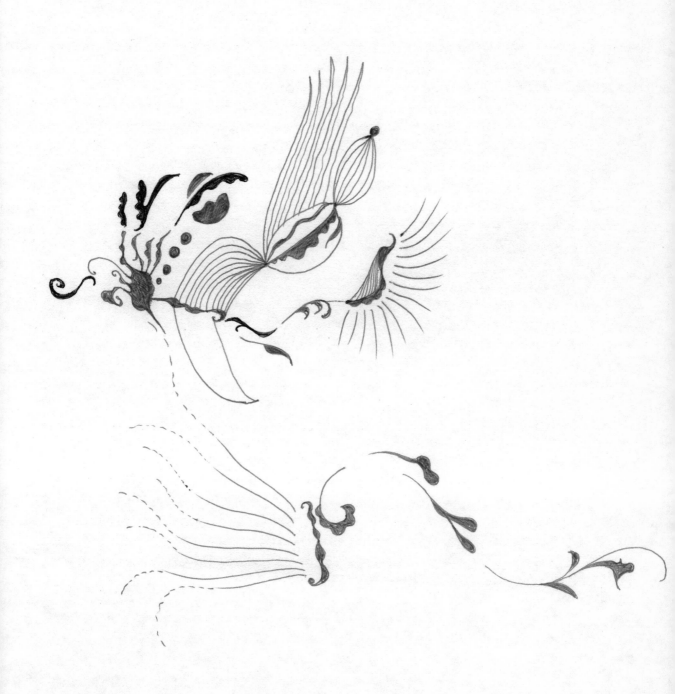

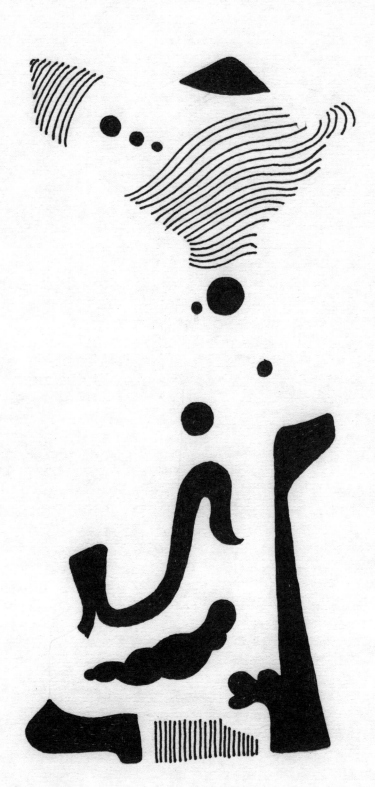

A50/MC → S

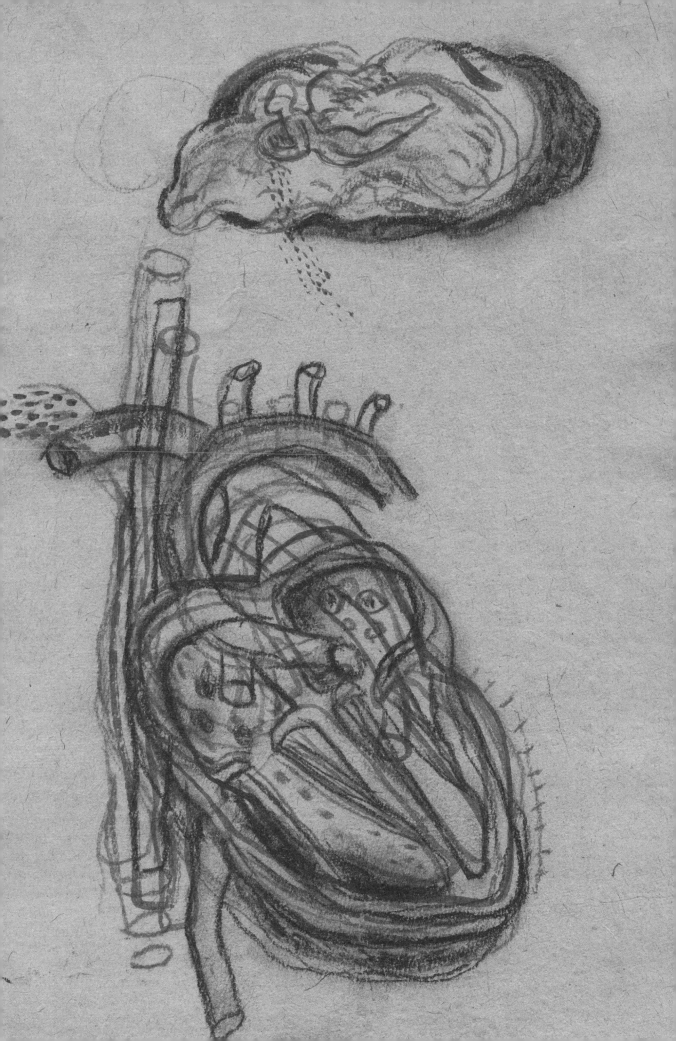

A- 51

J. Shamaathiam

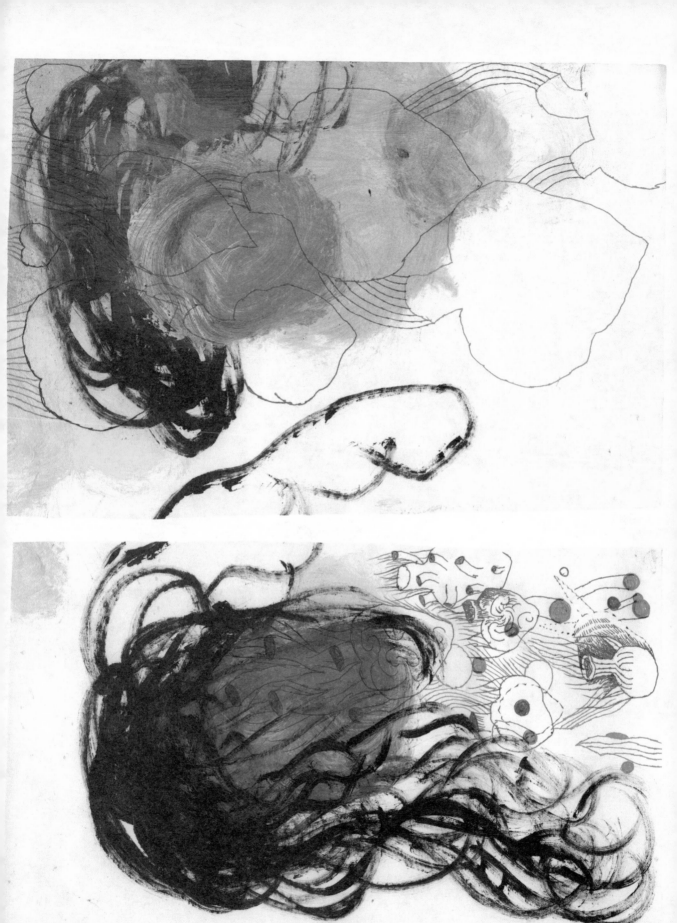

A 52.2

A 52.1

Drawings B1 to B52 / /

Chandraguptha Thenuwara (CT B1); Thamotharampillai Shanaathanan (TS B2); Jagath
Weerasinghe (JW B3); Muhanned Cader (MC B4); Thamotharampillai Shanaathanan (TS B5);
Jagath Weerasinghe (JW B6); Muhanned Cader (MC B7); Chandraguptha Thenuwará (CT B8);
Muhanned Cader (MC B9); Thamotharampillai Shanaathanan (TS B10); Jagath Weerasinghe
(JW B11); Chandraguptha Thenuwara (CT B12); Thamotharampillai Shanaathanan (TS B13);
Jagath Weerasinghe (JW B14); Muhanned Cader (MC B15); Chandraguptha Thenuwara (CT B16);
Jagath Weerasinghe (JW B17); Muhanned Cader (MC B18); Chandraguptha Thenuwara (CT B19);
Thamotharampillai Shanaathanan (TS B20); Muhanned Cader (MC B21); Chandraguptha
Thenuwara (CT B22); Thamotharampillai Shanaathanan (TS B23); Jagath Weerasinghe (JW B24);
Thamotharampillai Shanaathanan (TS B25); Chandraguptha Thenuwara (CT B26); Jagath
Weerasinghe (JW B27); Muhanned Cader (MC B28); Thamotharampillai Shanaathanan (TS B29);
Jagath Weerasinghe (JW B30); Muhanned Cader (MC B31); Chandraguptha Thenuwara (CT B32);
Muhanned Cader (MC B33); Thamotharampillai Shanaathanan (TS B34); Jagath Weerasinghe
(JW B35); Chandraguptha Thenuwara (CT B36); Thamotharampillai Shanaathanan (TS B37);
Jagath Weerasinghe (JW B38); Muhanned Cader (MC B39); Chandraguptha Thenuwara (CT B40);
Jagath Weerasinghe (JW B41); Muhanned Cader (MC B42); Chandraguptha Thenuwara (CT B43);
Thamotharampillai Shanaathanan (TS B44); Muhanned Cader (MC B45); Chandraguptha
Thenuwara (CT B46); Thamotharampillai Shanaathanan (TS B47); Jagath Weerasinghe (JW B48);
Thamotharampillai Shanaathanan (TS B49); Chandraguptha Thenuwara (CT B50); Jagath
Weerasinghe (JW B51.1 and B51.2); Muhanned Cader (MC B52).

B1

李小明 2005. 06. 02

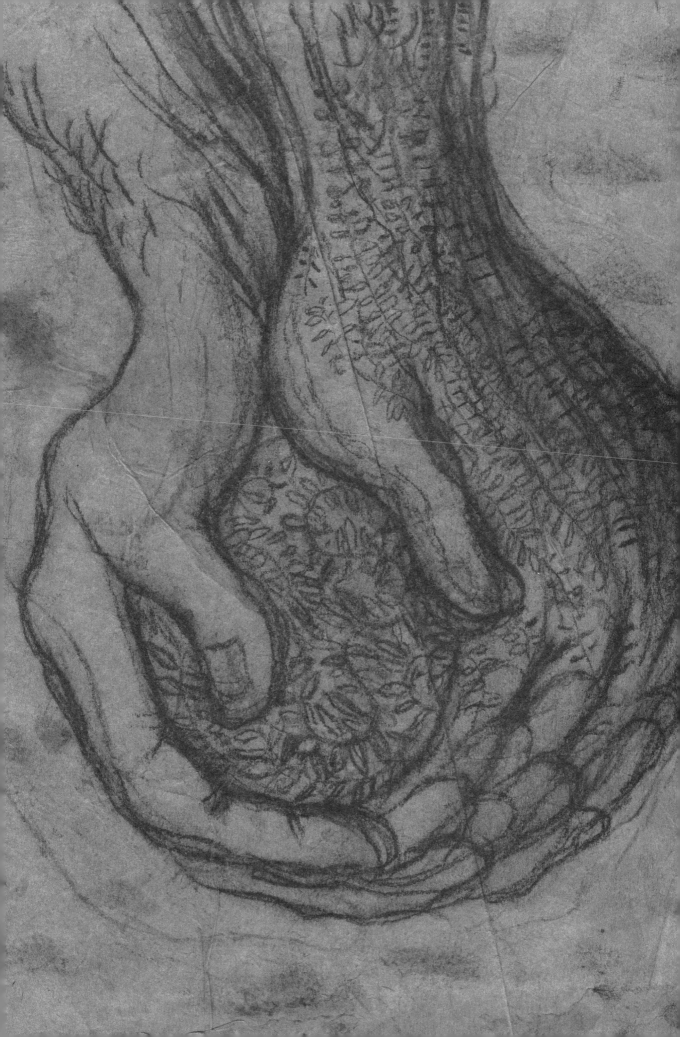

B4 - MC

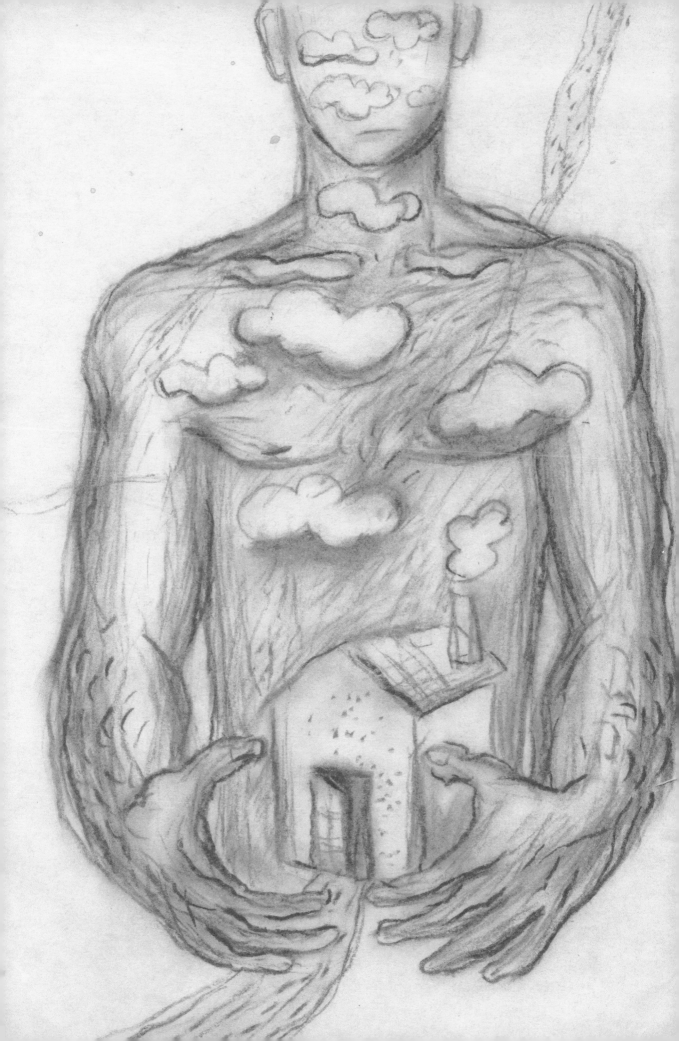

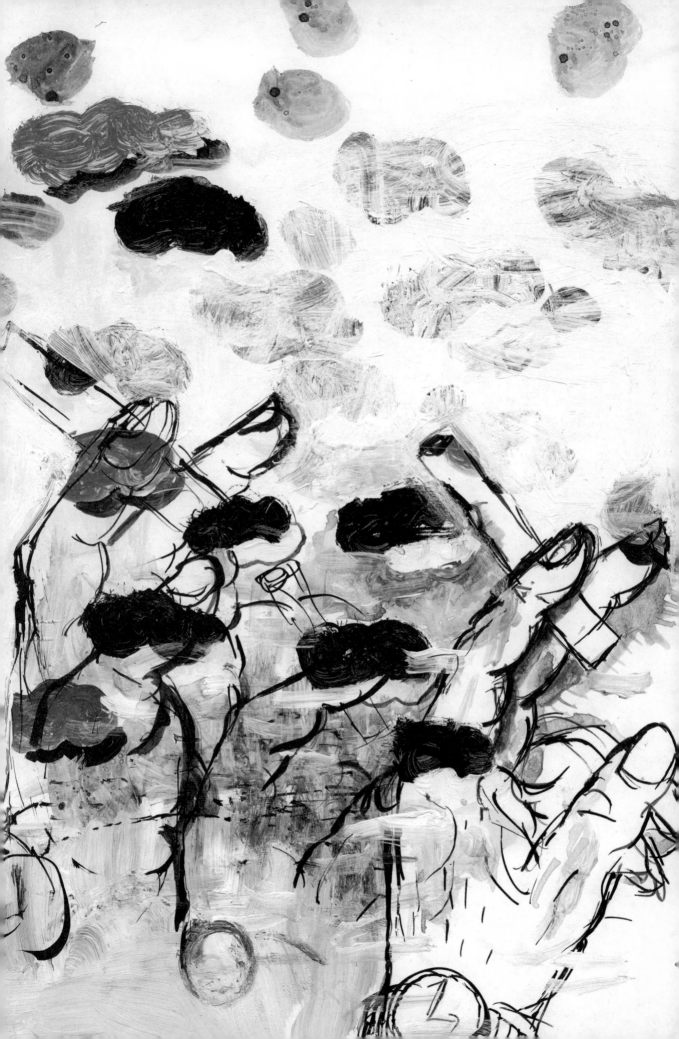

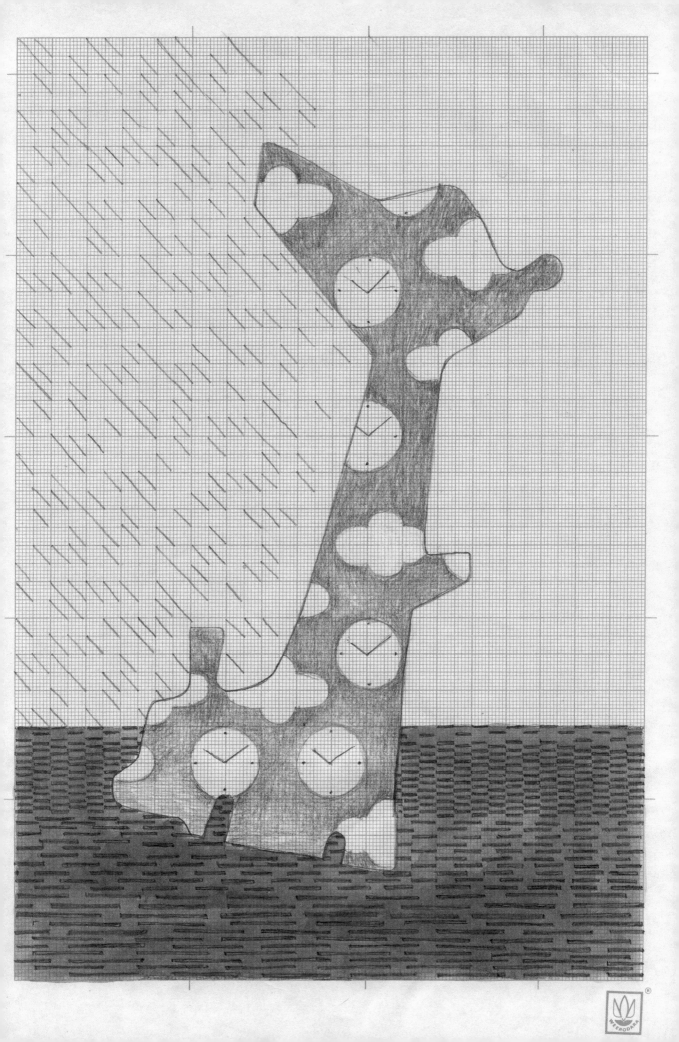

B7-MC

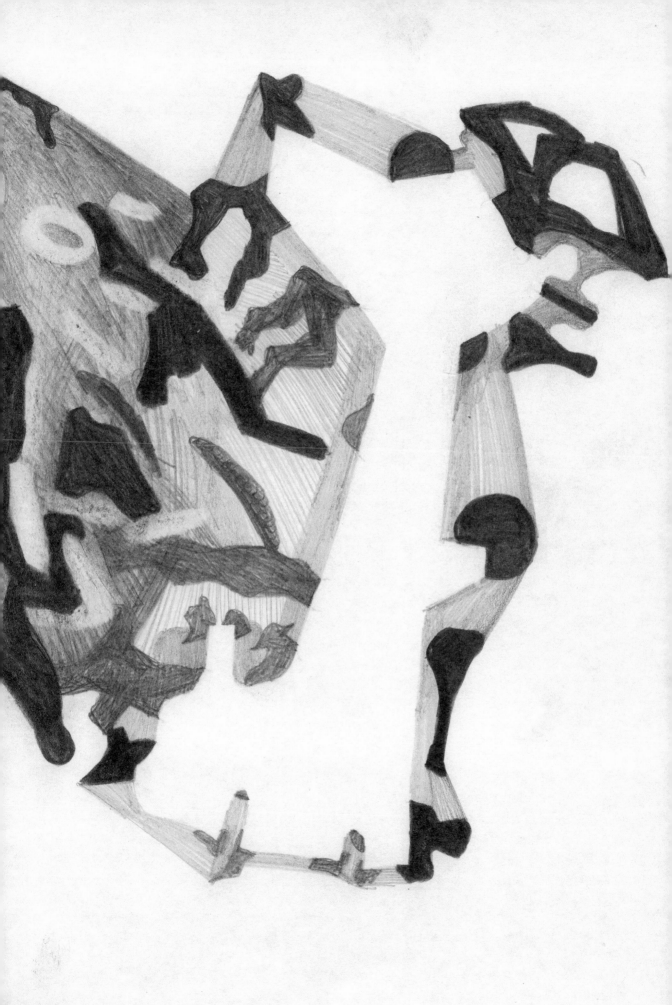

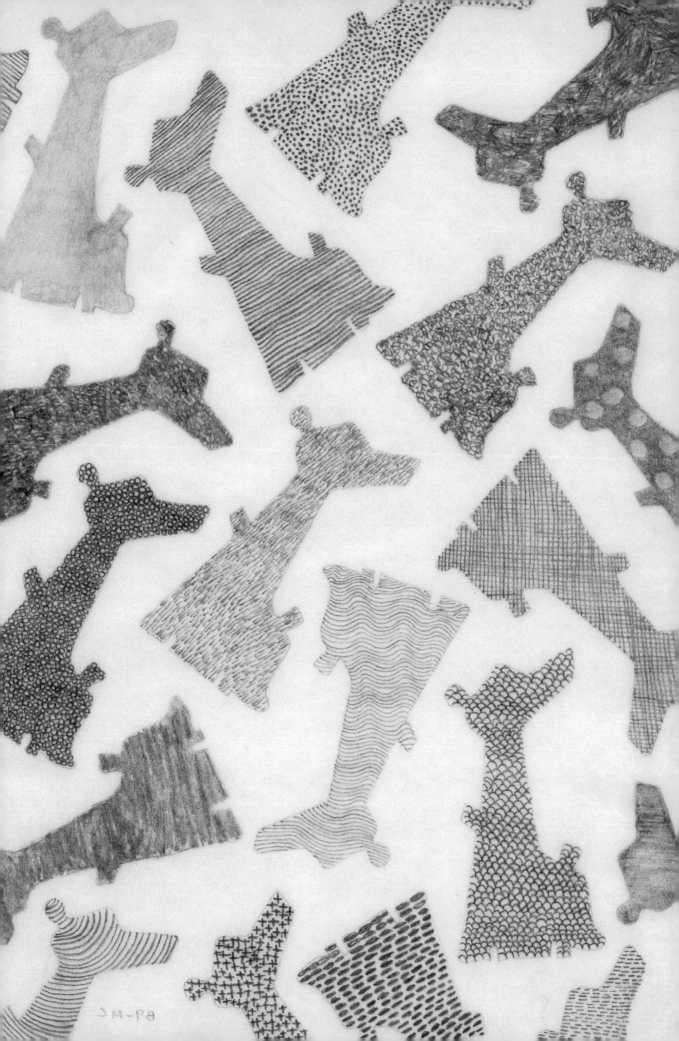

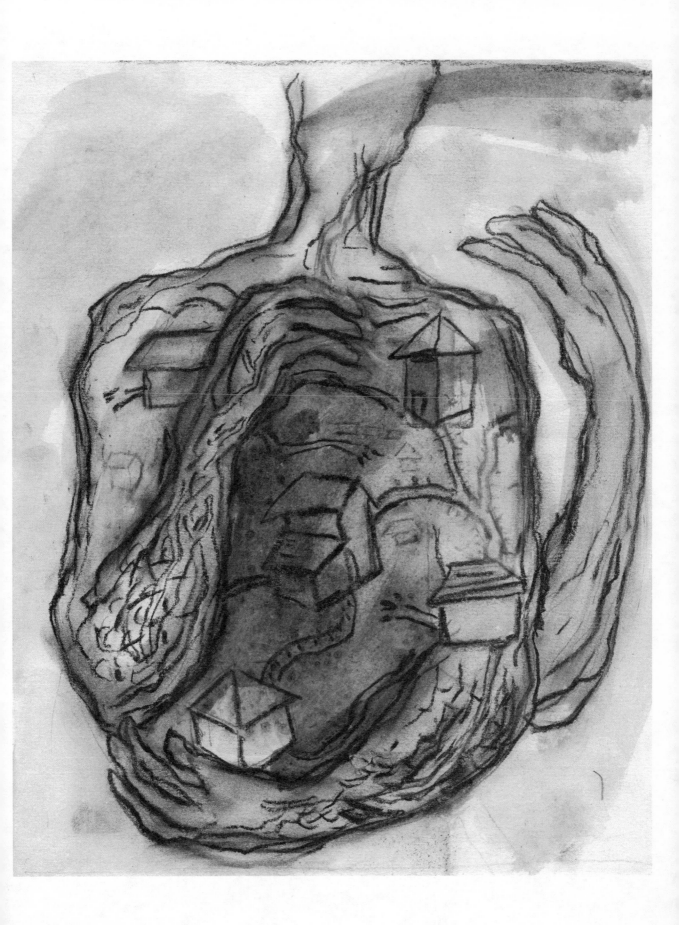

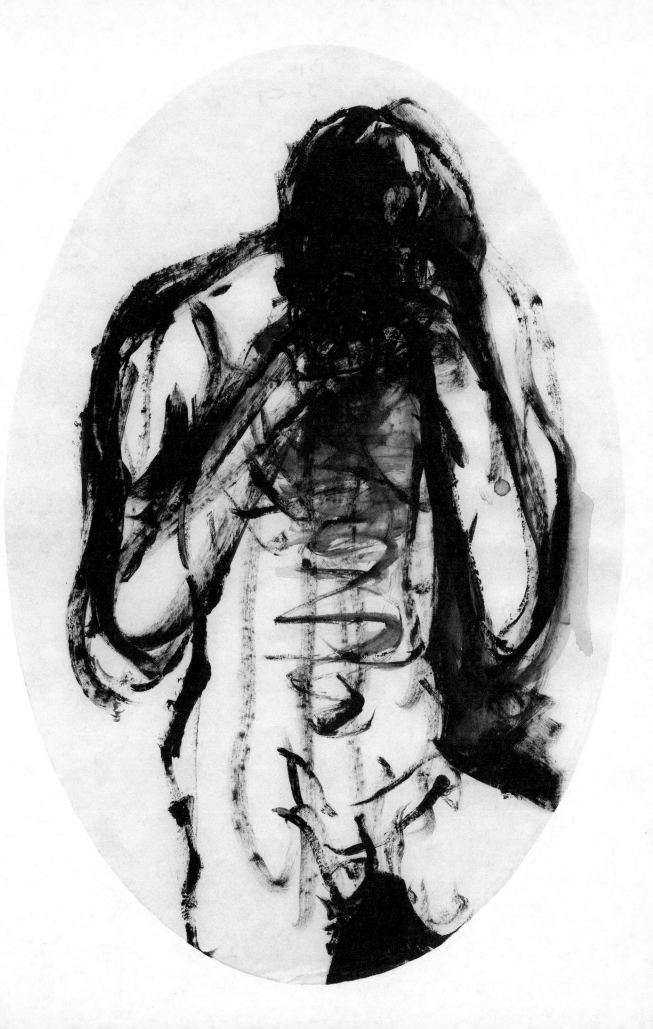

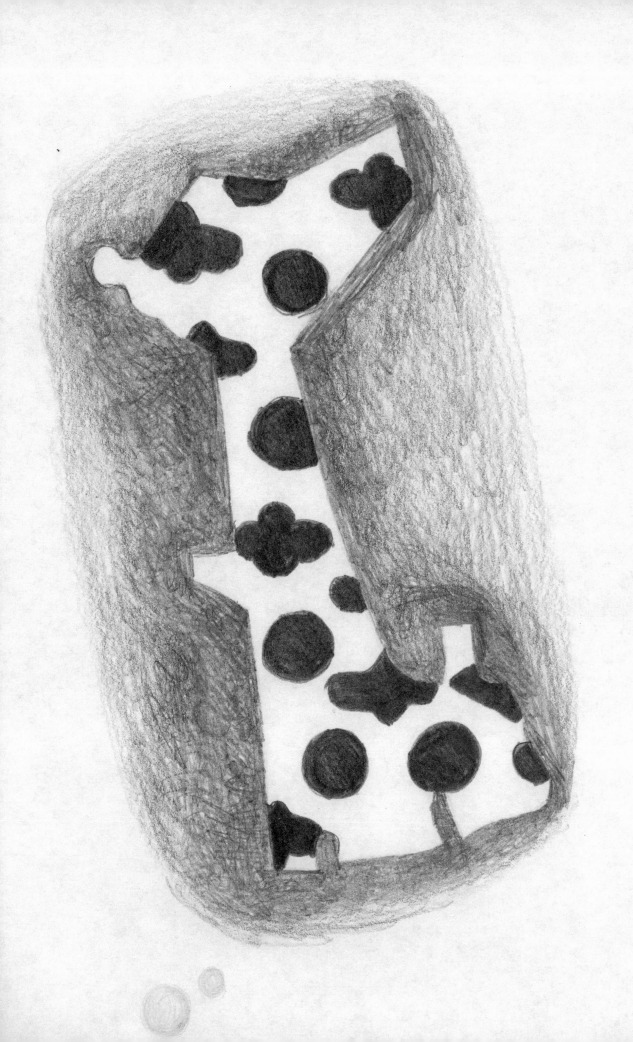

luXum 2005 08.12 B12

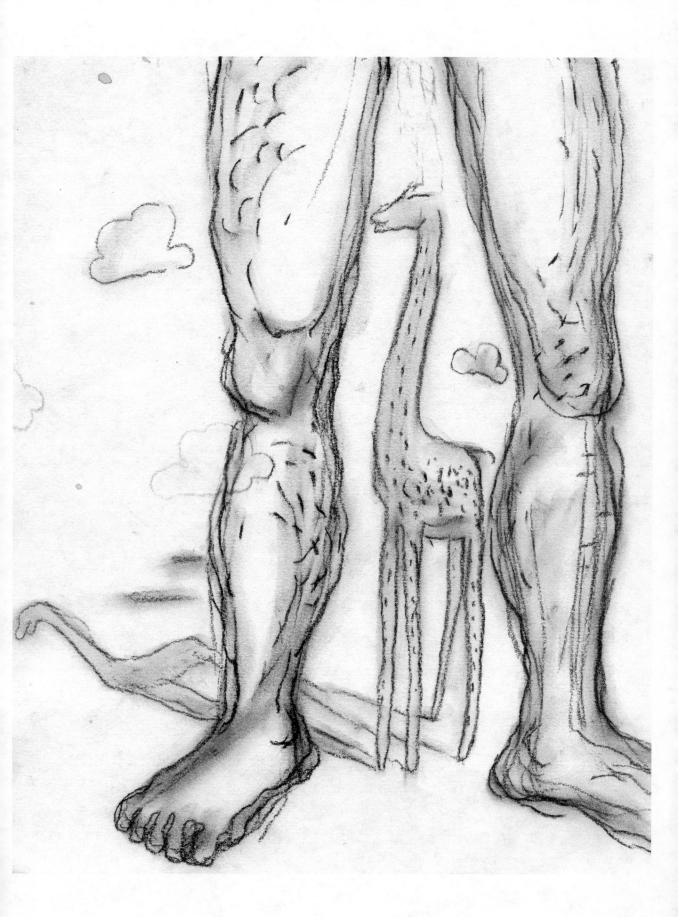

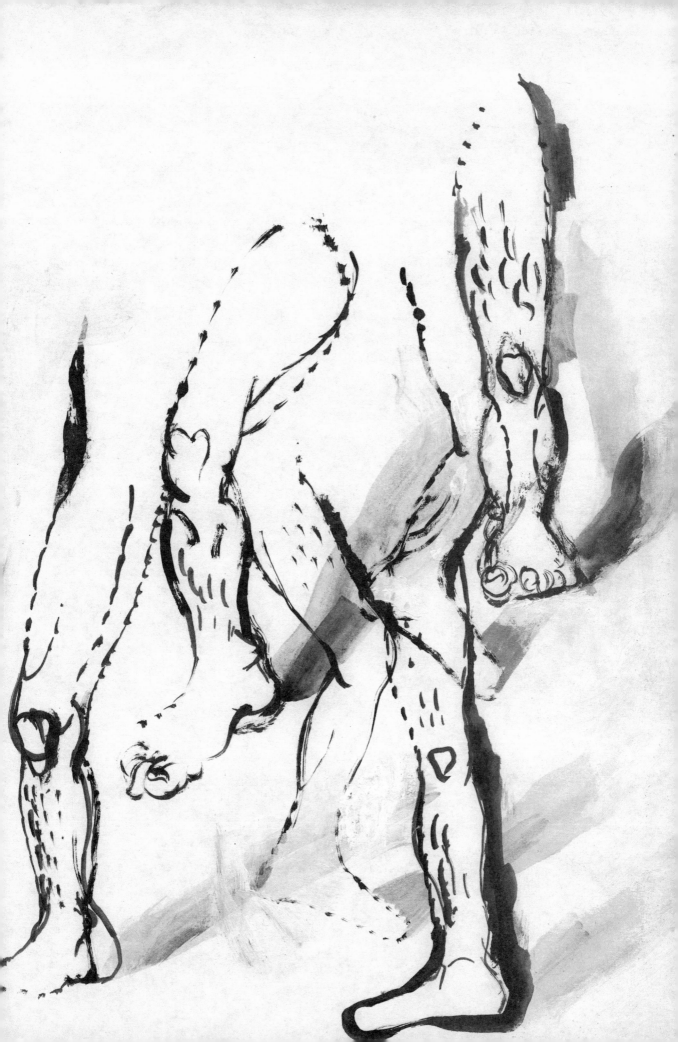

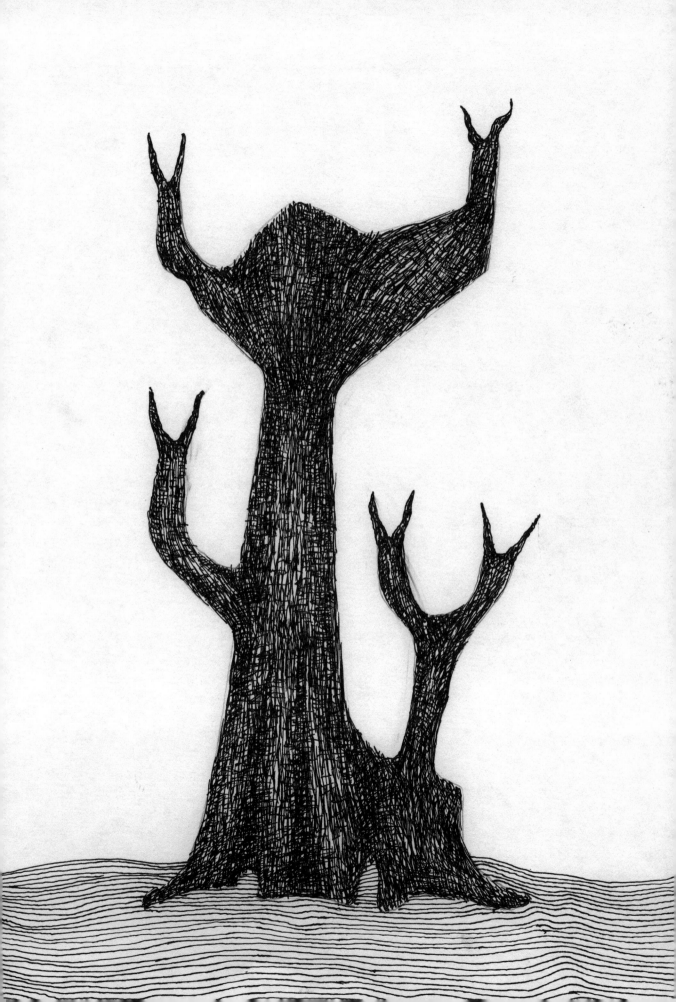

MC-B15

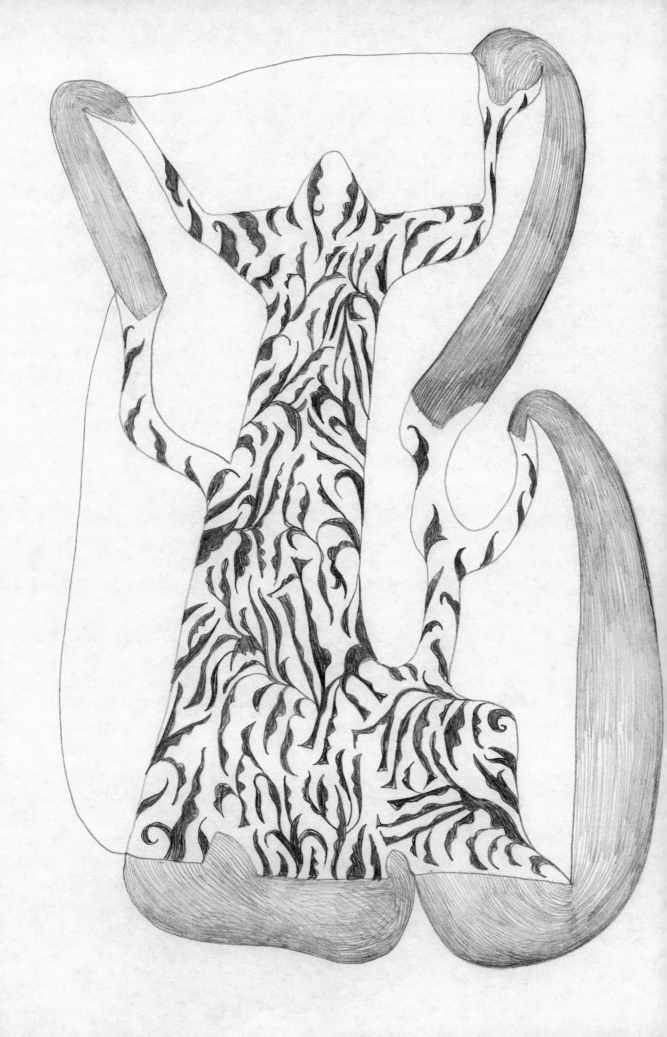

B/6

ly*um 2005. 09. 23

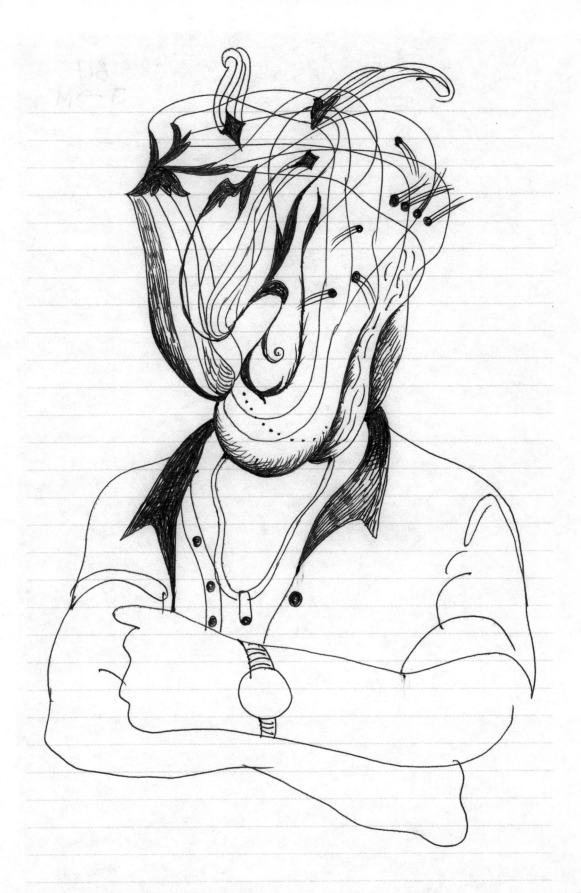

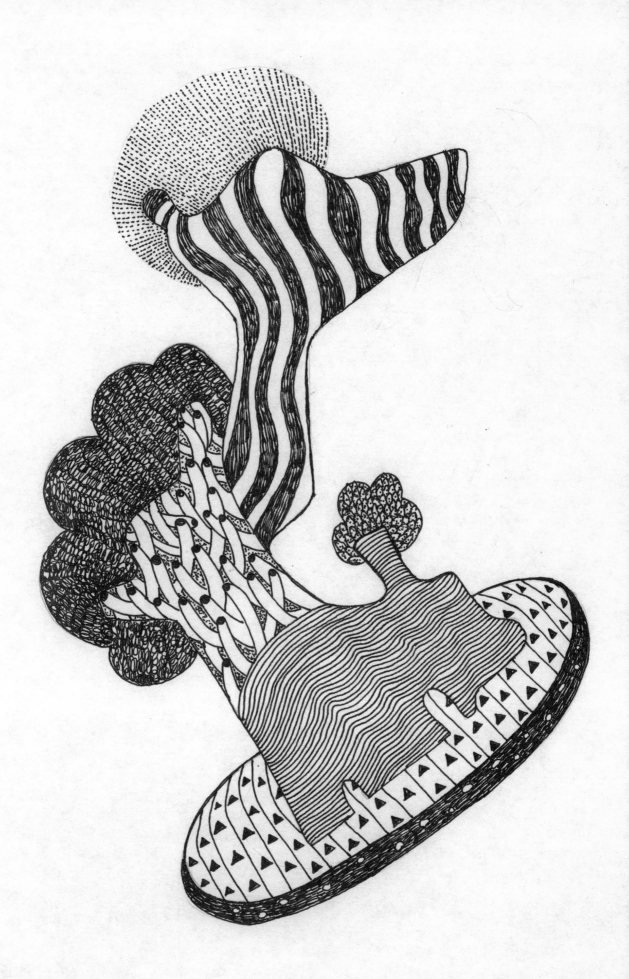

MC-B18

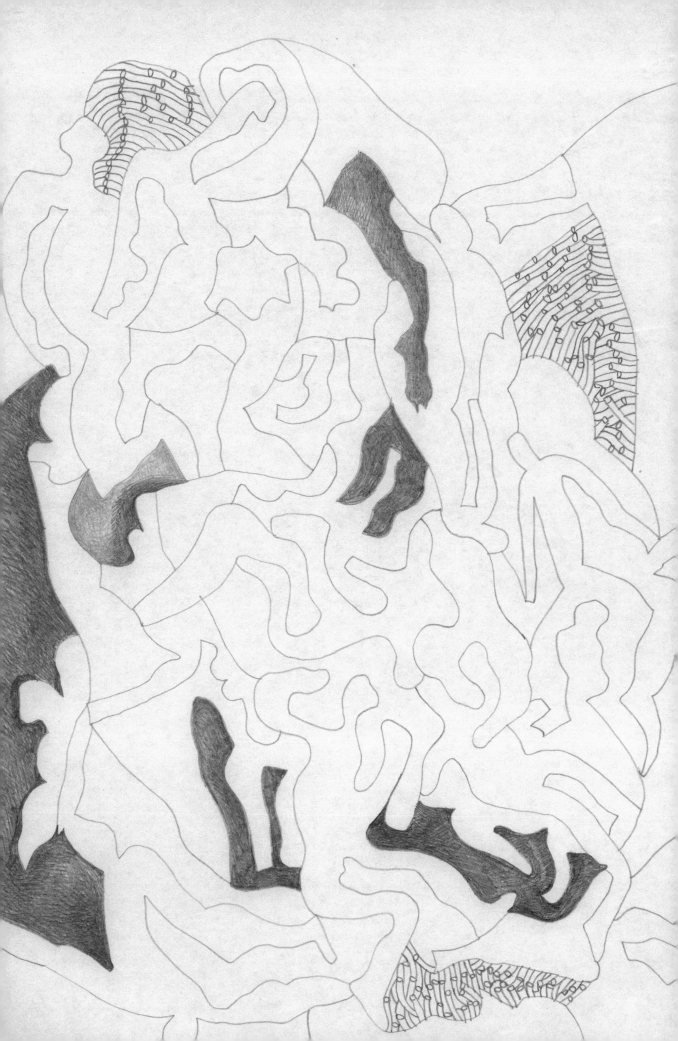

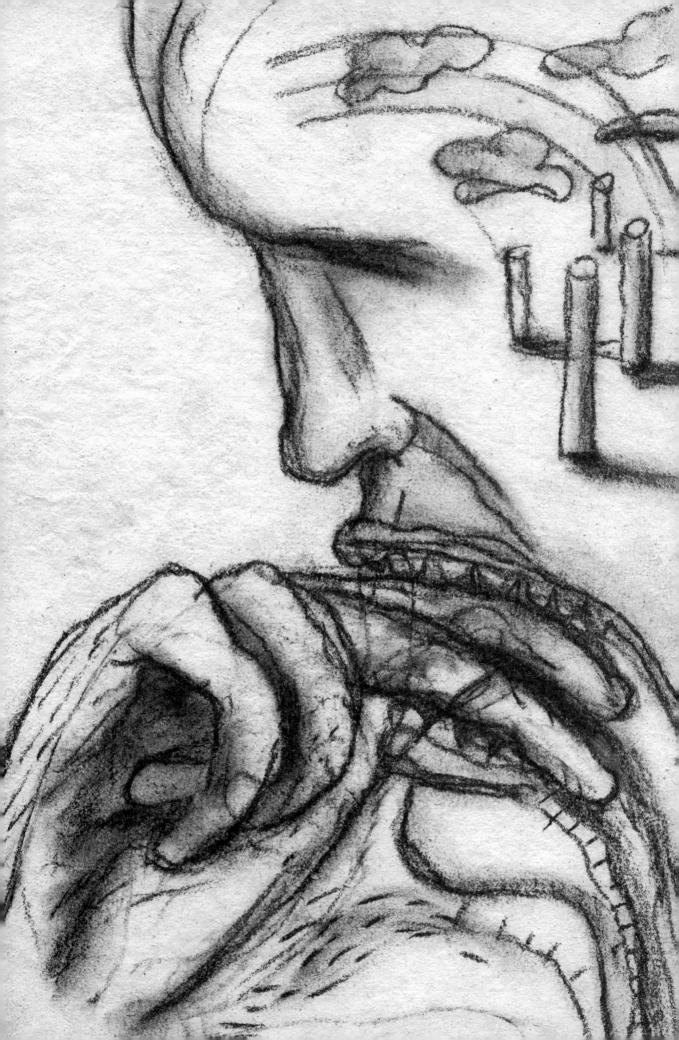

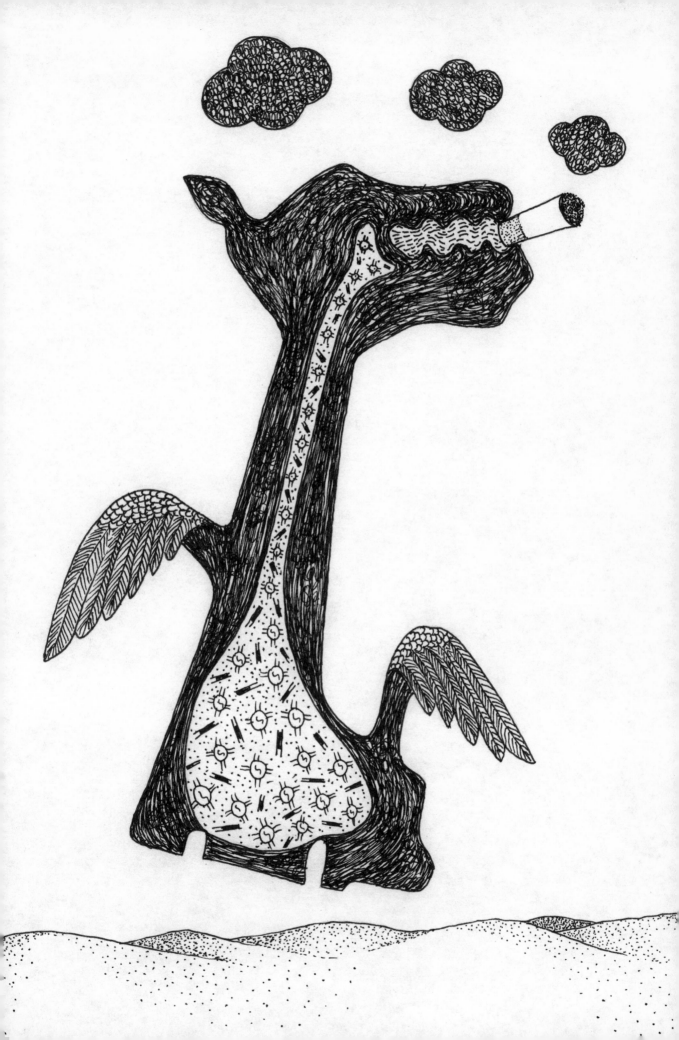

MG-1321

B 22

Gylum 2007 Dec 04

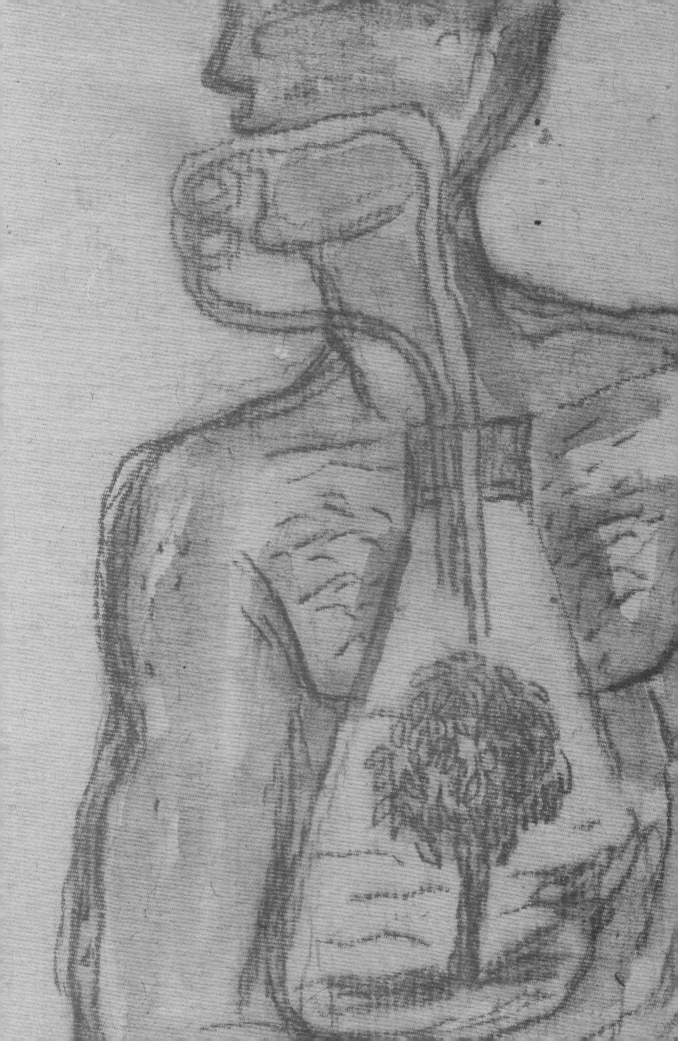

Shanaathanan
B-23.

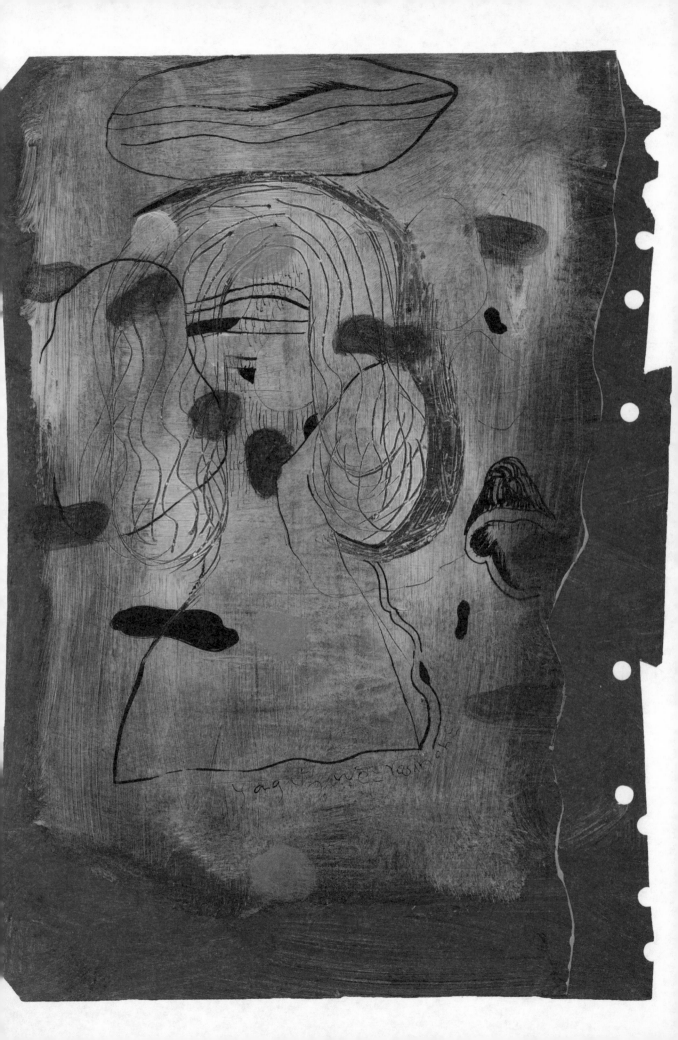

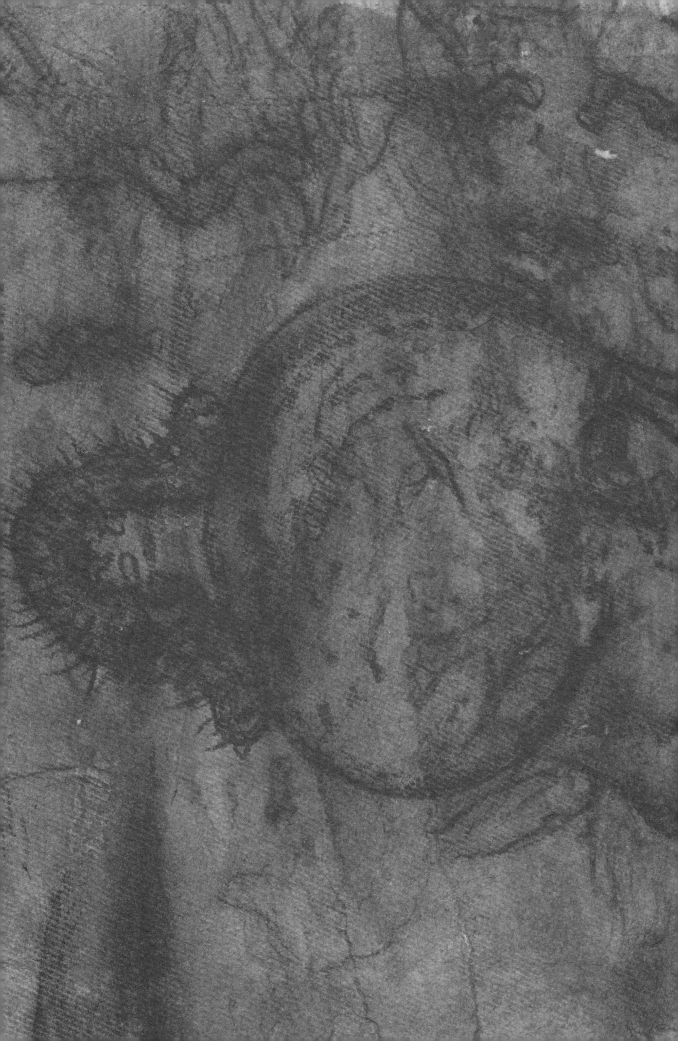

B-25

J. Shanahanan.

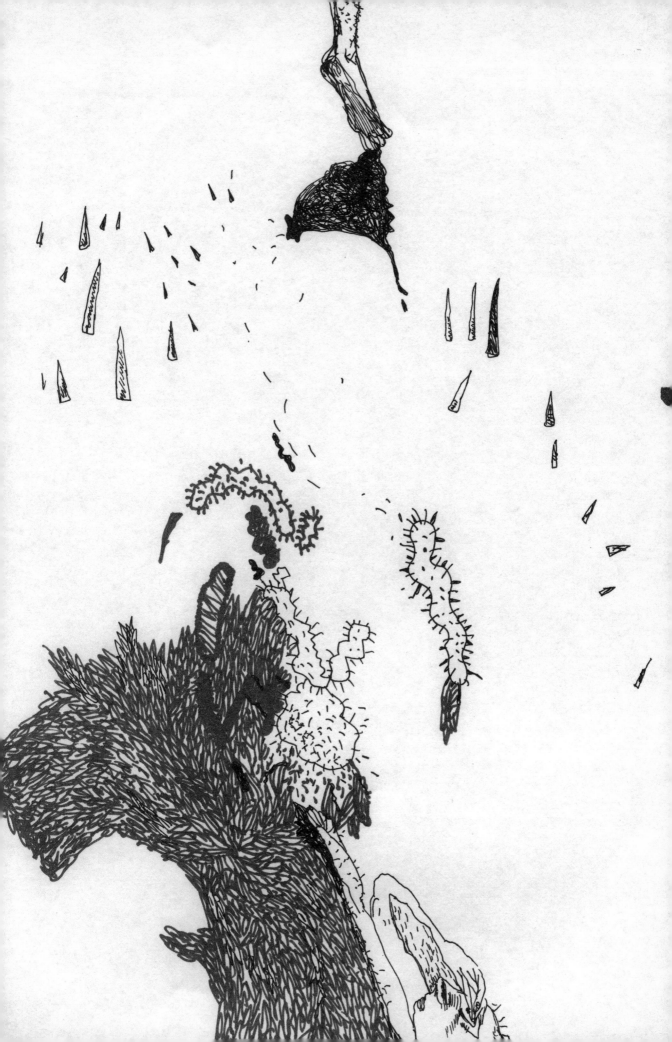

B 26

2006. 01. 30

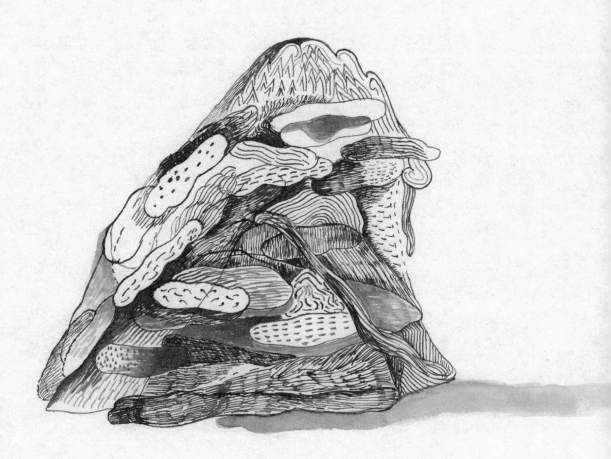

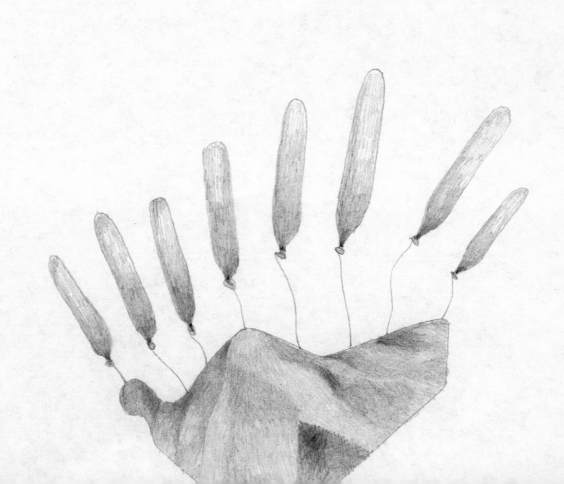

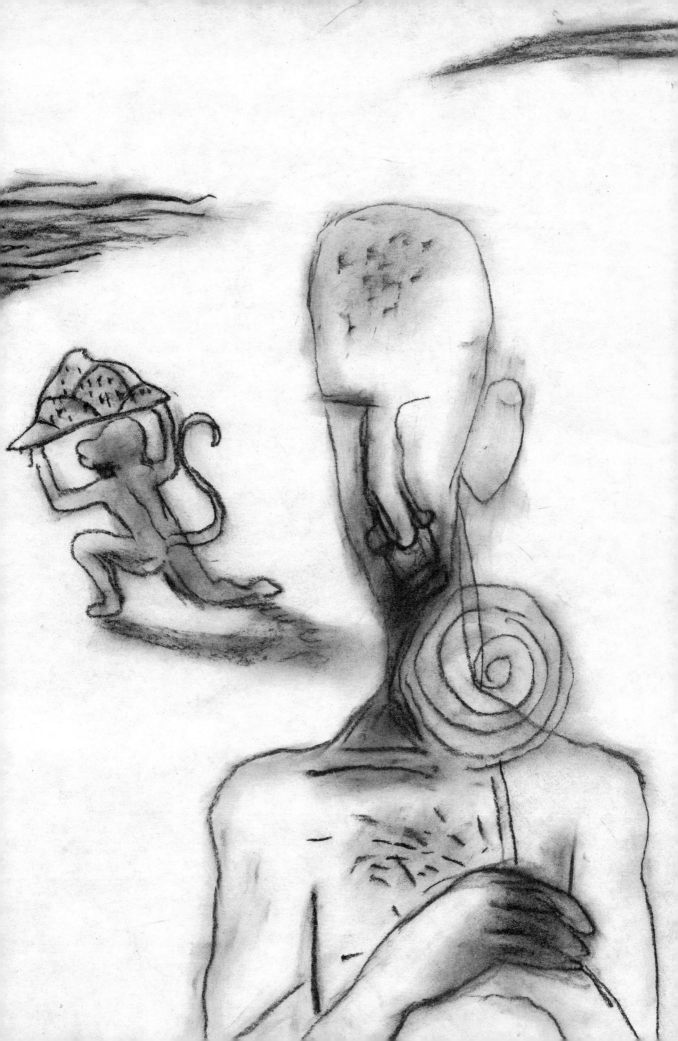

B-29

J. Shannahan

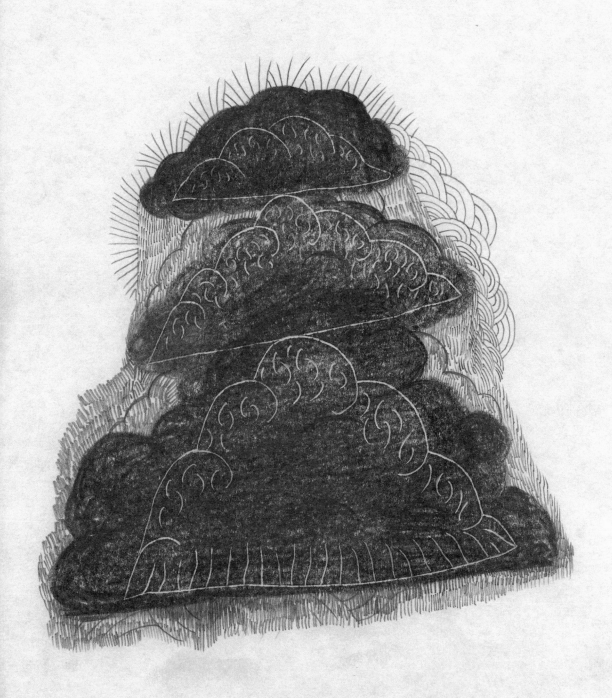

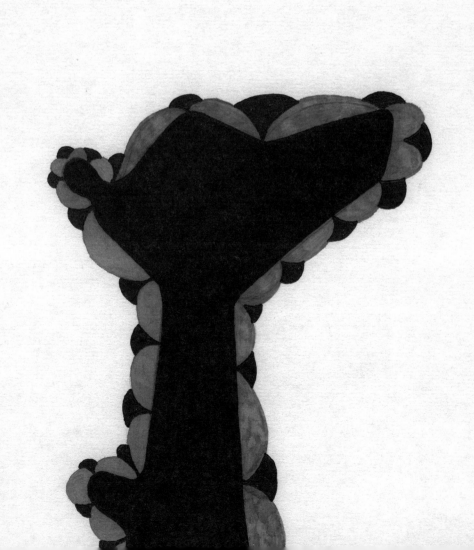

B31/MC

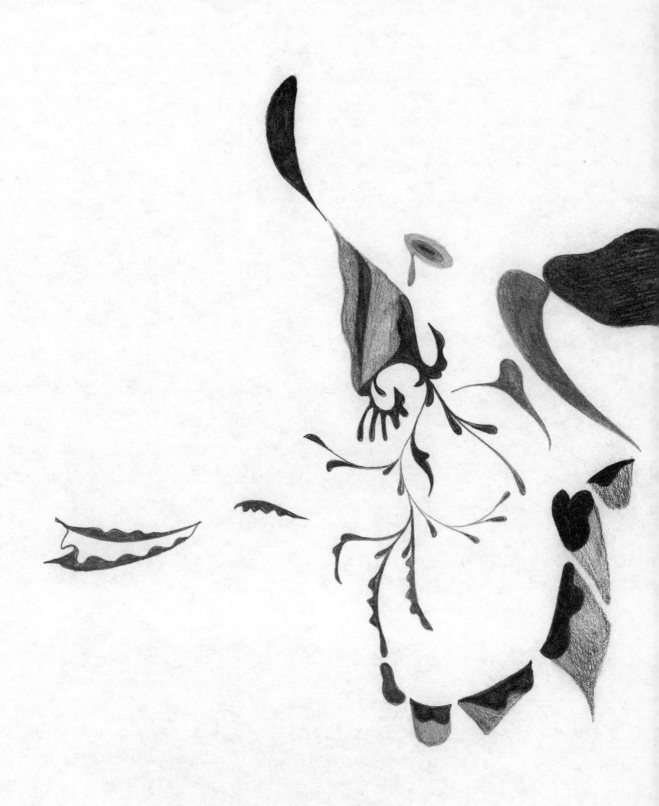

B 32

dyKim 2006.06.01

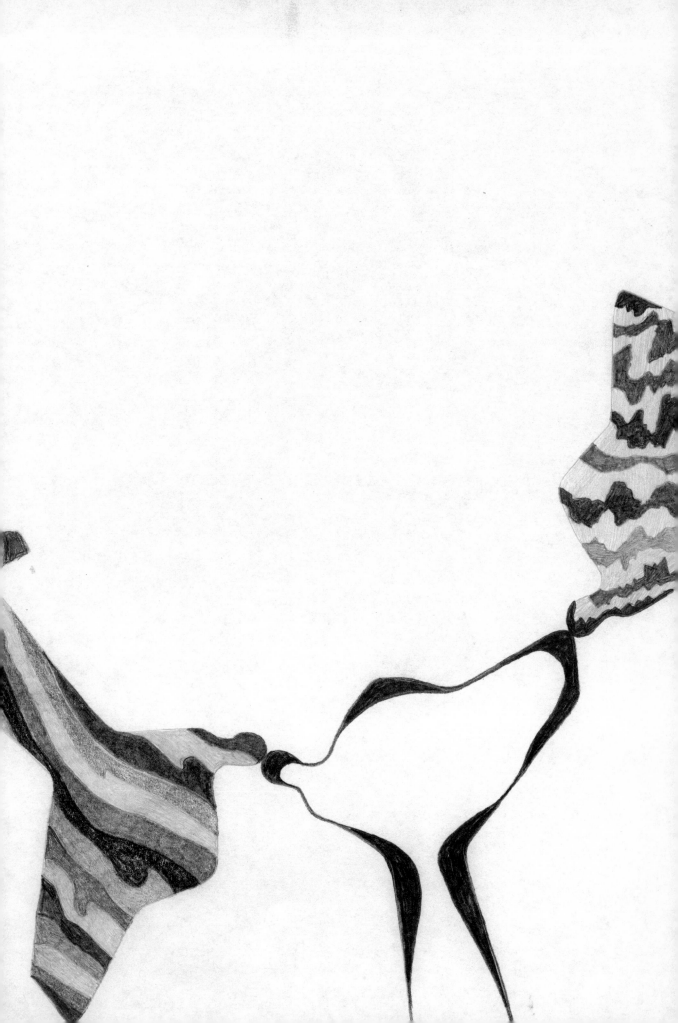

↑

MC B33

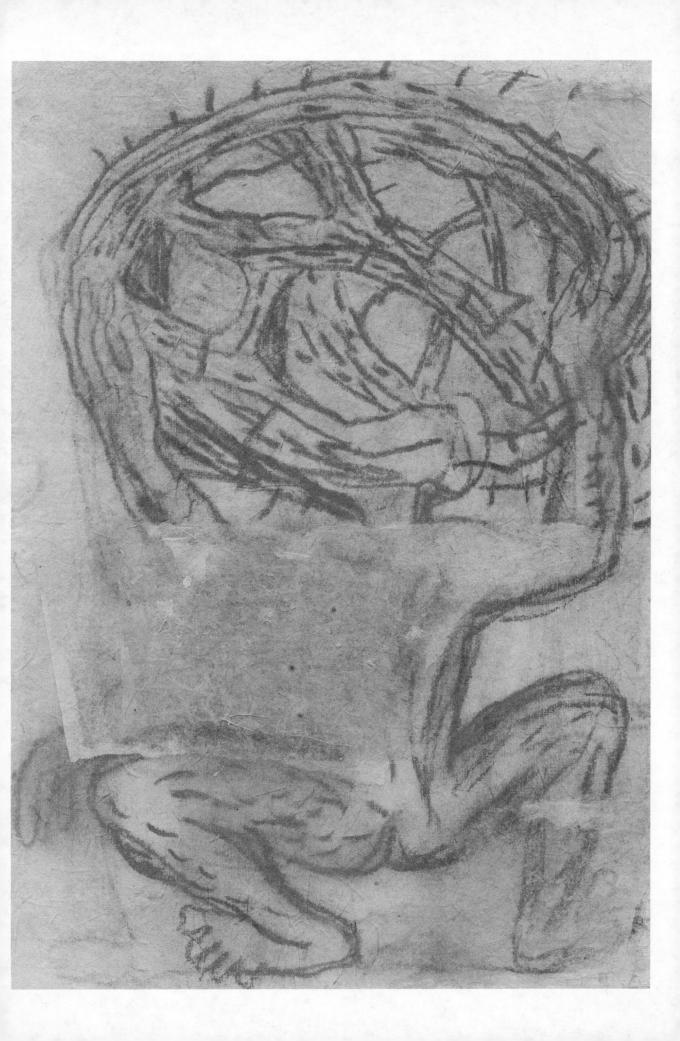

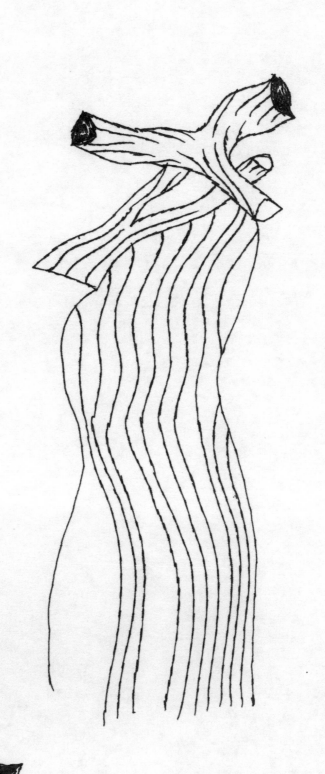

535
J→

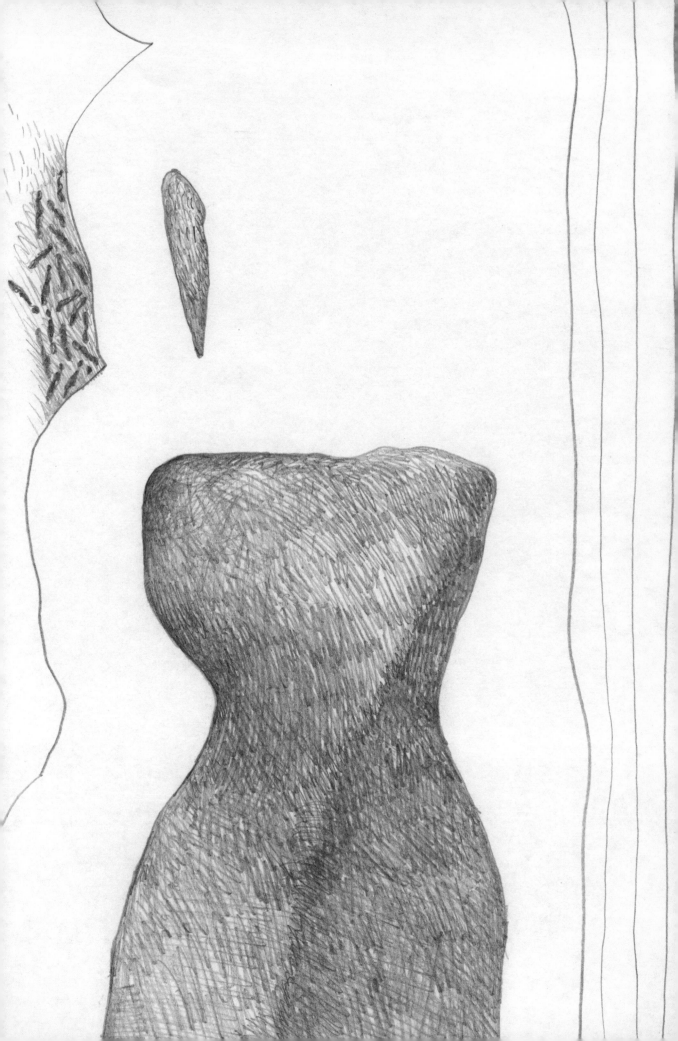

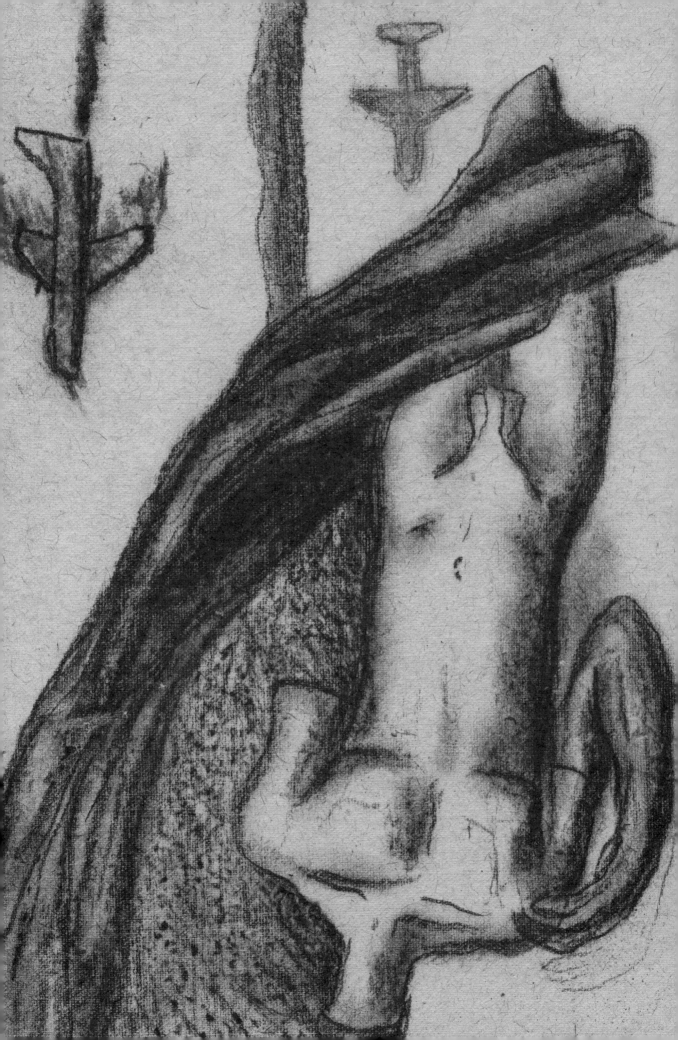

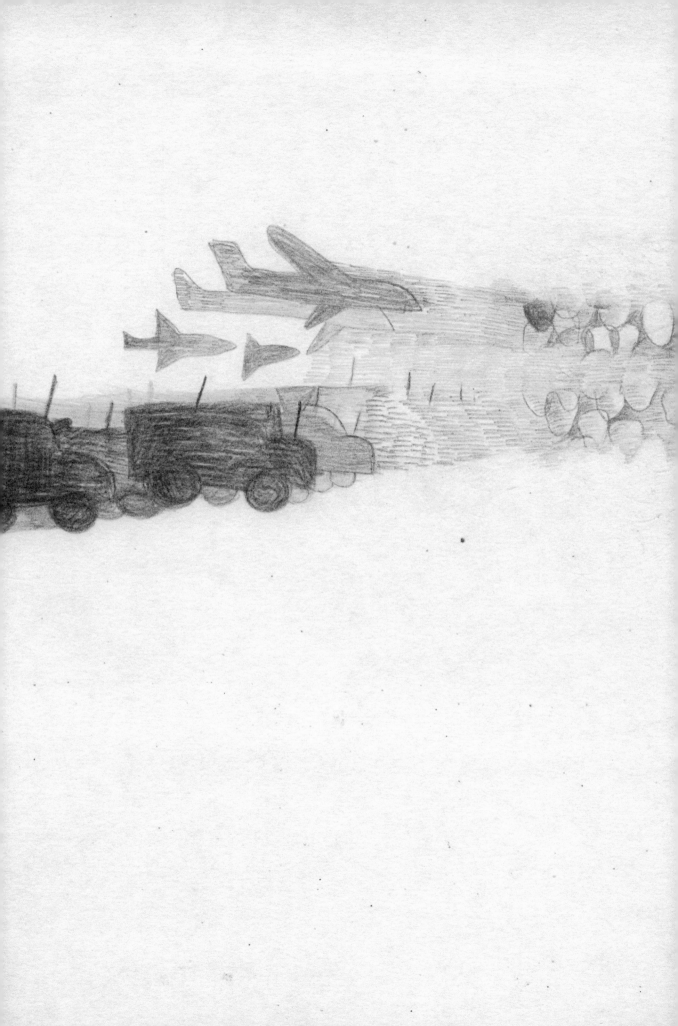

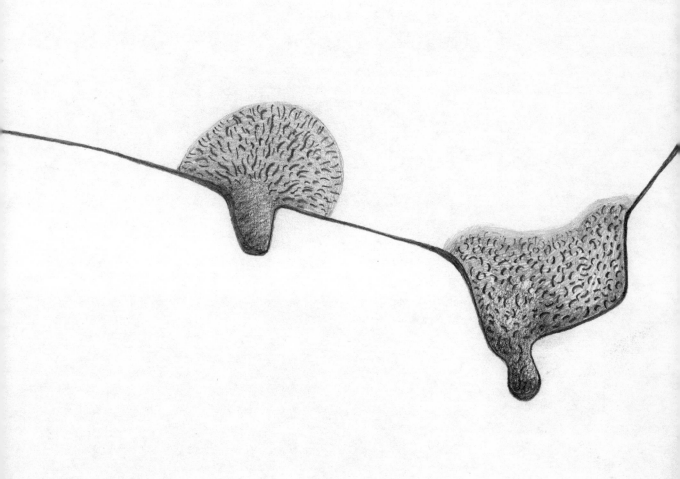

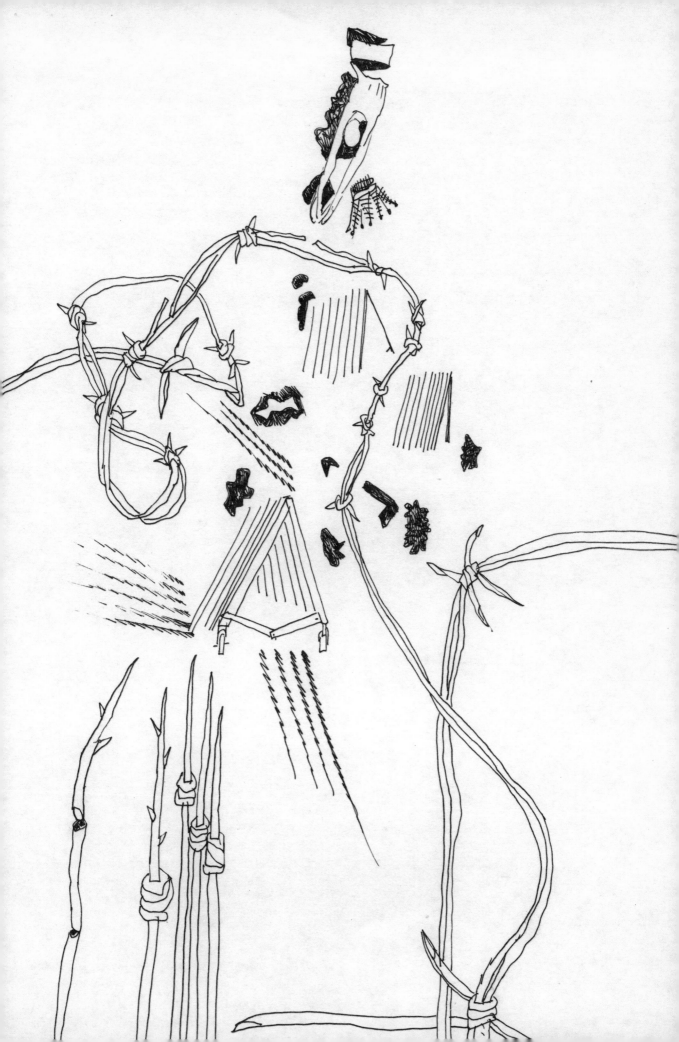

2007. 02. 13
B40 toJ.

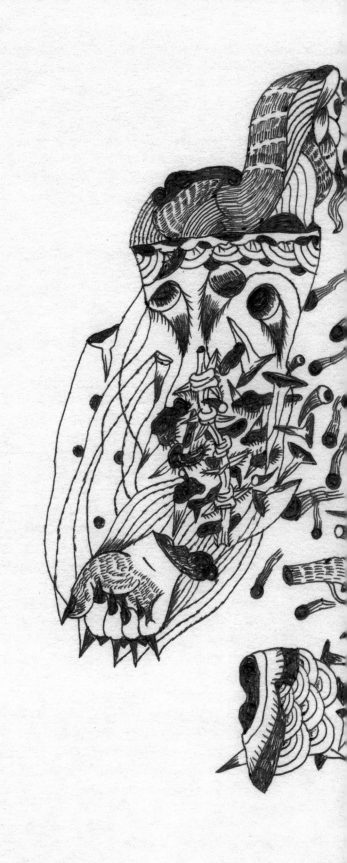

B41

J → M

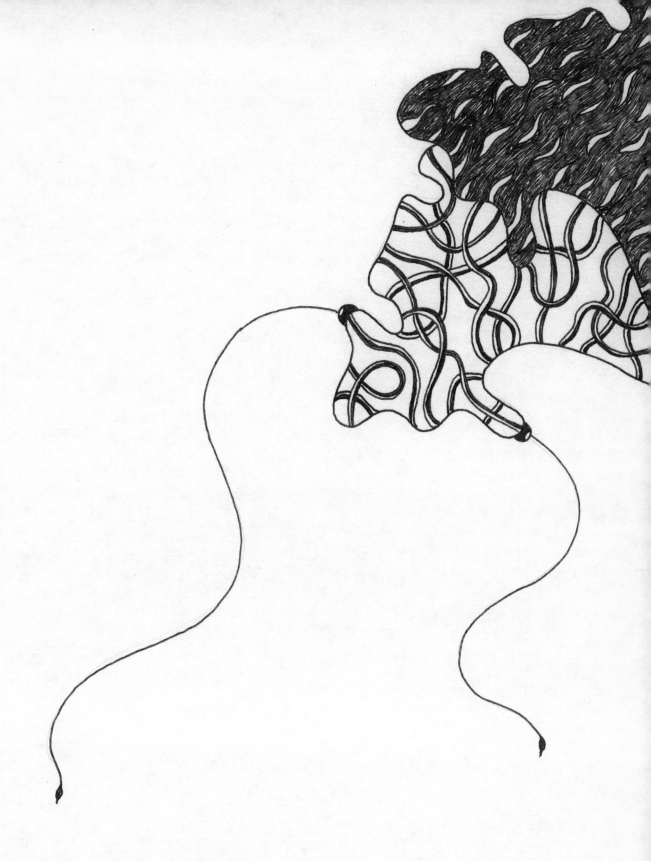

MC-B42

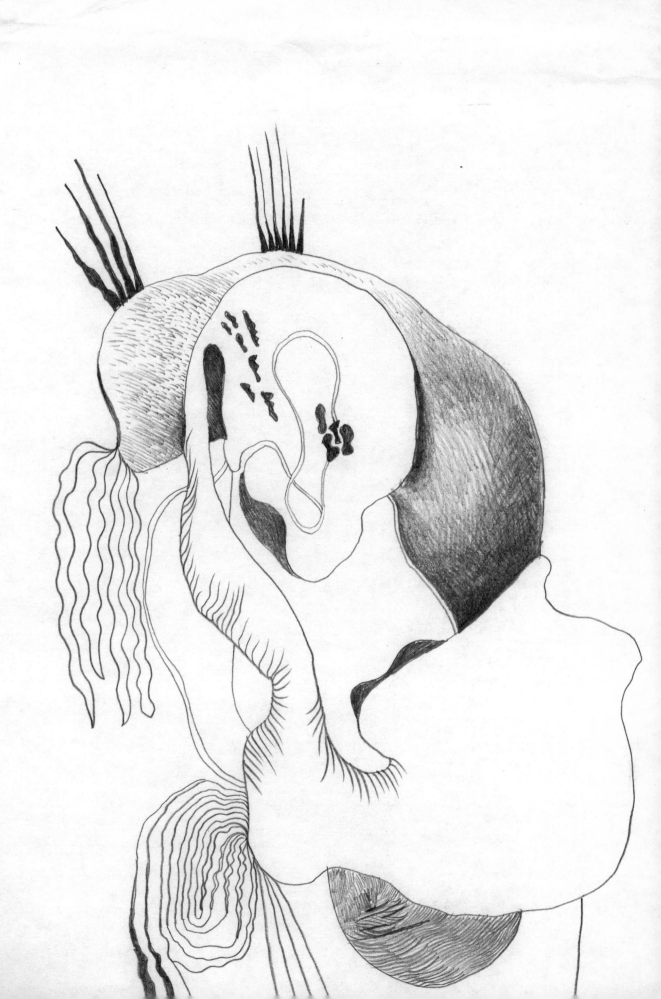

B43
2007 03. 14

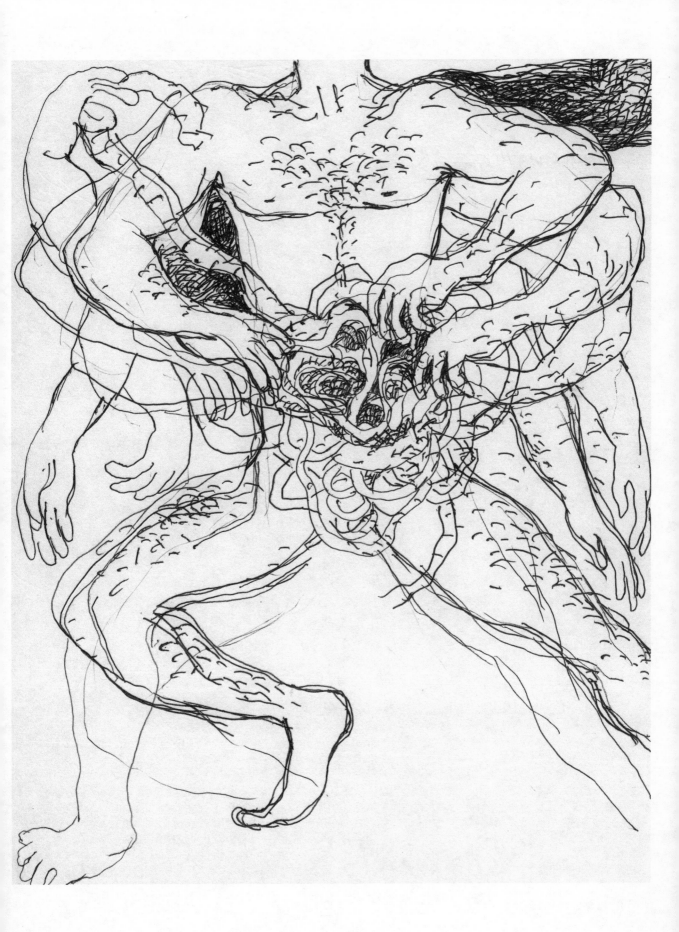

B 44

O. Shanaghani

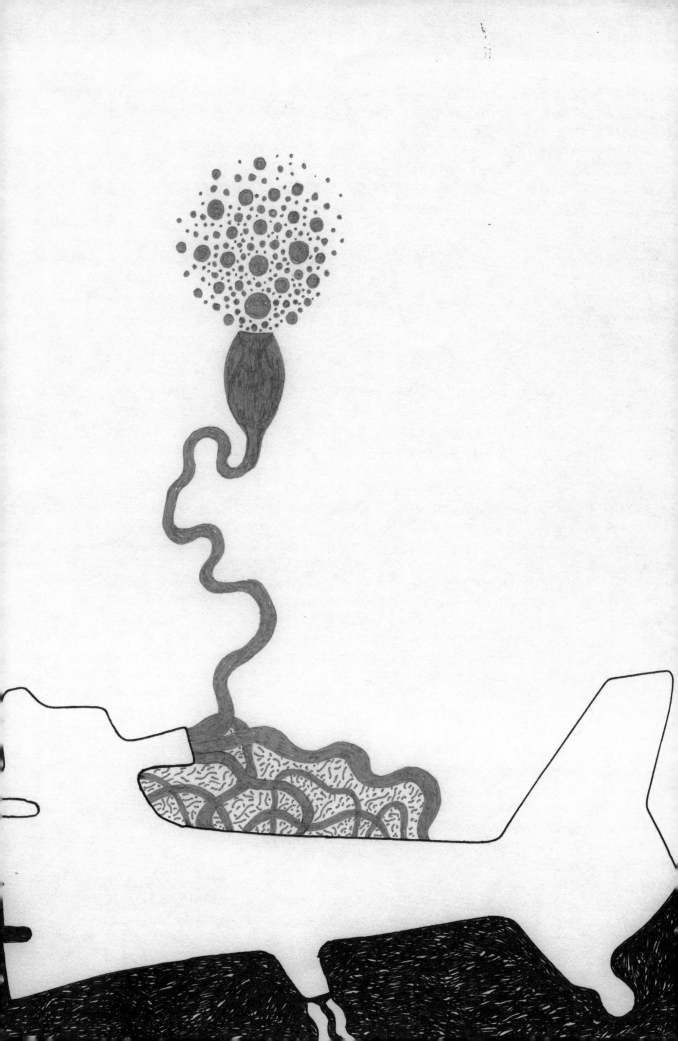

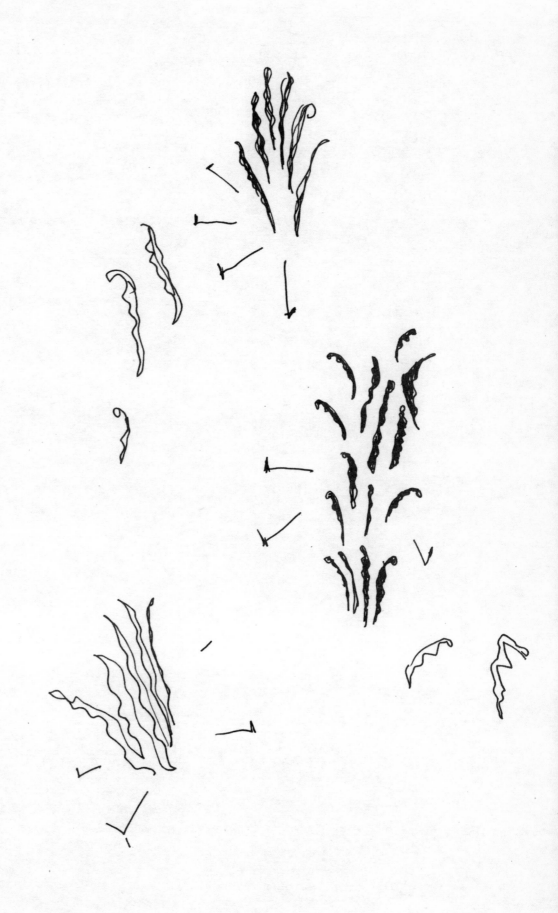

2007.07.26 klum B46

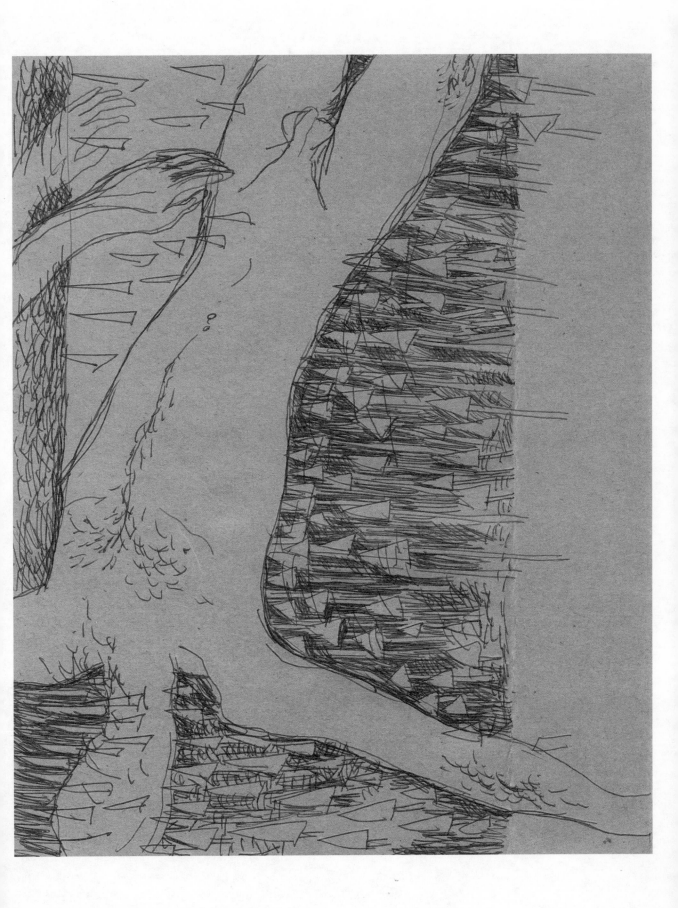

B-47

J. Shamathi

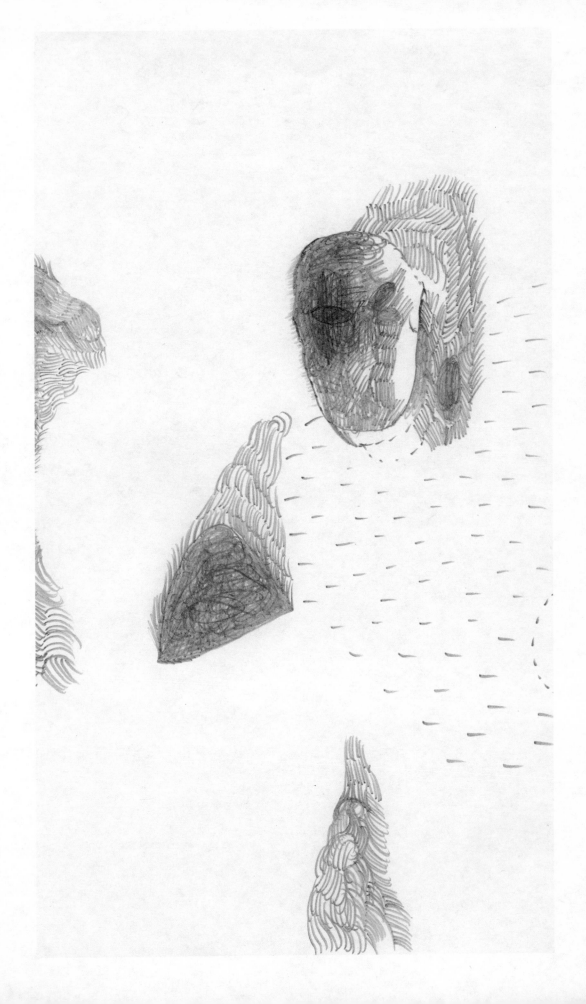

B48

J →S

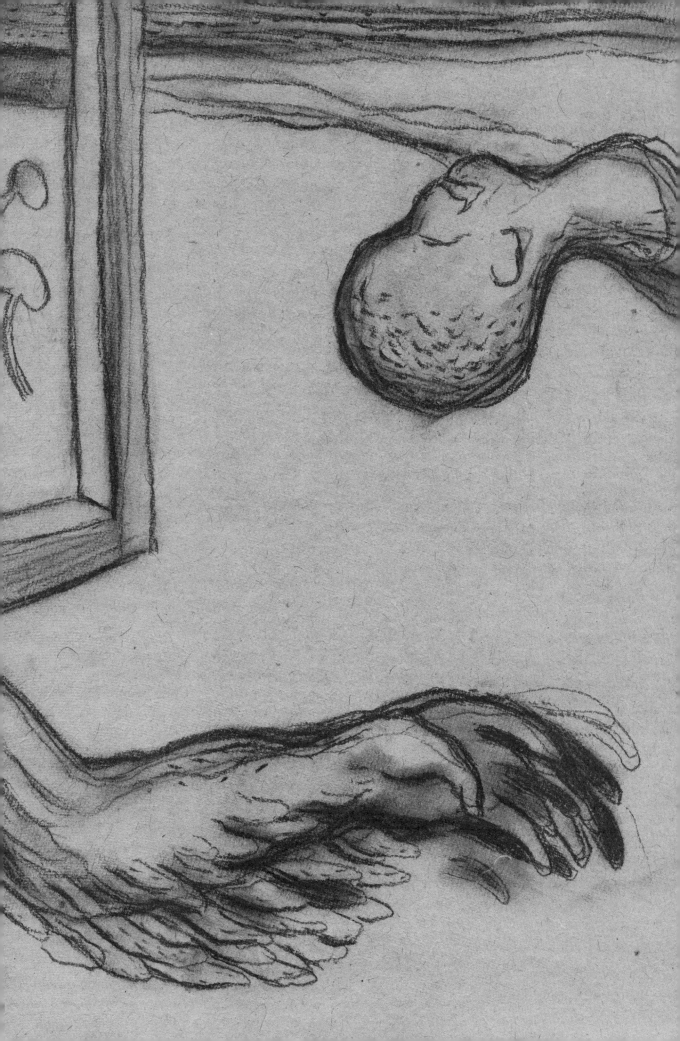

B 49

J. Shannathan

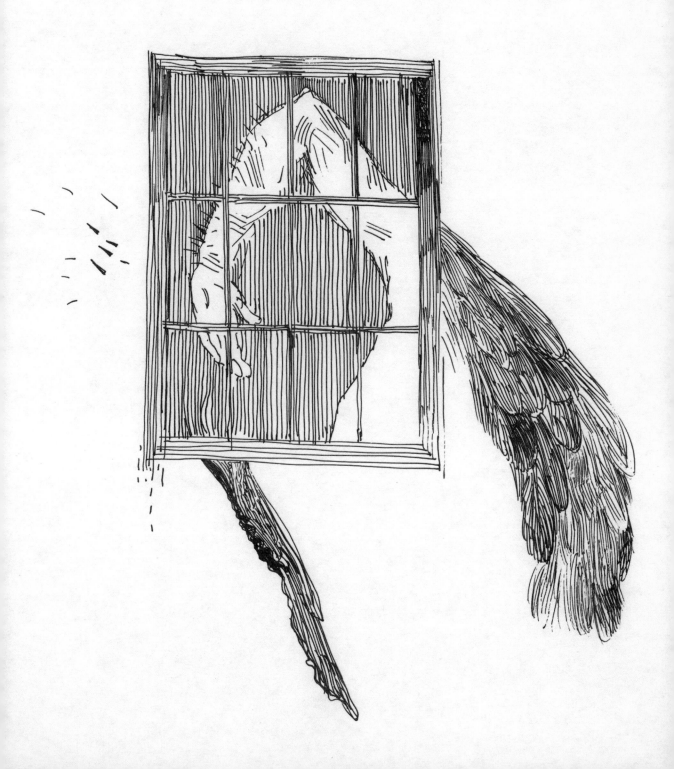

B50

2007.10.08

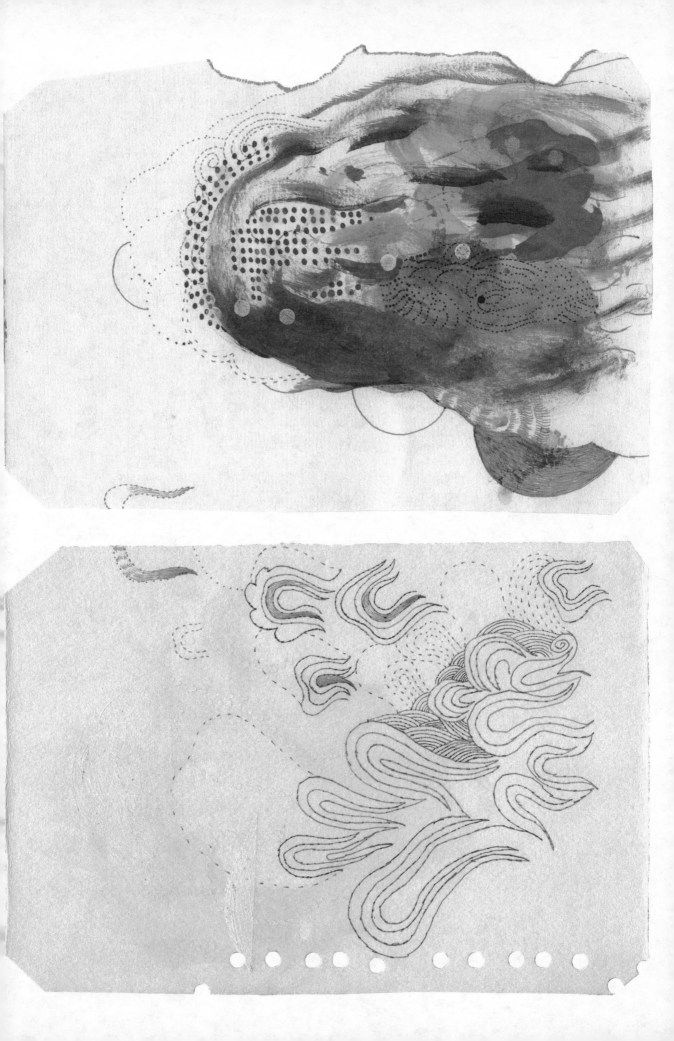

MC-B52

Drawings C1 to C52 //

Thamotharampillai Shanaathanan (TS C1); Jagath Weerasinghe (JW C2); Muhanned Cader (MC C3); Chandraguptha Thenuwara (CT C4); Jagath Weerasinghe (JW C5); Muhanned Cader (MC C6); Chandraguptha Thenuwara (CT C7); Jagath Weerasinghe (JW C8); Thamotharampillai Shanaathanan (TS C9); Muhanned Cader (MC C10); Chandraguptha Thenuwara (CT C11); Muhanned Cader (MC C12); Chandraguptha Thenuwara (CT C13); Thamotharampillai Shanaathanan (TS C14); Jagath Weerasinghe (JW C15); Thamotharampillai Shanaathanan (TS C16); Chandraguptha Thenuwara (CT C17); Thamotharampillai Shanaathanan (TS C18); Jagath Weerasinghe (JW C19); Muhanned Cader (MC C20); Jagath Weerasinghe (JW C21); Muhanned Cader (MC C22); Chandraguptha Thenuwara (CT C23); Thamotharampillai Shanaathanan (TS C24); Jagath Weerasinghe (JW C25); Thamotharampillai Shanaathanan (TS C26); Muhanned Cader (MC C27); Chandraguptha Thenuwara (CT C28); Jagath Weerasinghe (JW C29); Muhanned Cader (MC C30); Chandraguptha Thenuwara (CT C31); Jagath Weerasinghe (JW C32); Thamotharampillai Shanaathanan (TS C33); Muhanned Cader (MC C34); Chandraguptha Thenuwara (CT C35); Muhanned Cader (MC C36); Chandraguptha Thenuwara (CT C37); Thamotharampillai Shanaathanan (TS C38); Jagath Weerasinghe (JW C39); Thamotharampillai Shanaathanan (TS C40); Chandraguptha Thenuwara (CT C41); Thamotharampillai Shanaathanan (TS C42); Jagath Weerasinghe (JW C43); Muhanned Cader (MC C44); Jagath Weerasinghe (JW C45); Muhanned Cader (MC C46); Chandraguptha Thenuwara (CT C47); Thamotharampillai Shanaathanan (TS C48); Jagath Weerasinghe (JW C49); Thamotharampillai Shanaathanan (TS C50); Muhanned Cader (MC C51); Chandraguptha Thenuwara (CT C52).

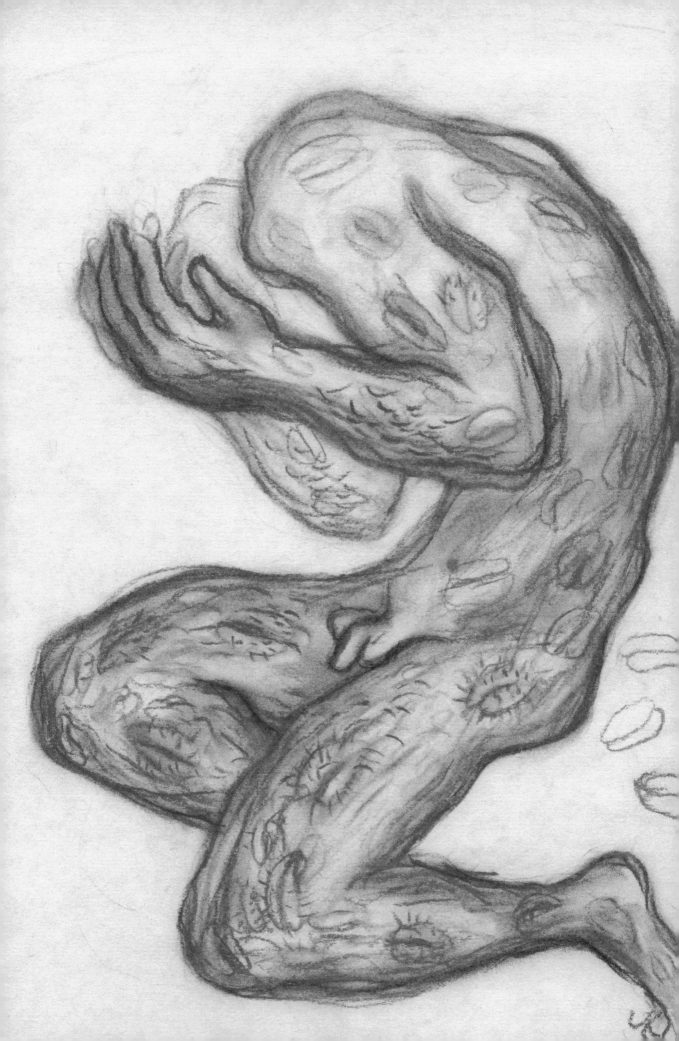

'India'

J Sivanathan
C1

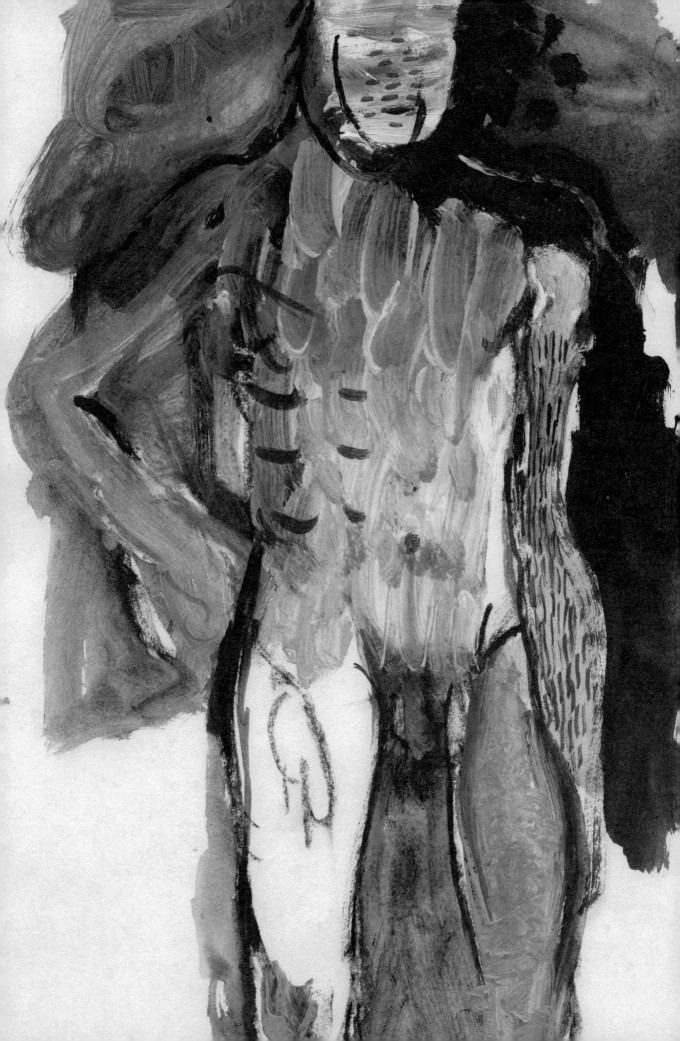

C2

J → M

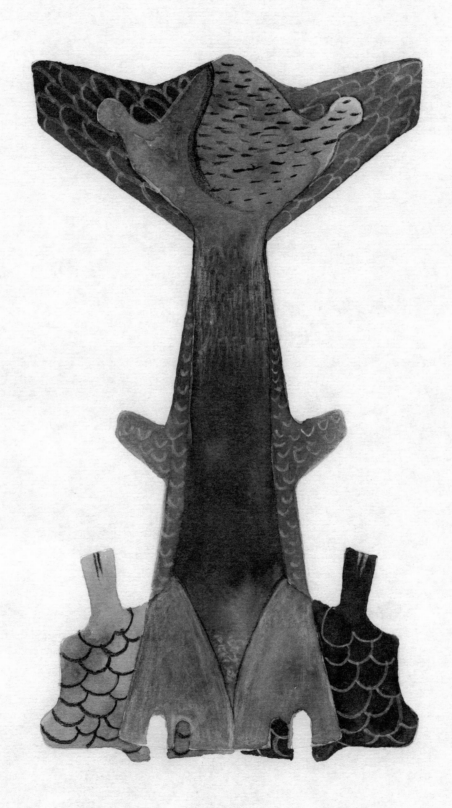

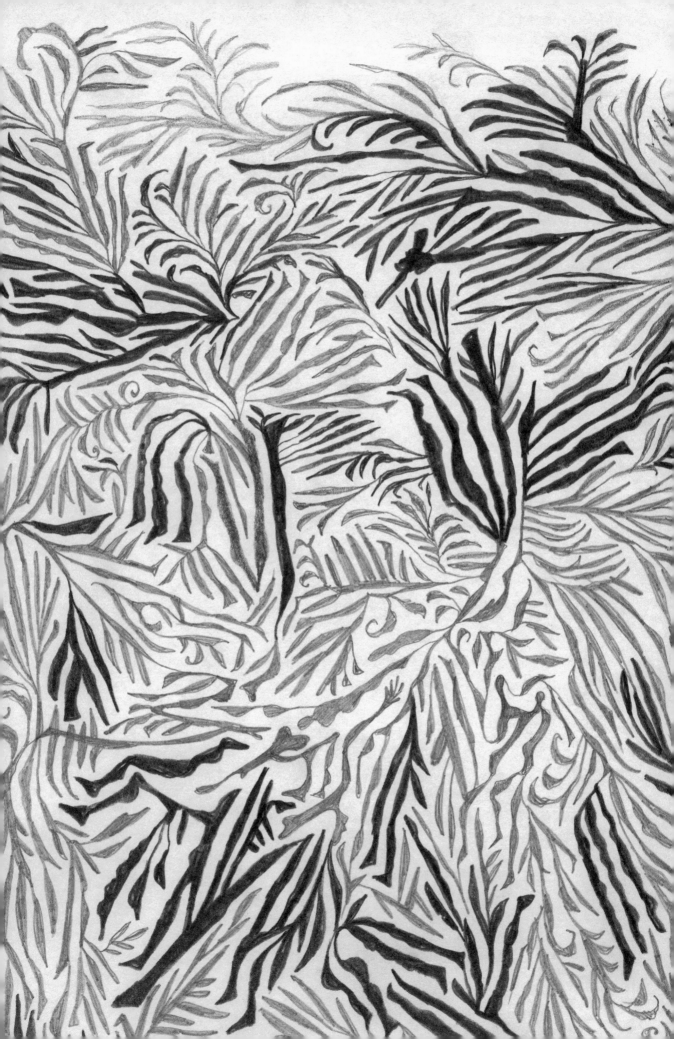

lyKum 28. 06. 05 C4

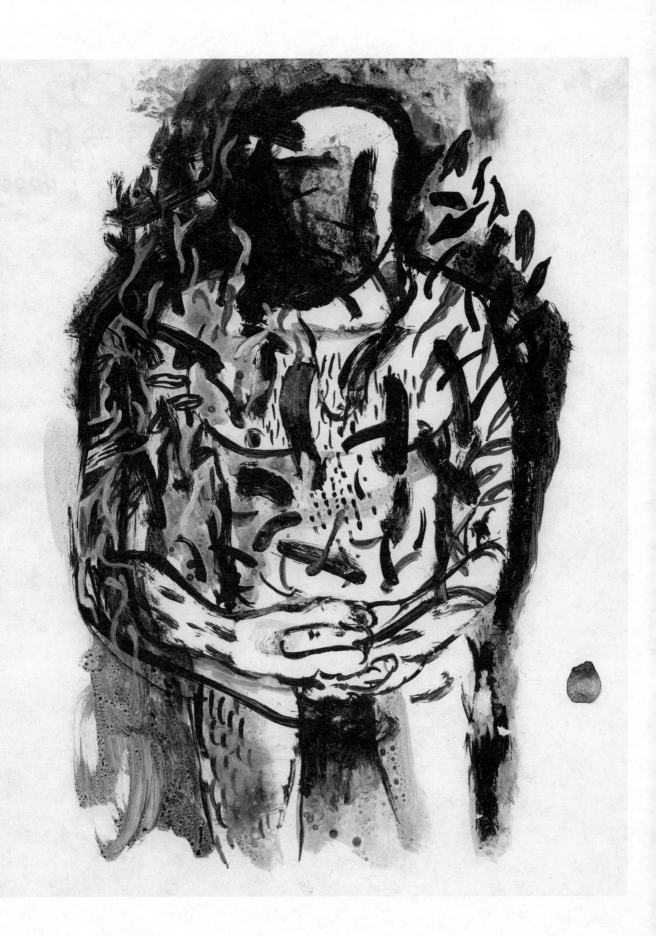

C5

J→M

30.6.2005

Yaath/

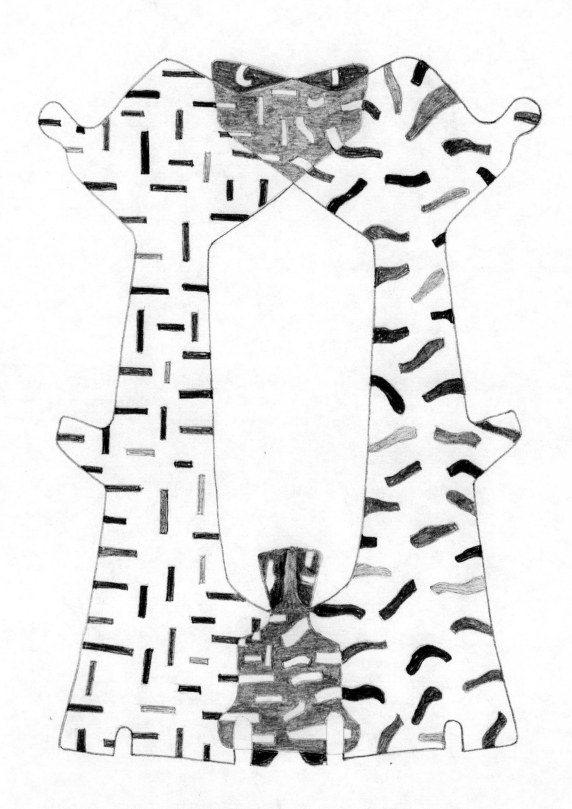

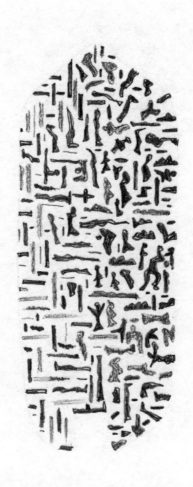

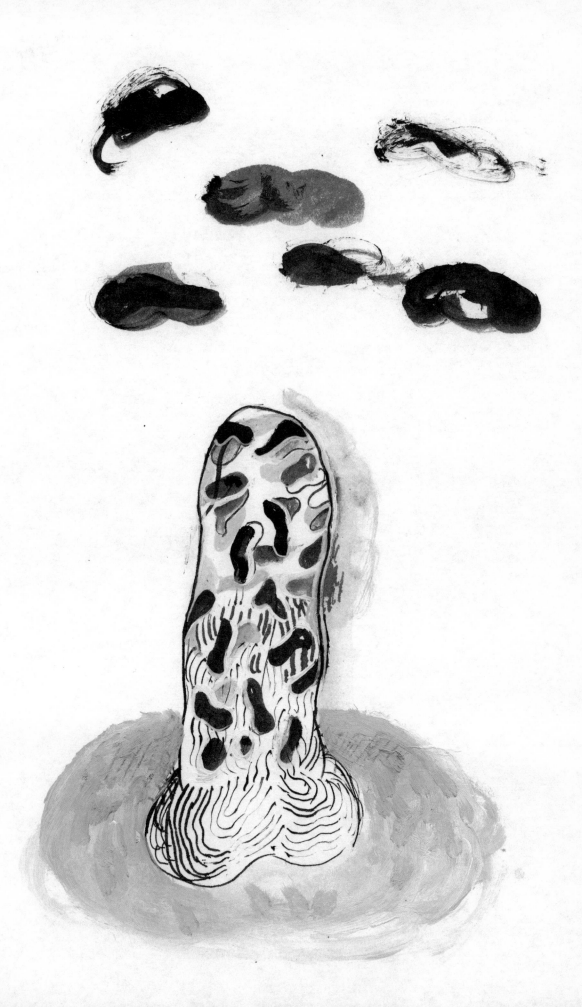

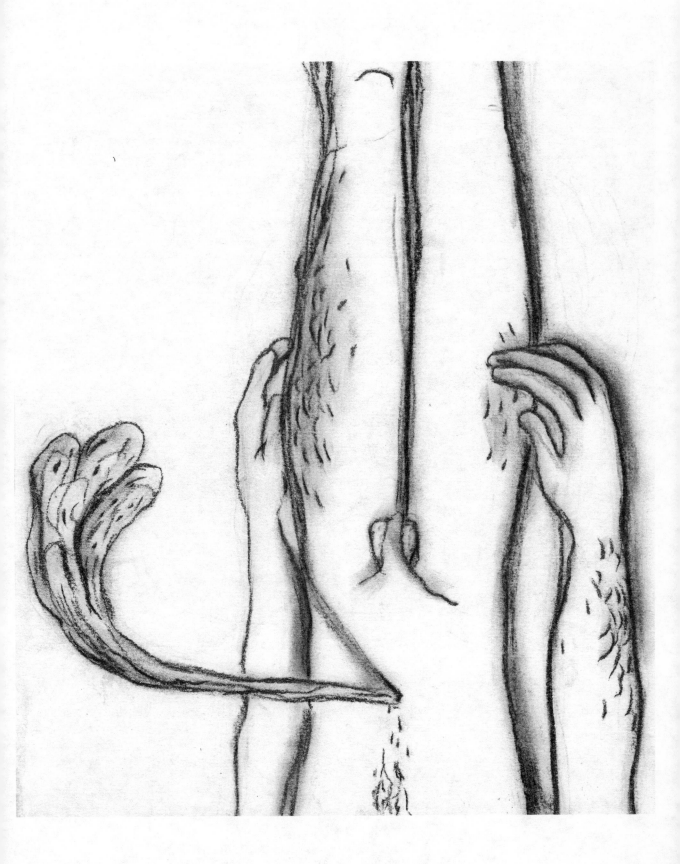

c 9

Blumenthein

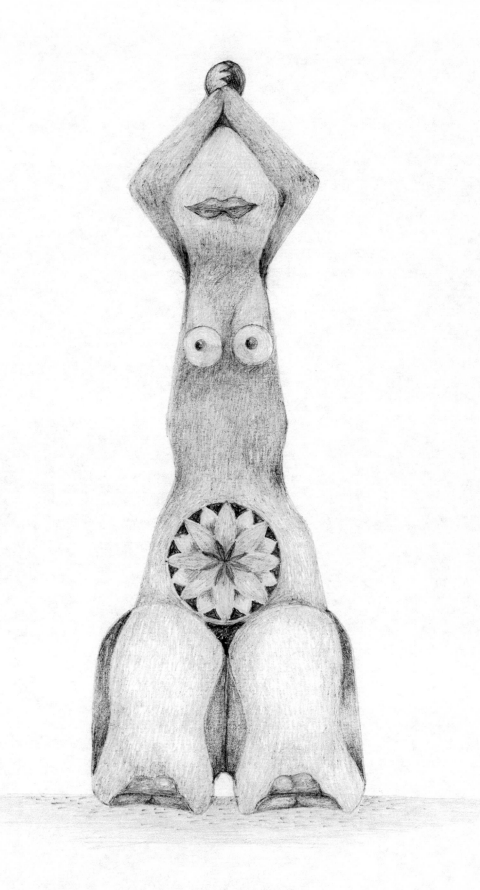

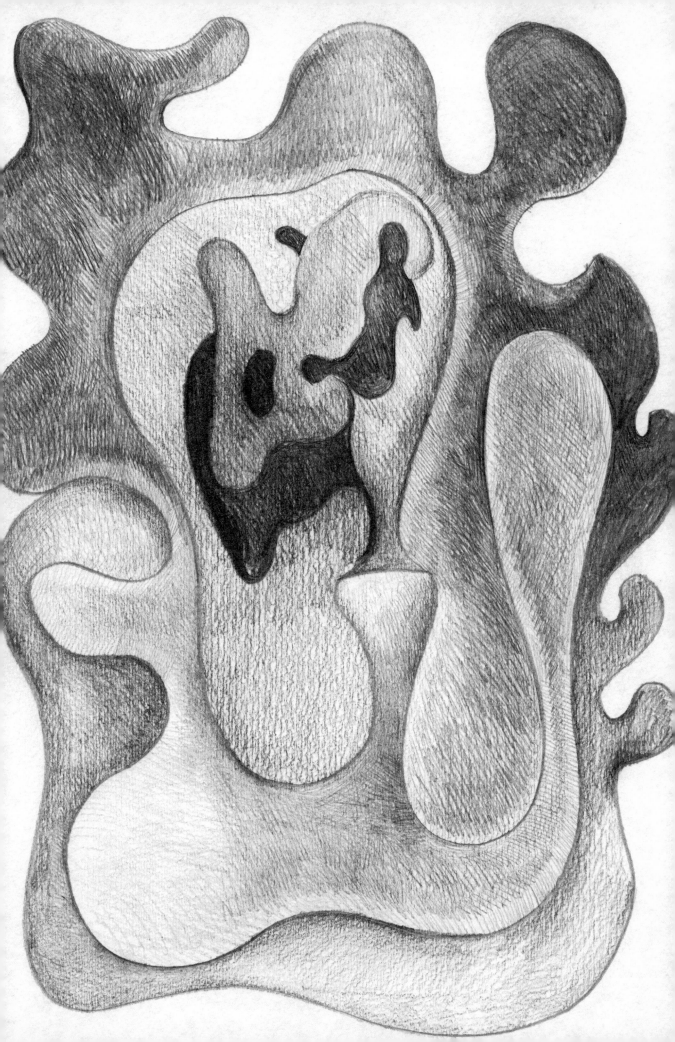

luXum 2005·08·13 C13

J Shanaahan

C 14

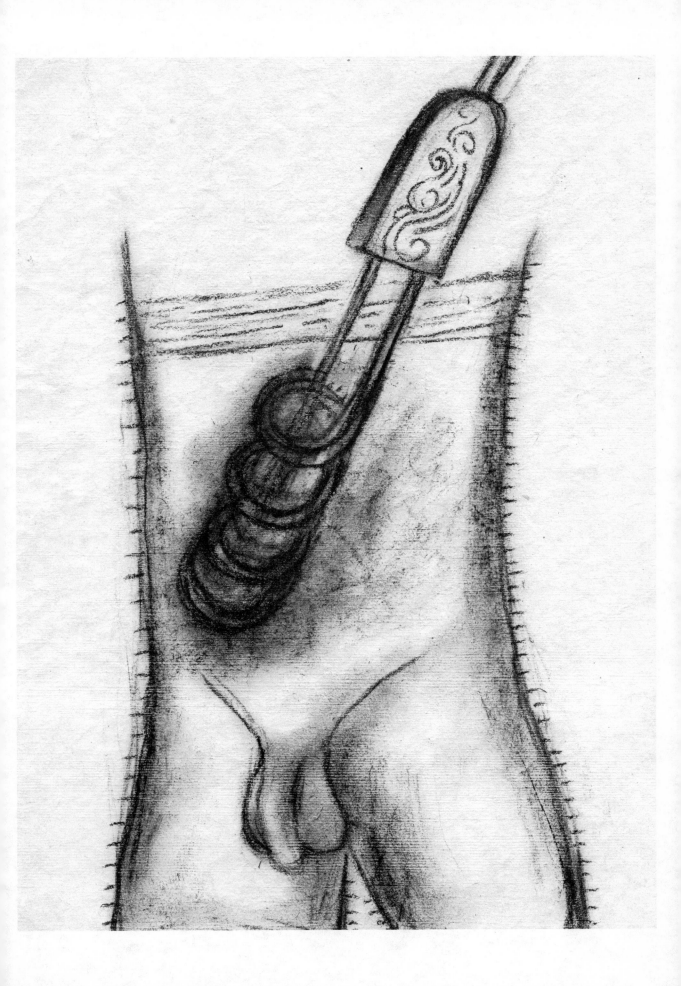

C-16
T· Shanaalhanan

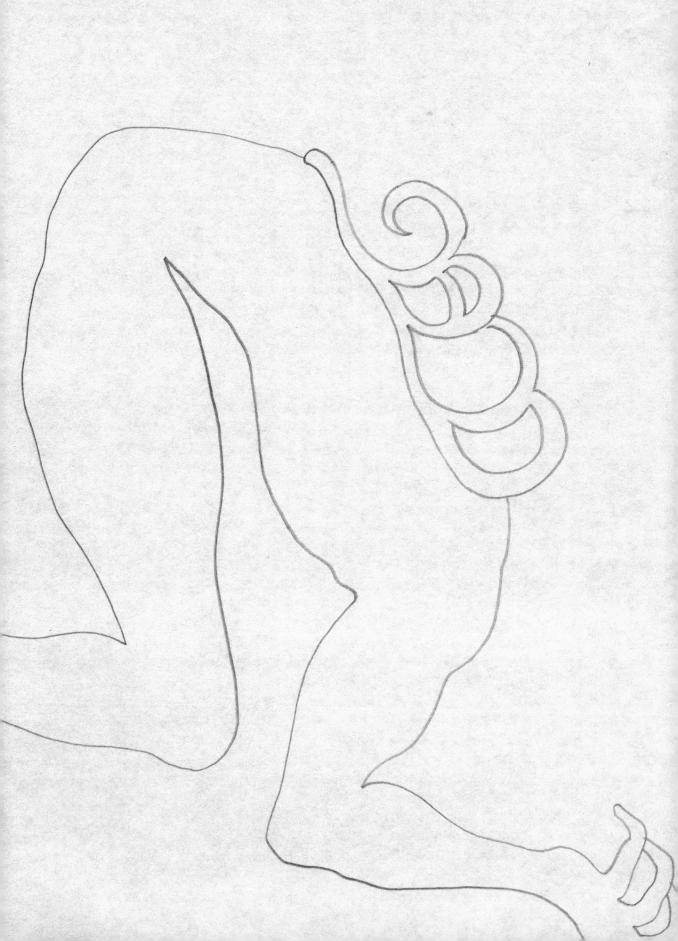

C17 城市 2005. 11.01

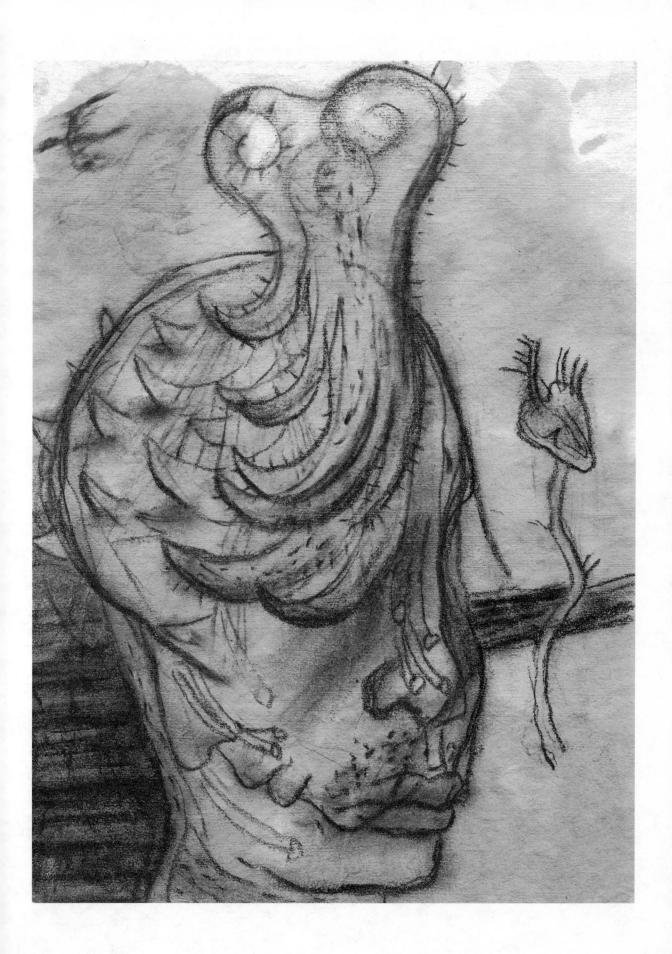

C 18
Sana

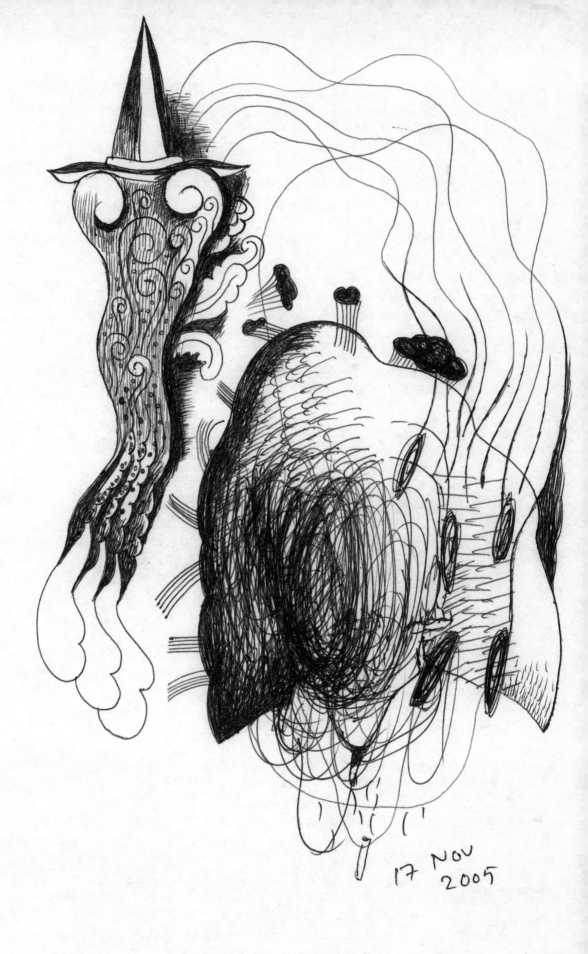

17 NOV
2005

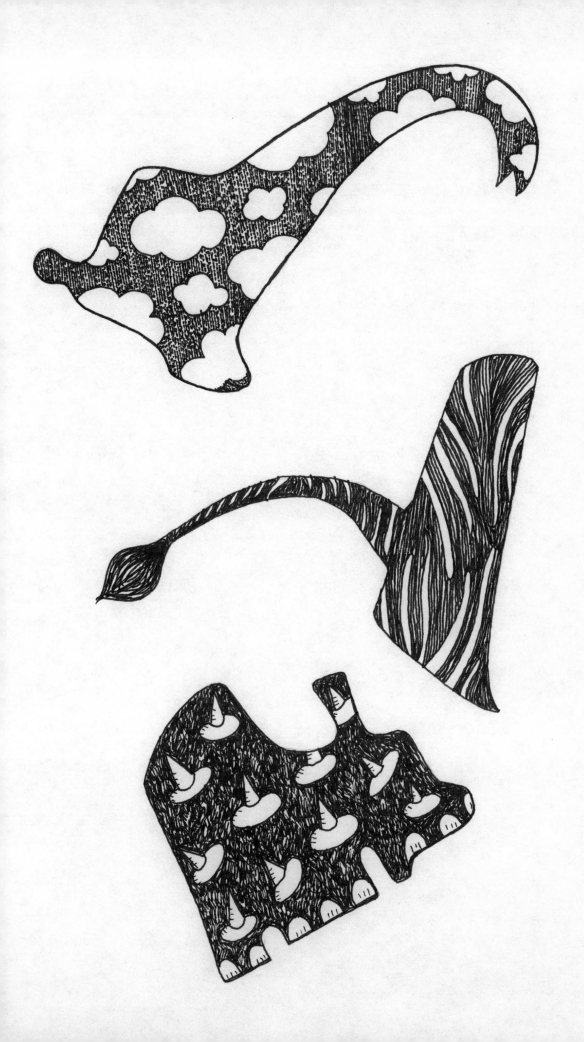

G20 — MC —> J

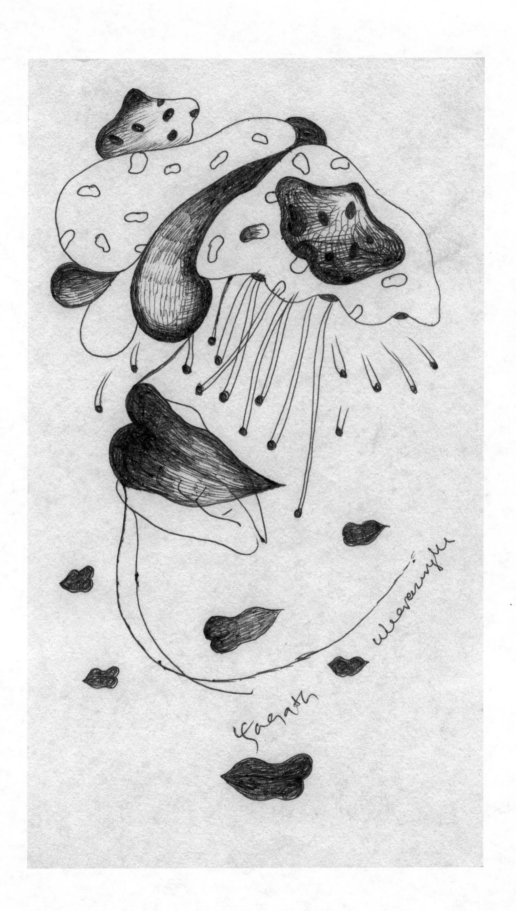

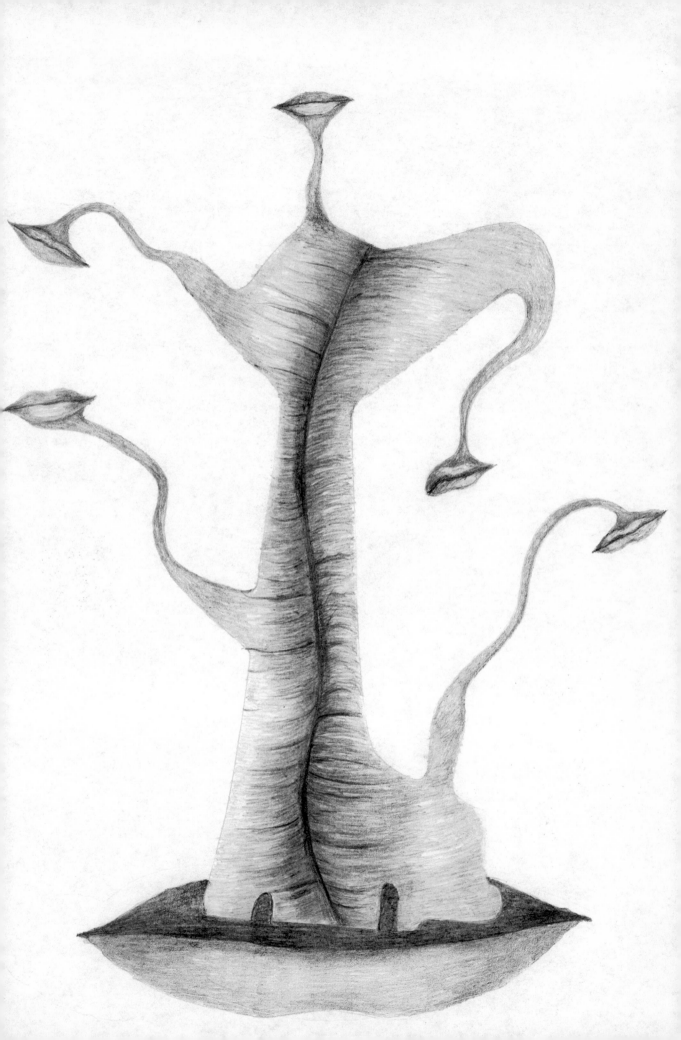

MC-CZ2

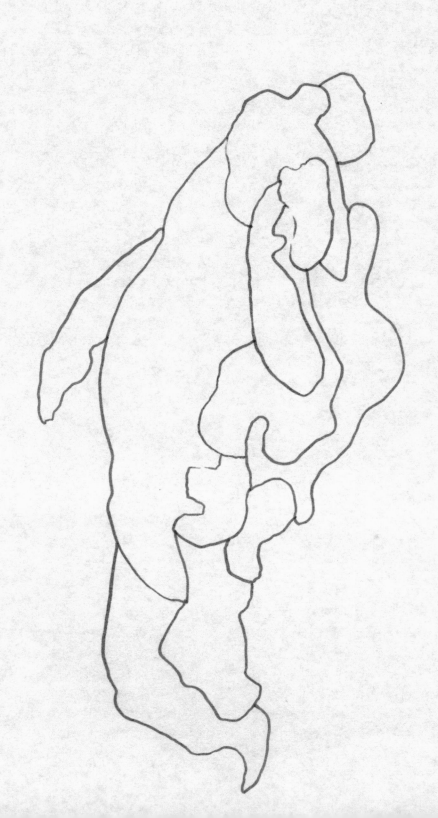

2006.01.01

C 23

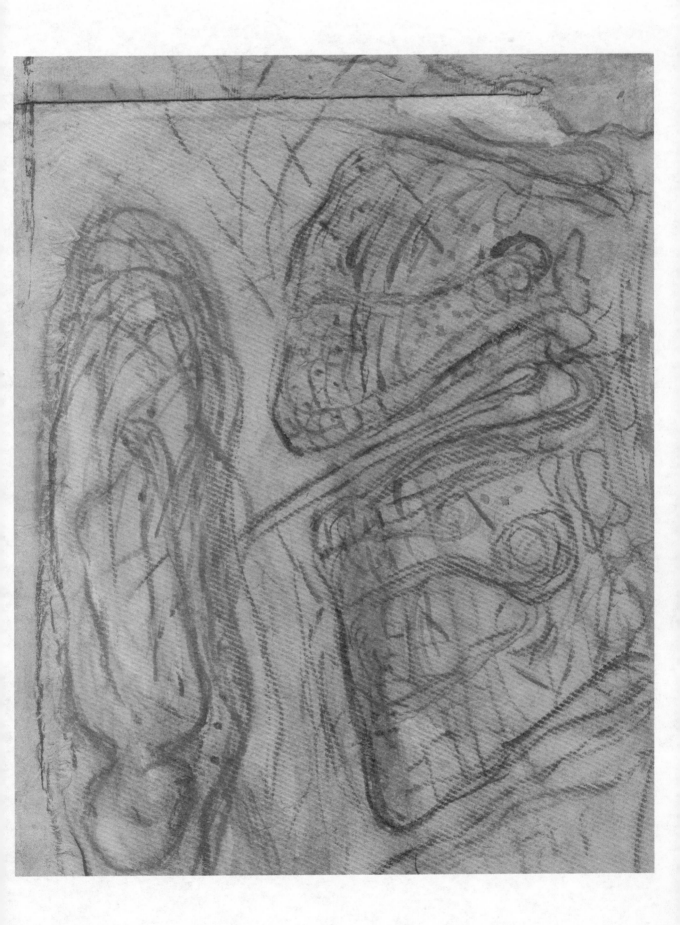

J. Skwarkhein

C-79

C-24

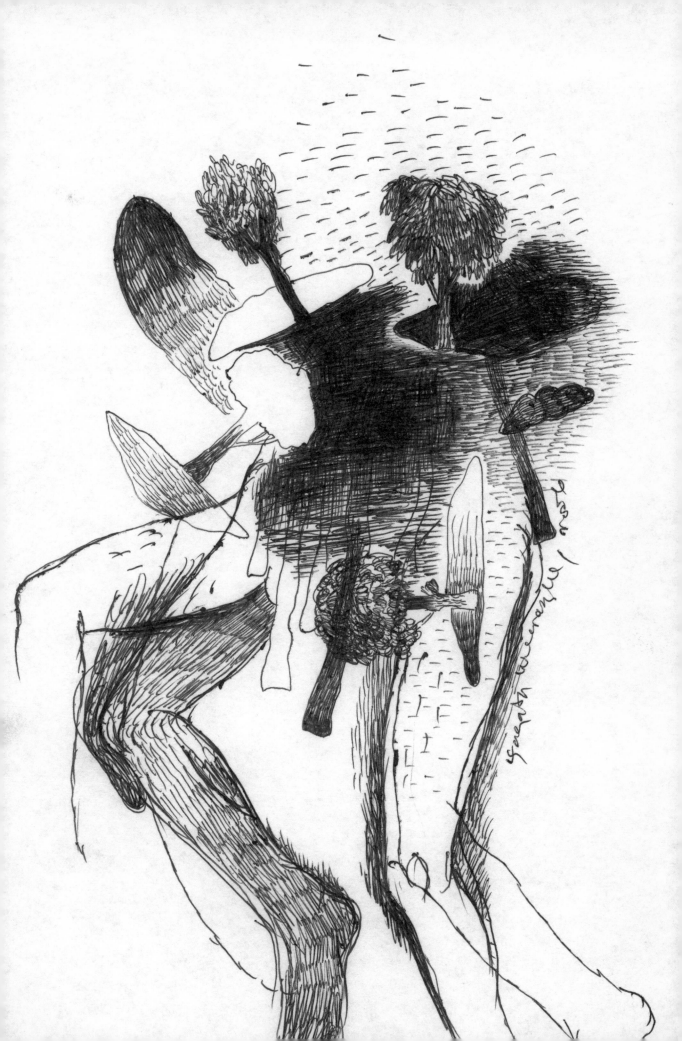

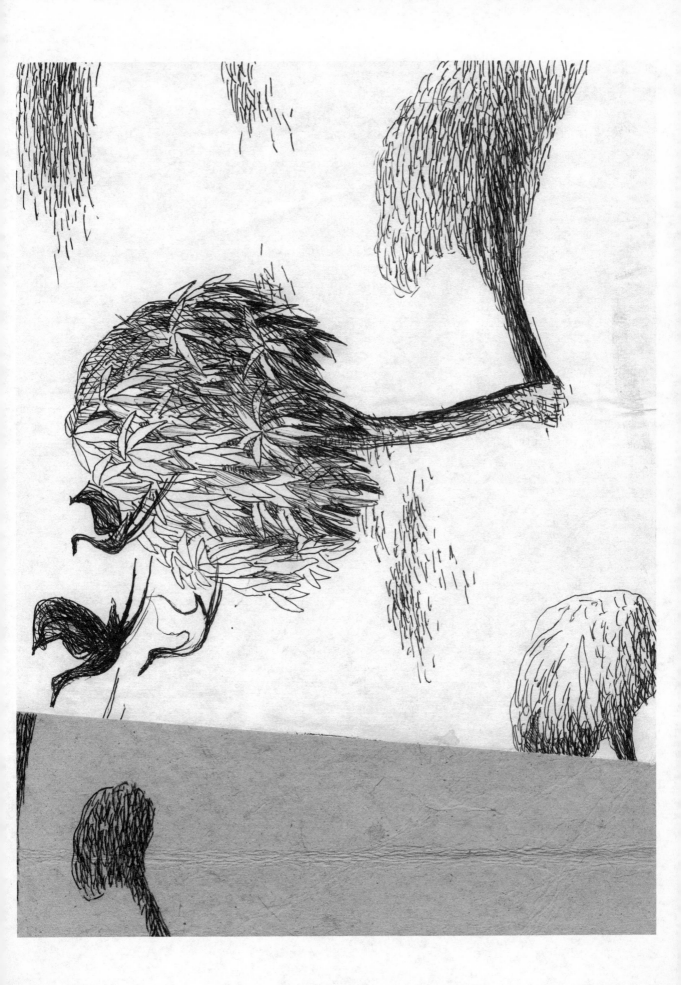

J. Shinar Haran
27.
C-26

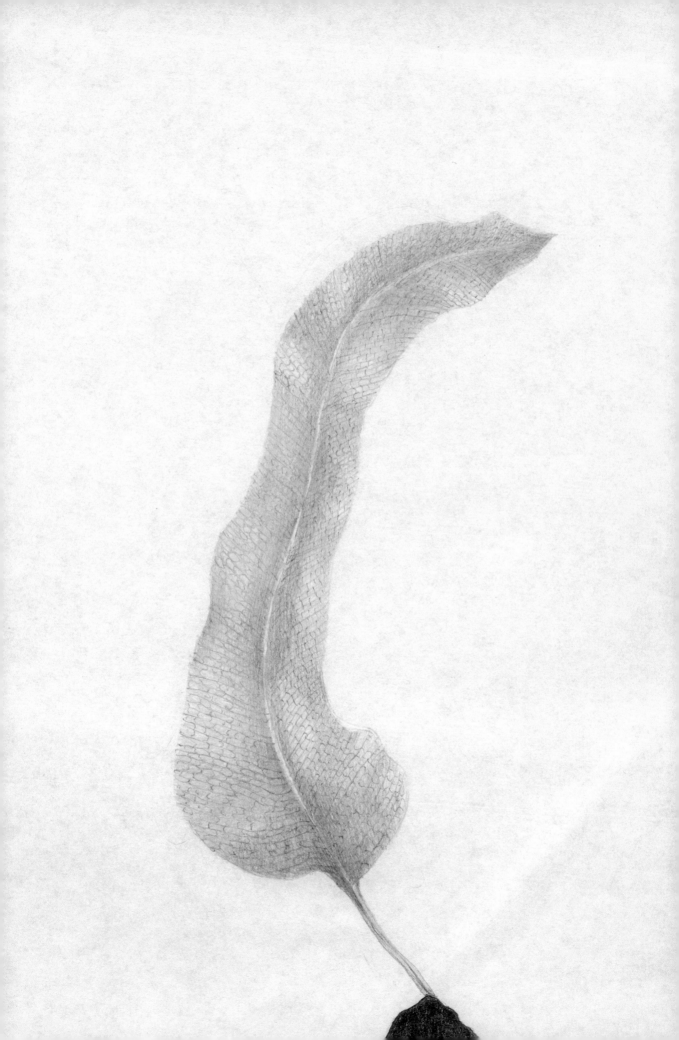

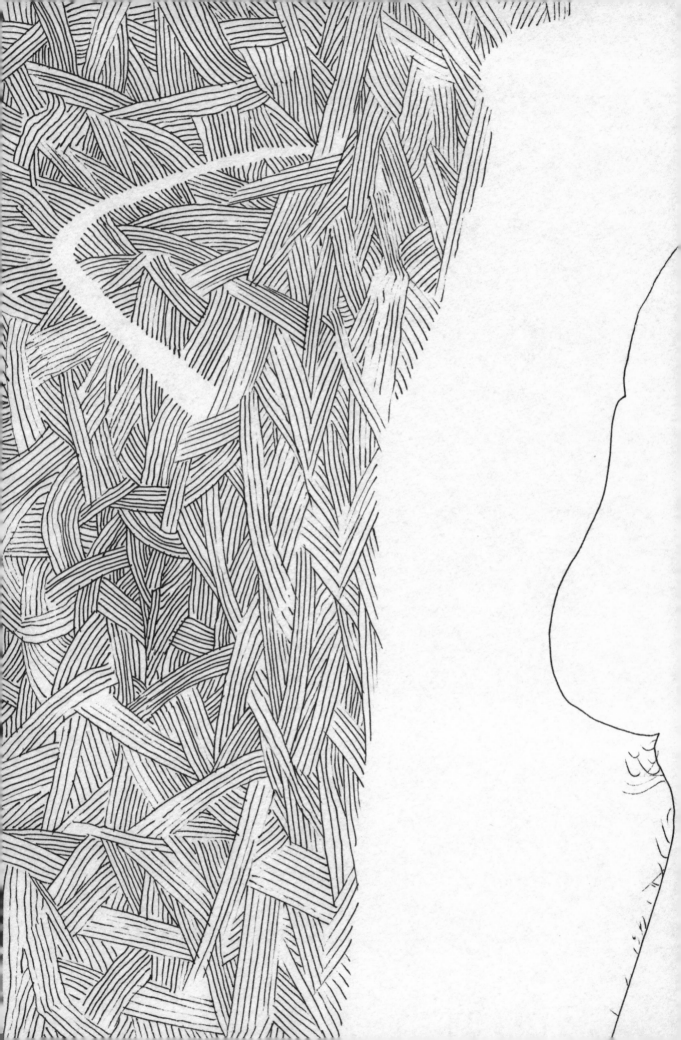

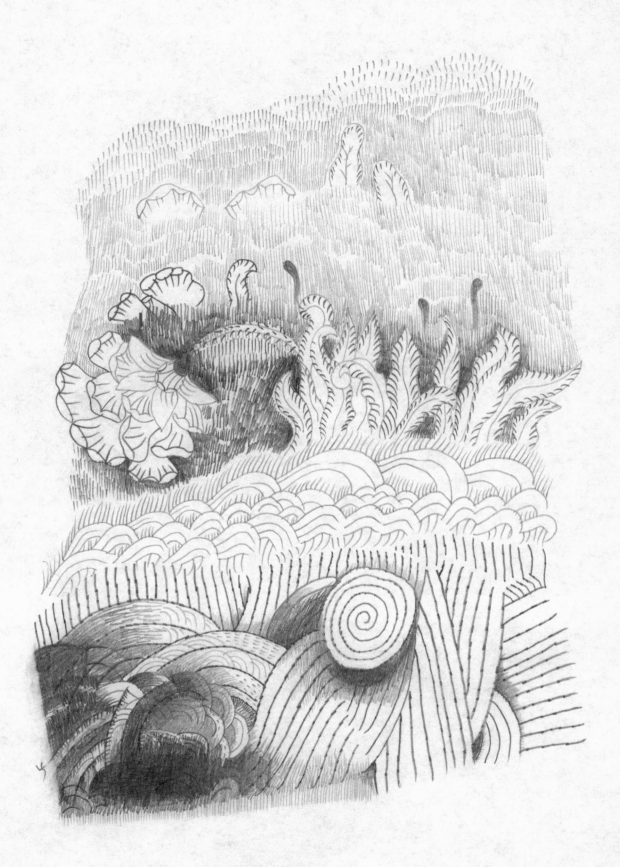

C 30/ MC

C 31

2006. 05. 31

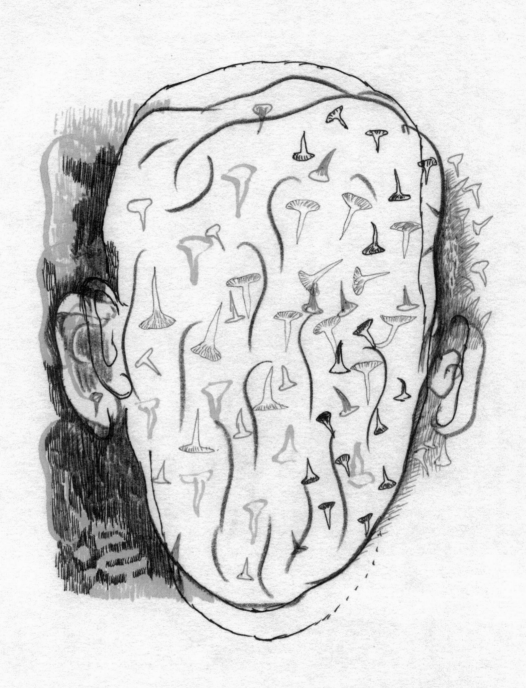

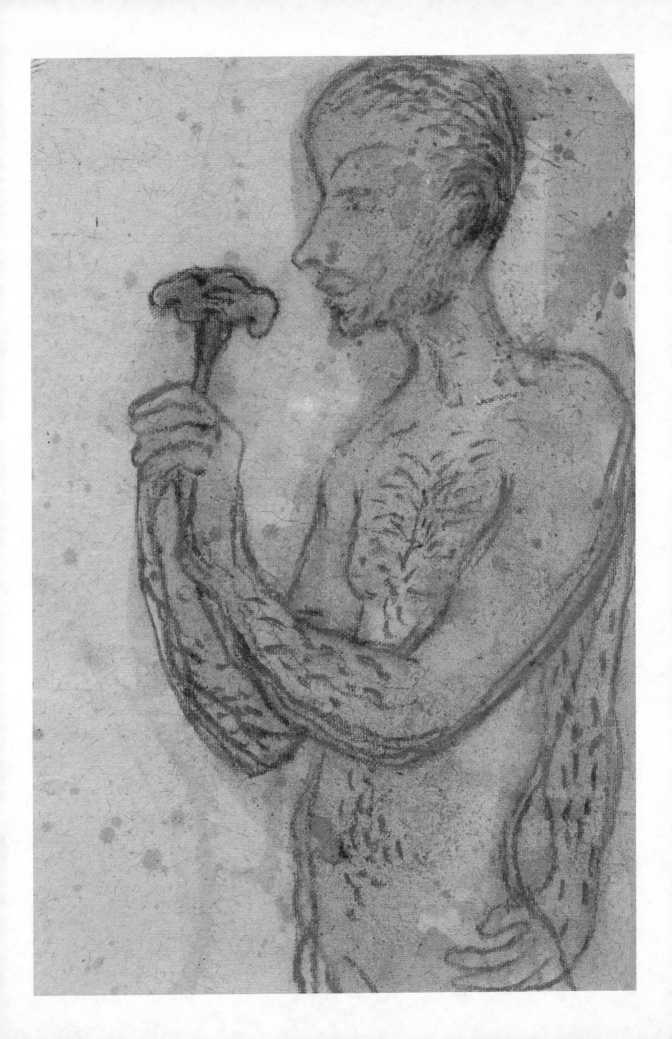

C-33

J. Shanmugam

C 35

2006.06.22

C36/MC

2006. 07 07 C 37

C 38

J. Smith
J. Shmorell
to J

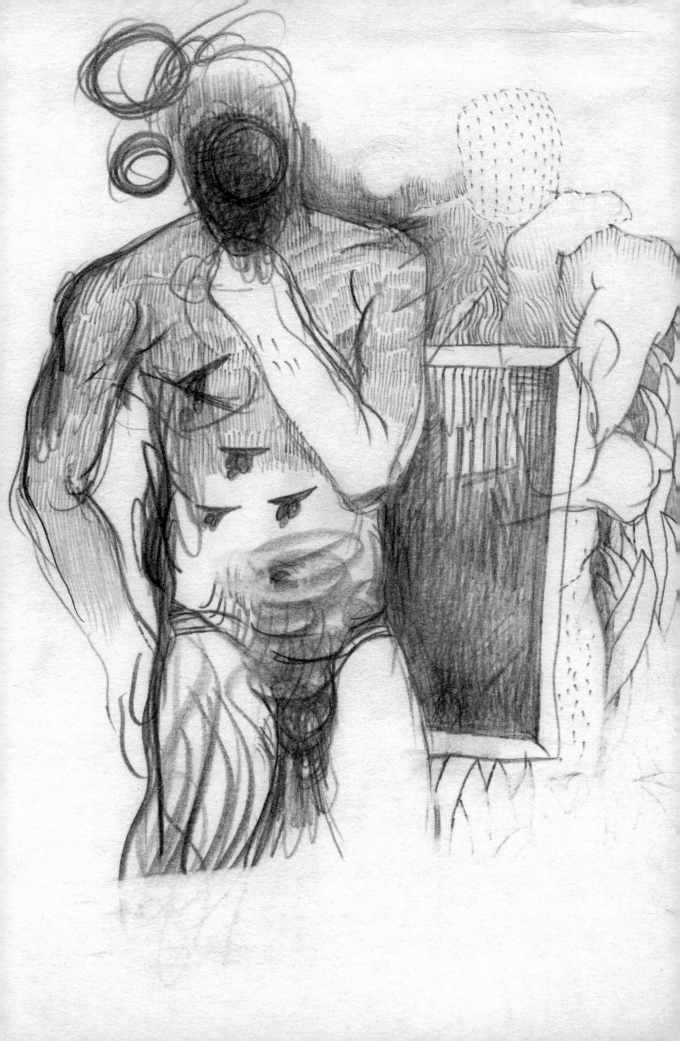

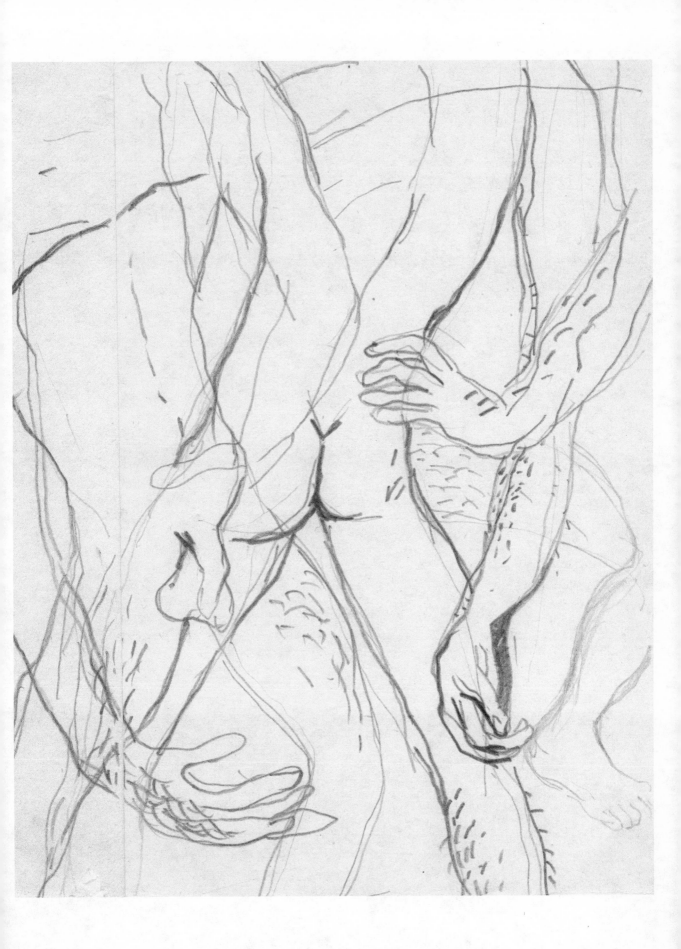

2007. 01. 17

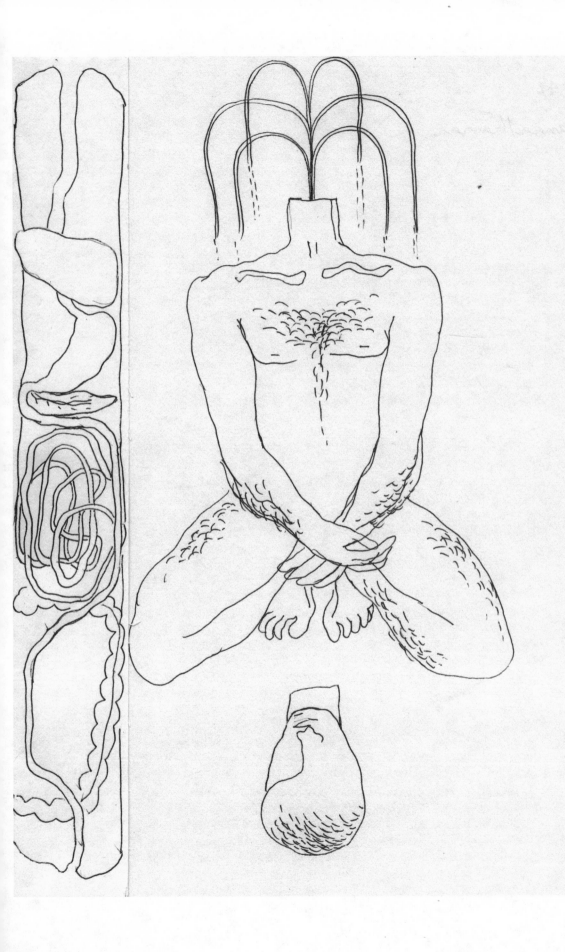

c - 42

Shanaathanan

J → M
C 45

MↃC26 → T
C46

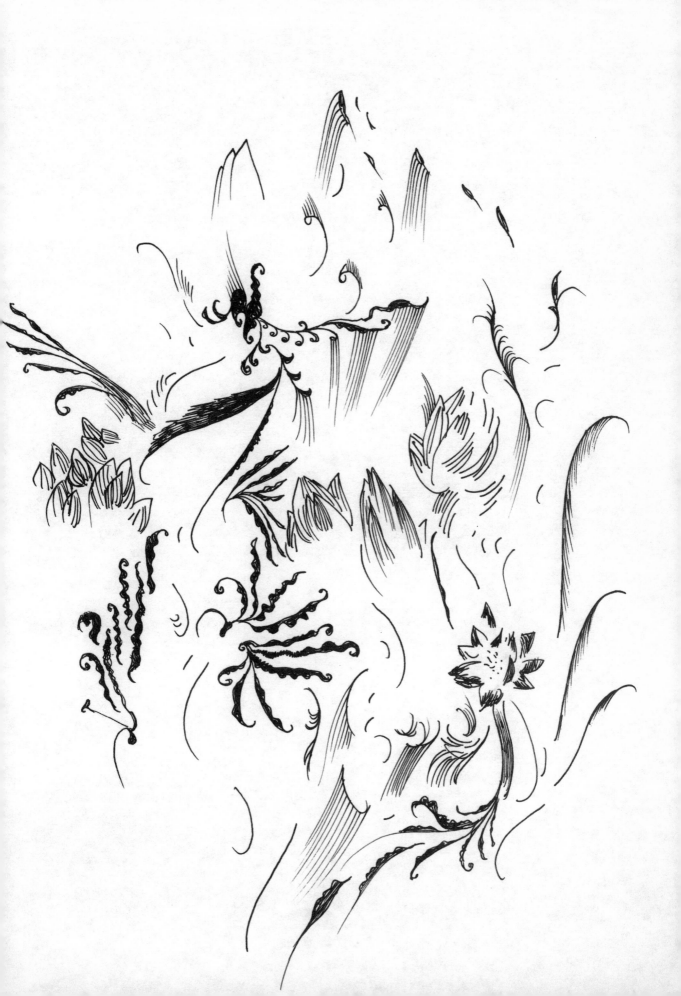

C 47 → Ghana.

lik 2007. 08. 13

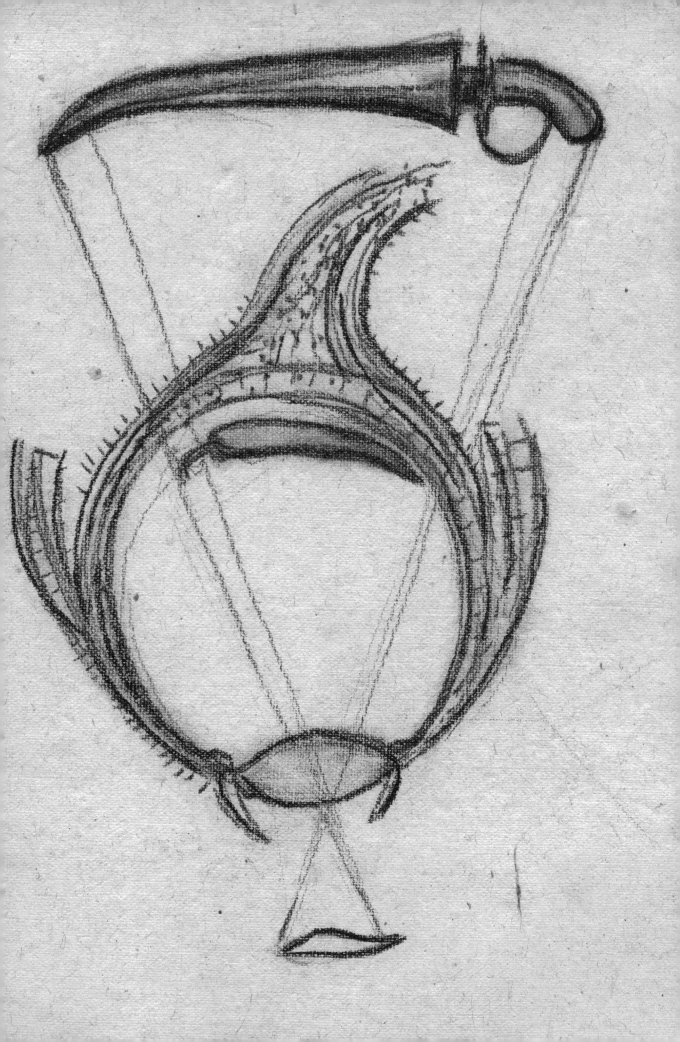

C 48
J. Shannel Verrier

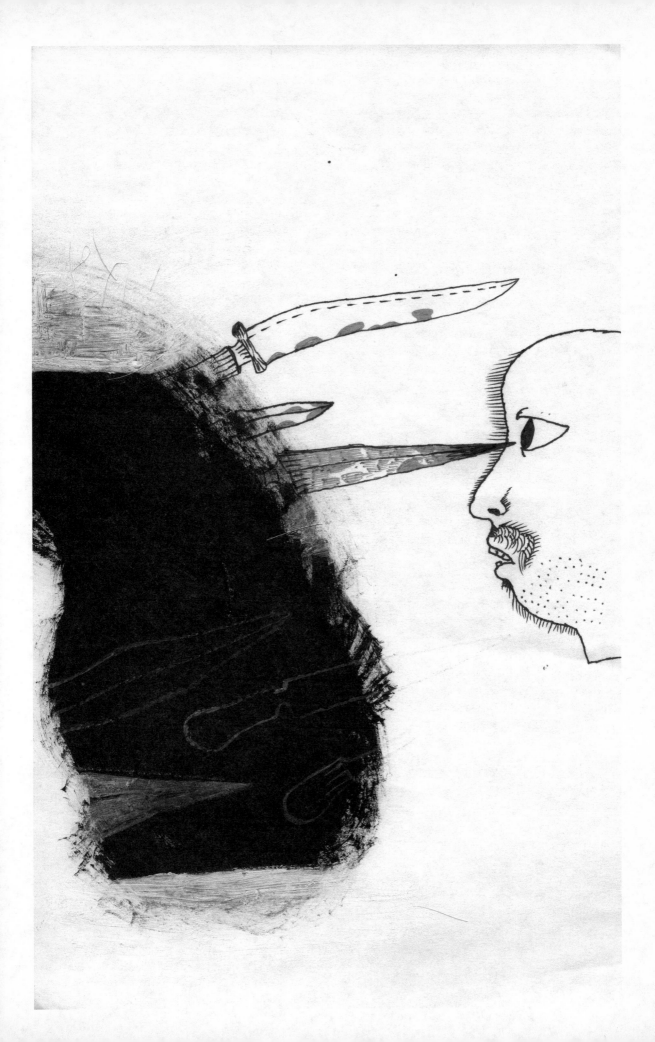

From J → S
(48(?))

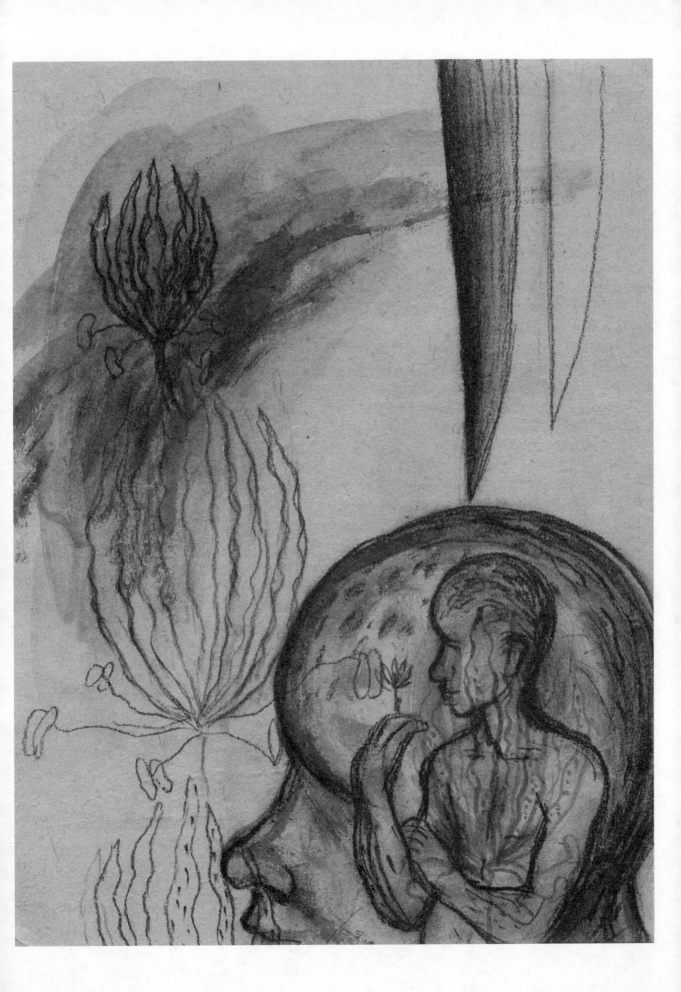

C -50

I Shamia Ikanen

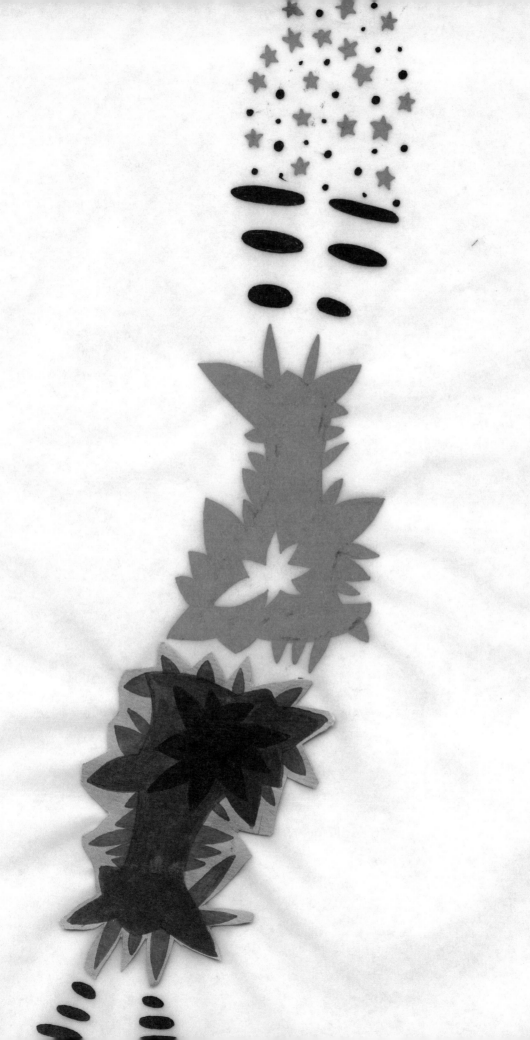

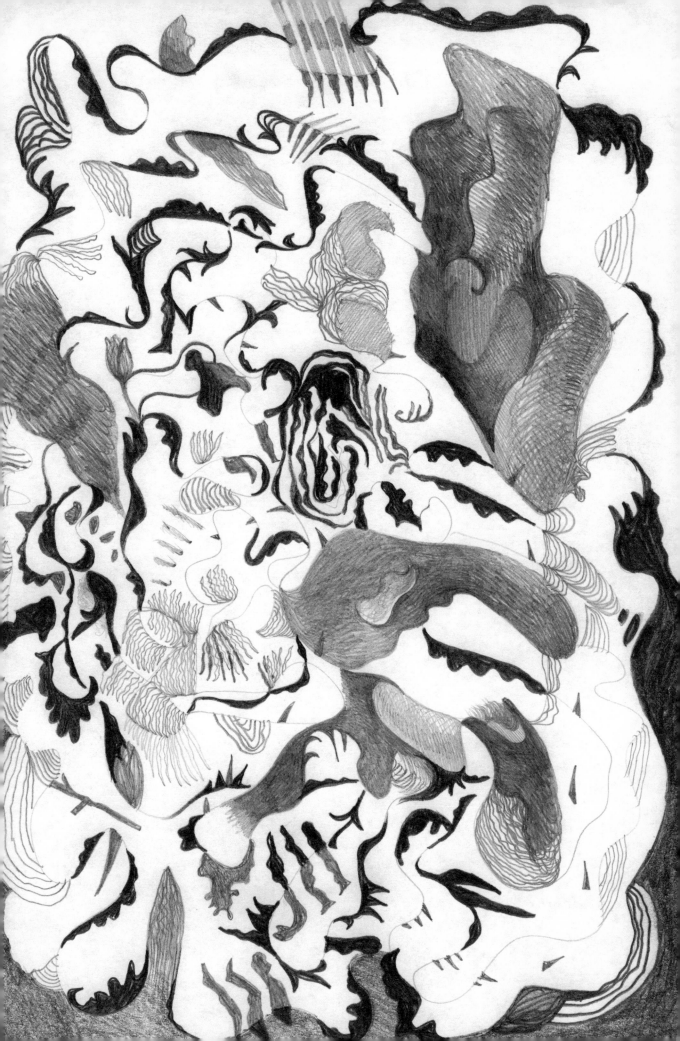

C 52

Coxley 2007 11. 20

Drawings D1 to D52 / /

Jagath Weerasinghe (JW D1); Muhanned Cader (MC D2); Chandraguptha Thenuwara (CT D3); Thamotharampillai Shanaathanan (TS D4); Chandraguptha Thenuwara (CT D5); Thamotharampillai Shanaathanan (TS D6); Jagath Weerasinghe (JW D7); Thamotharampillai Shanaathanan (TS D8); Chandraguptha Thenuwara (CT D9); Jagath Weerasinghe (JW D10); Muhanned Cader (MC D11); Thamotharampillai Shanaathanan (TS D12); Jagath Weerasinghe (JW D13); Muhanned Cader (MC D14); Chandraguptha Thenuwara (CT D15); Muhanned Cader (MC D16); Thamotharampillai Shanaathanan (TS D17); Jagath Weerasinghe (JW D18); Muhanned Cader (MC D19); Chandraguptha Thenuwara (CT D20); Thamotharampillai Shanaathanan (TS D21); Jagath Weerasinghe (JW D22); Muhanned Cader (MC D23); Chandraguptha Thenuwara (CT D24); Muhanned Cader (MC D25); Jagath Weerasinghe (JW D26); Chandraguptha Thenuwara (CT D27); Thamotharampillai Shanaathanan (TS D28); Chandraguptha Thenuwara (CT D29); Thamotharampillai Shanaathanan (TS D30); Jagath Weerasinghe (JW D31); Thamotharampillai Shanaathanan (TS D32); Chandraguptha Thenuwara (CT D33); Jagath Weerasinghe (JW D34); Muhanned Cader (MC D35); Thamotharampillai Shanaathanan (TS D36); Jagath Weerasinghe (JW D37); Muhanned Cader (MC D38); Chandraguptha Thenuwara (CT D39); Muhanned Cader (MC D40); Thamotharampillai Shanaathanan (TS D41); Jagath Weerasinghe (JW D42); Muhanned Cader (MC D43); Chandraguptha Thenuwara (CT D44); Thamotharampillai Shanaathanan (TS D45); Jagath Weerasinghe (JW D46); Muhanned Cader (MC D47); Chandraguptha Thenuwara (CT D48); Muhanned Cader (MC D49); Jagath Weerasinghe (JW D50); Chandraguptha Thenuwara (CT D51); Thamotharampillai Shanaathanan (TS D52).

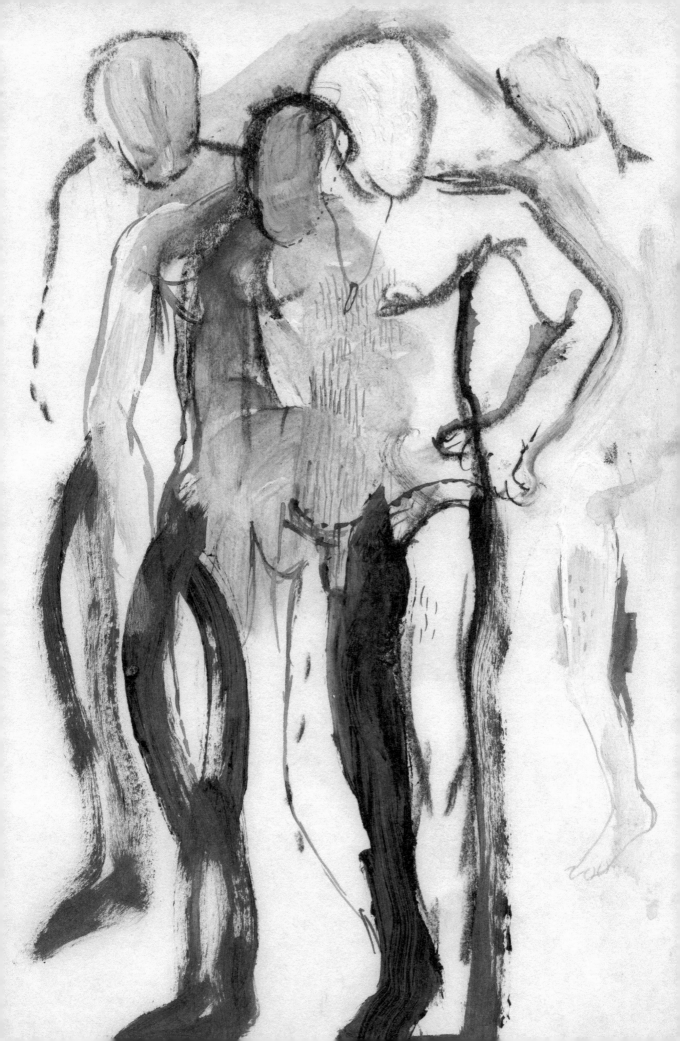

D1 From J to M 31 May 2005

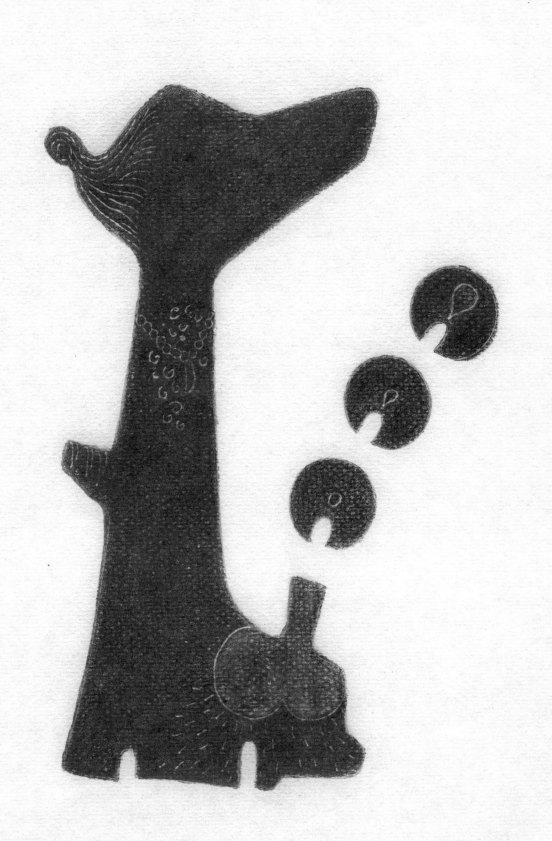

MC-D2

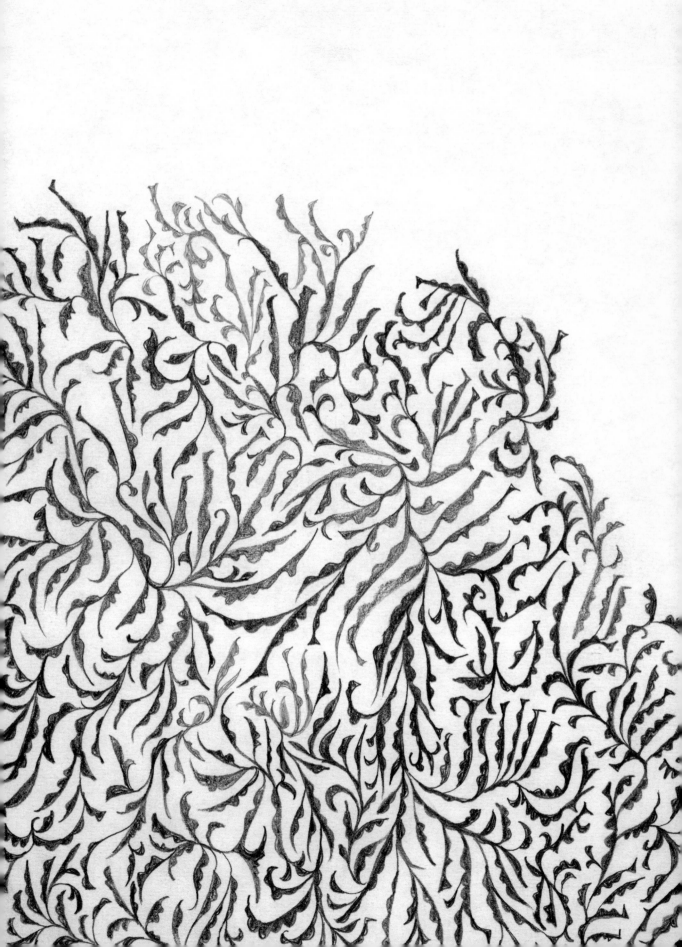

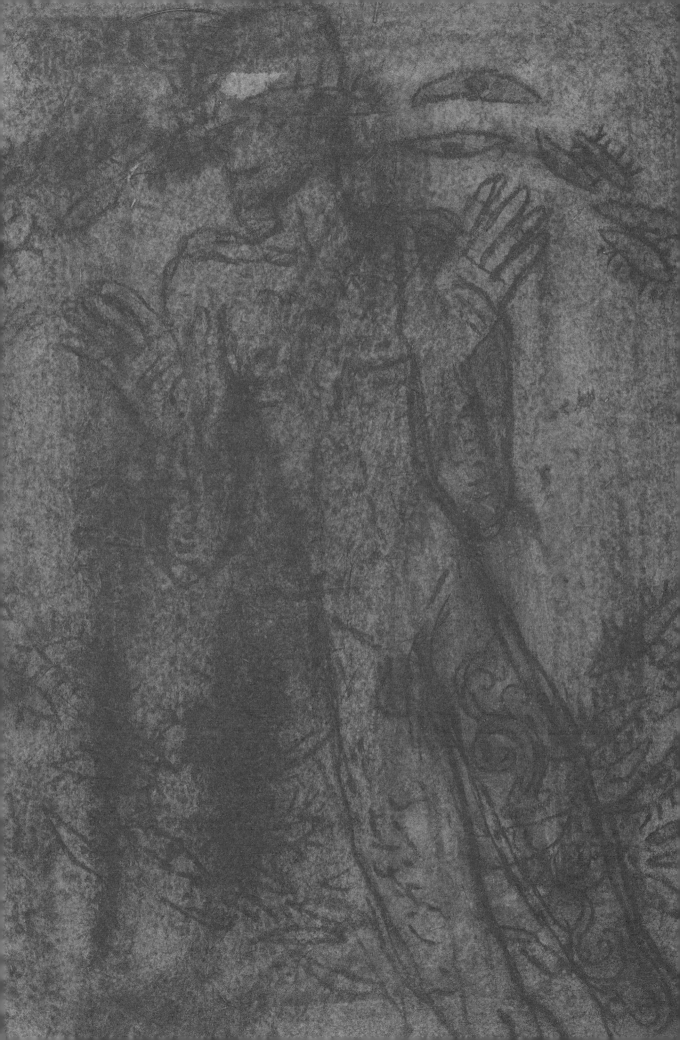

D 4

J. Strathöven

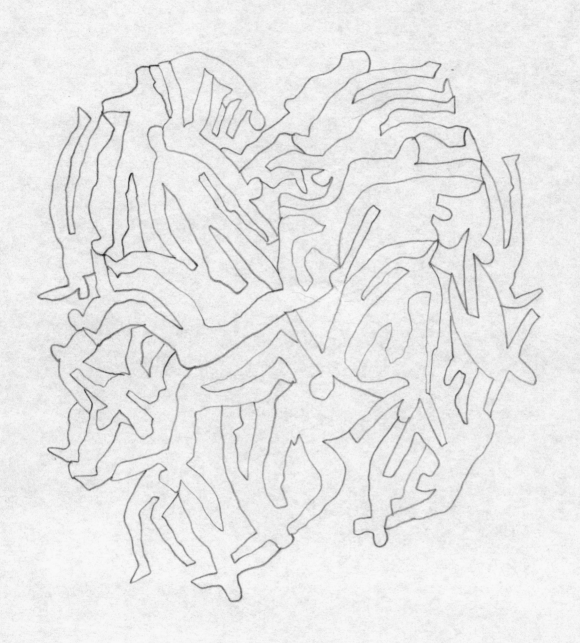

lyXum 2005. 07 04 D5

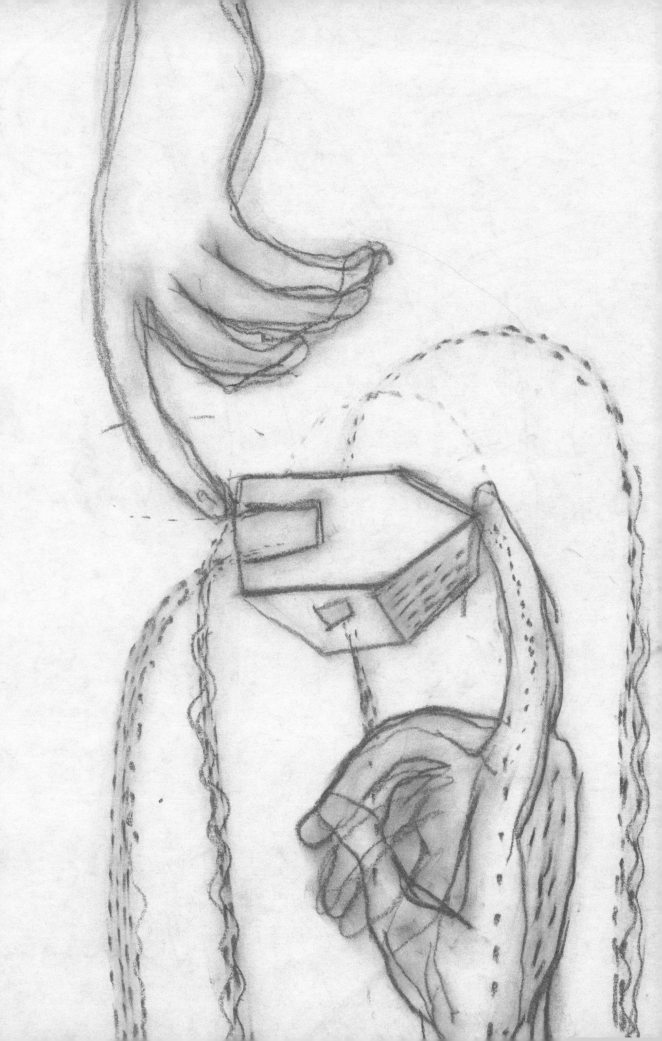

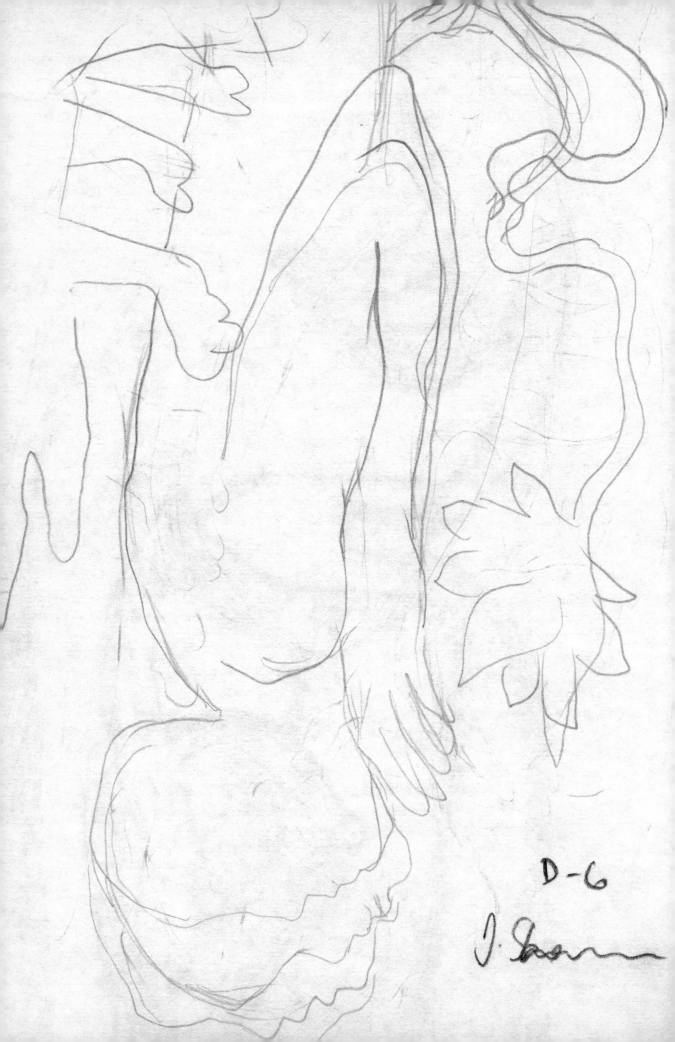

D-6

J. Seoun

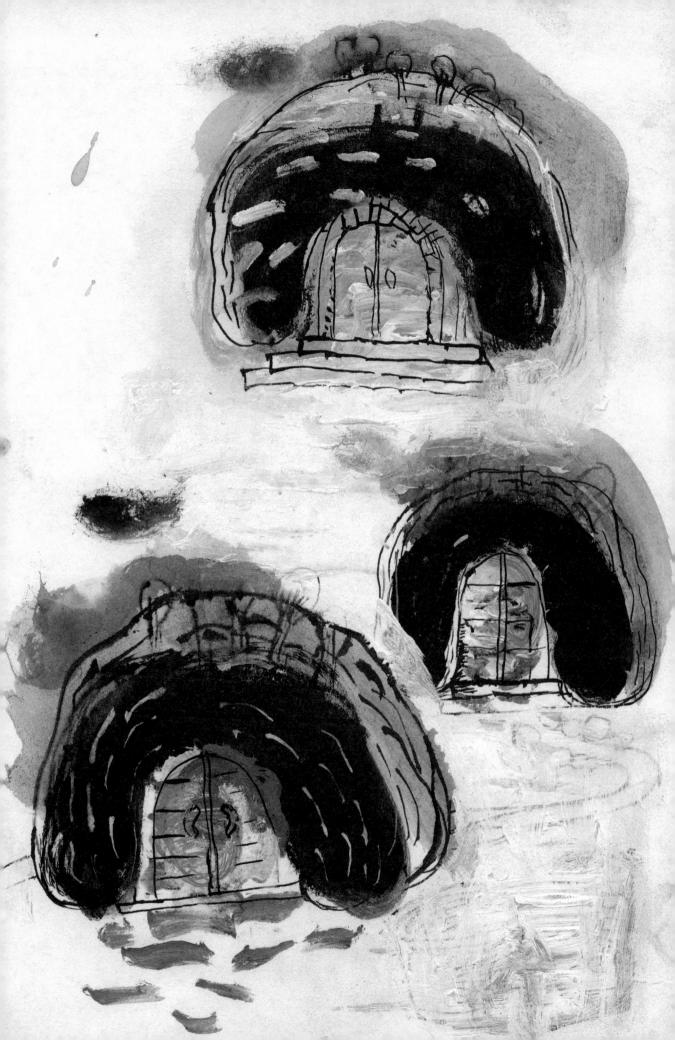

D7
J → S

D7
J → S

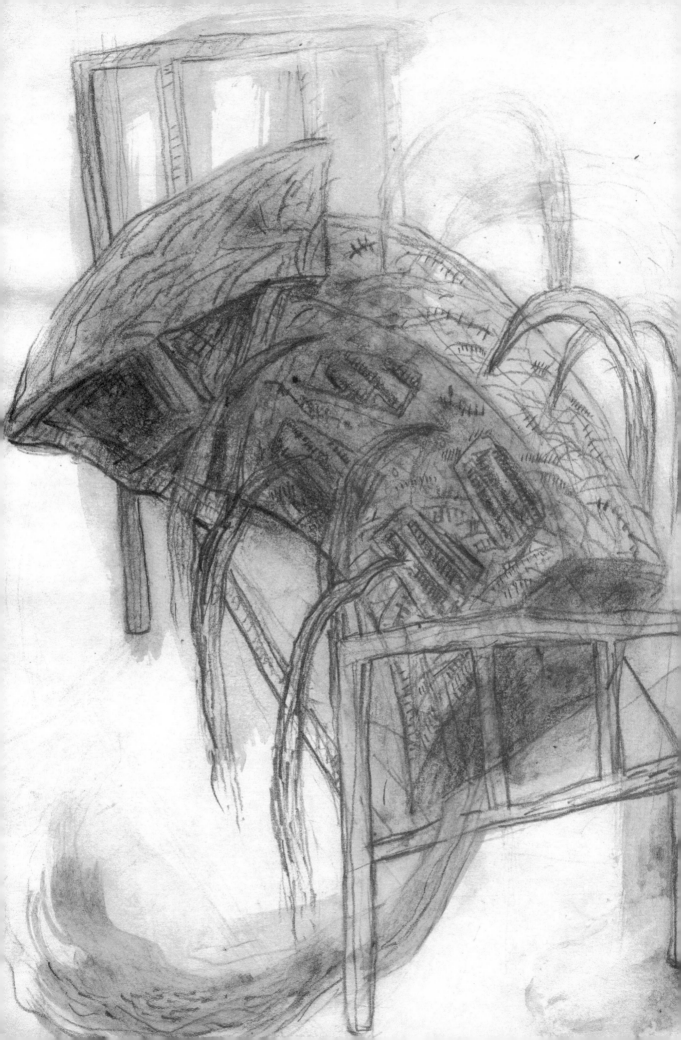

D 8

J Shanaathanan

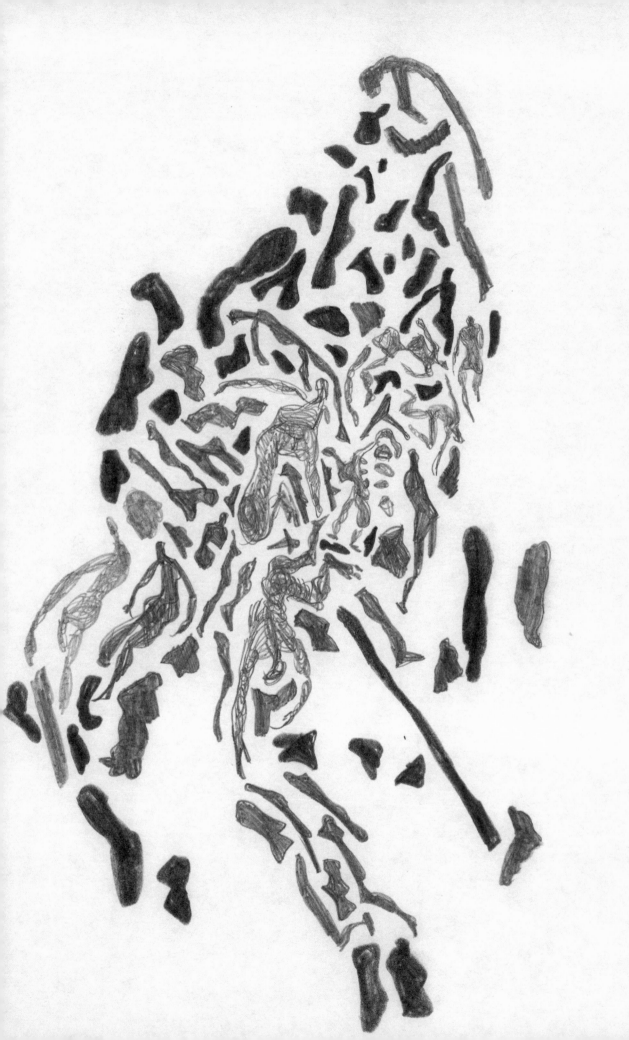

CyXieng 2003. 07. 03 D 9

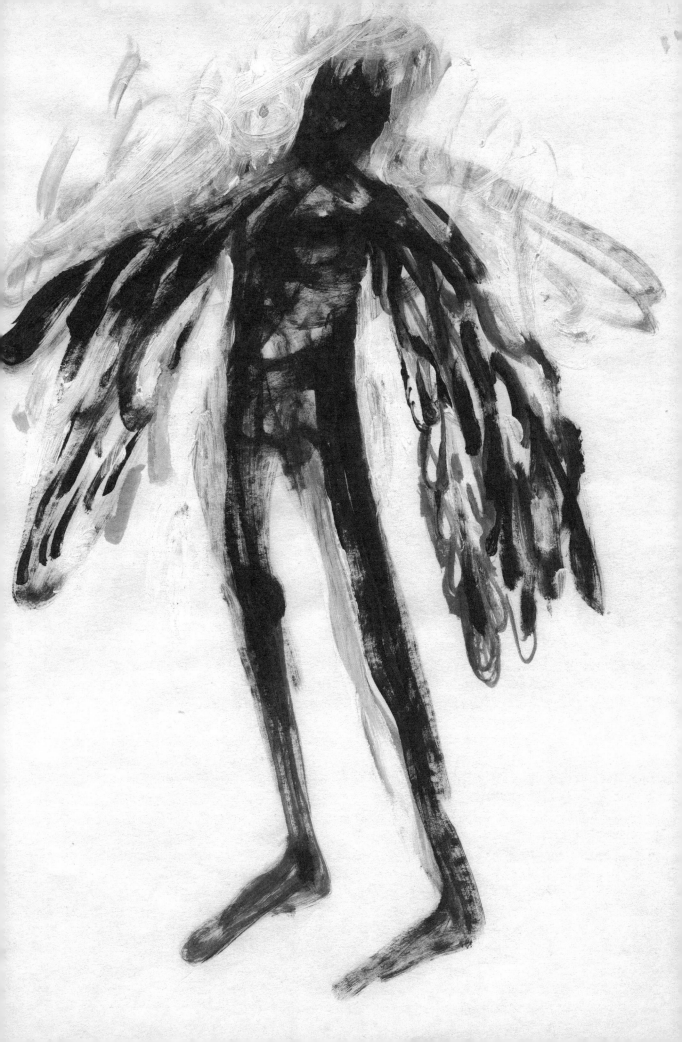

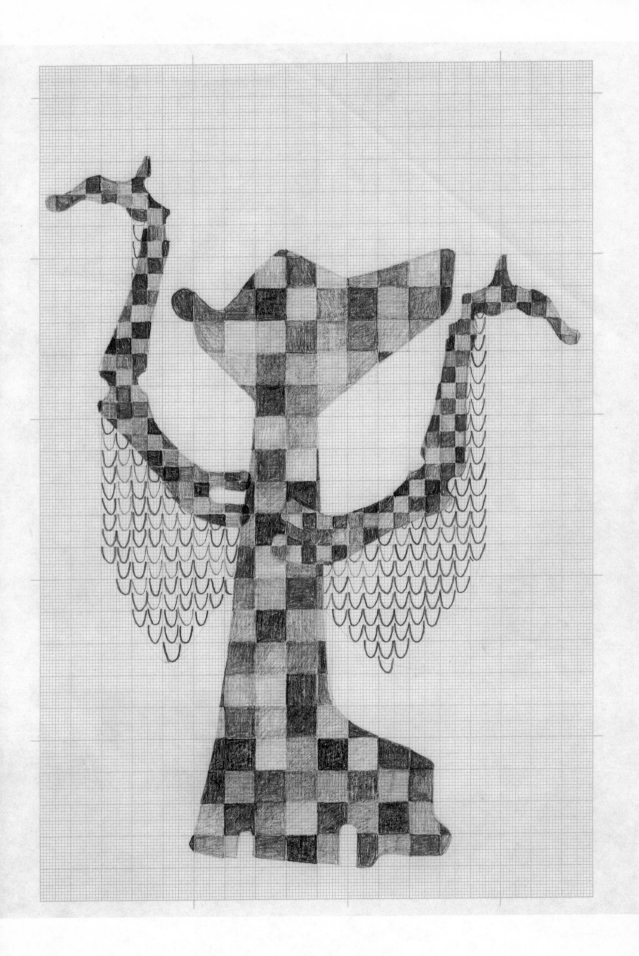

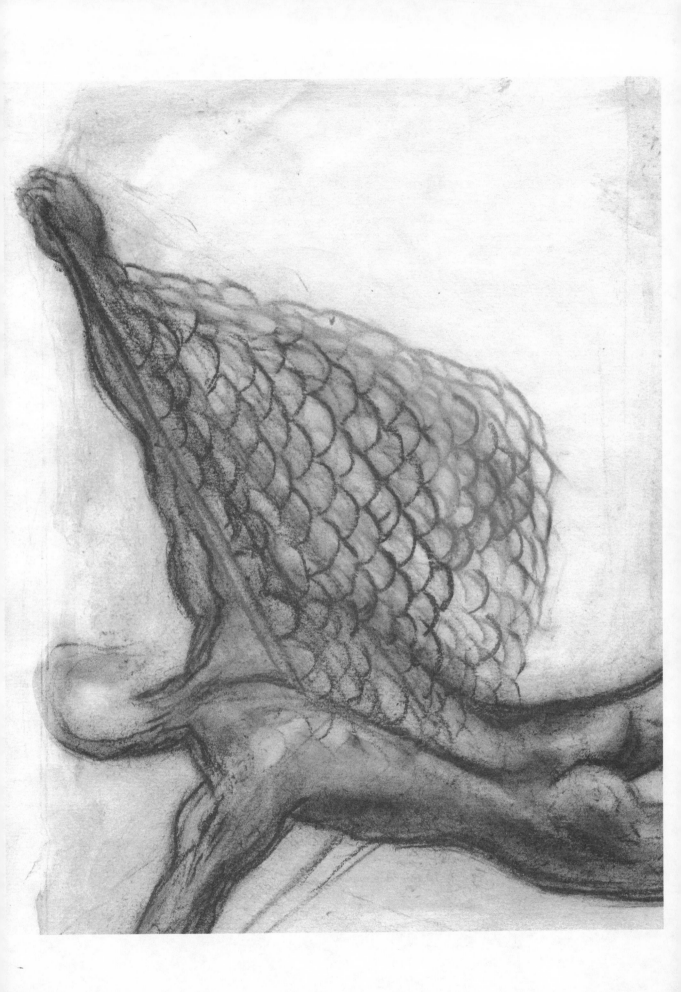

Grandmere

D12)

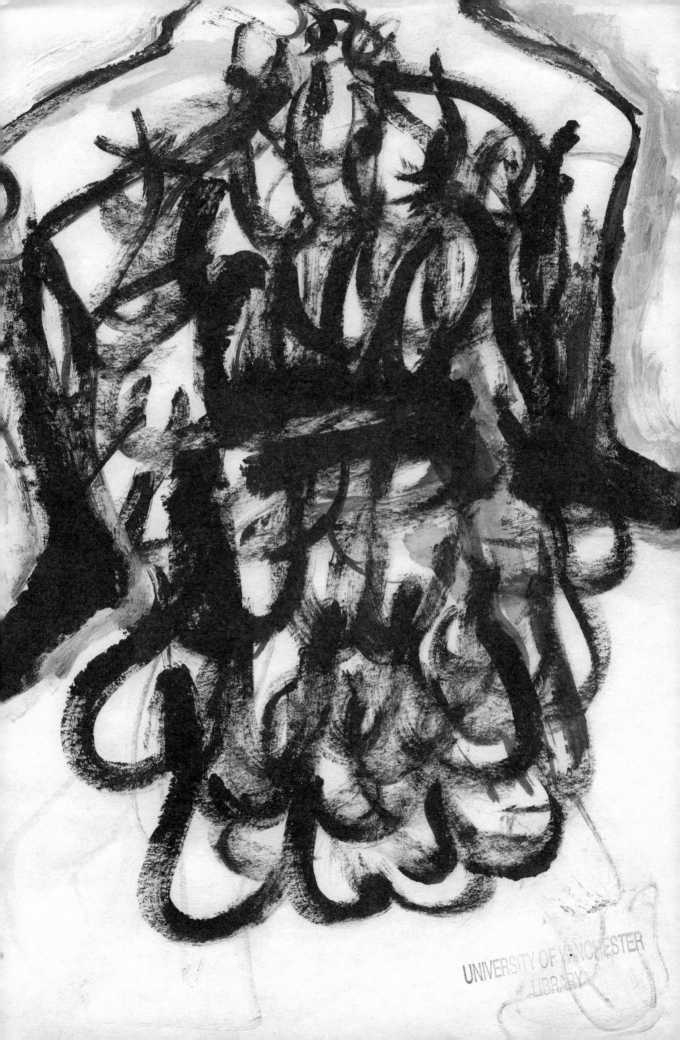

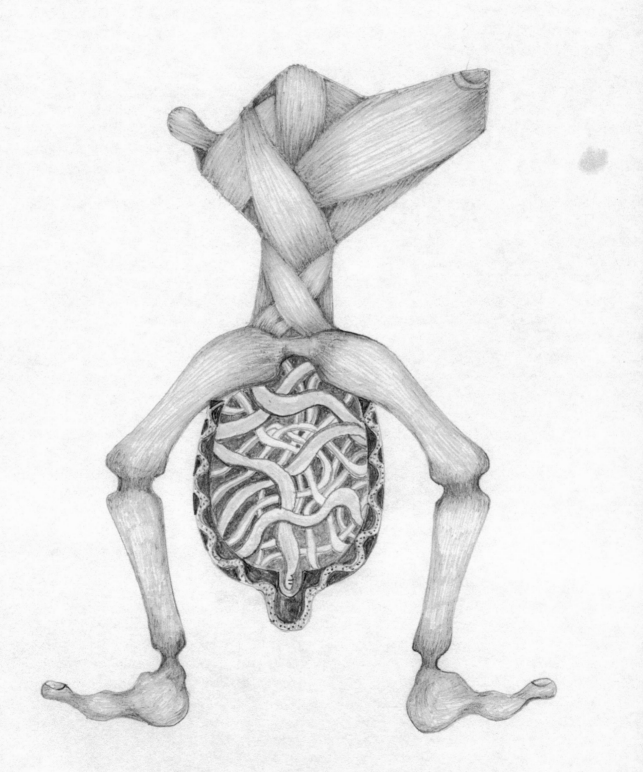

MC D14

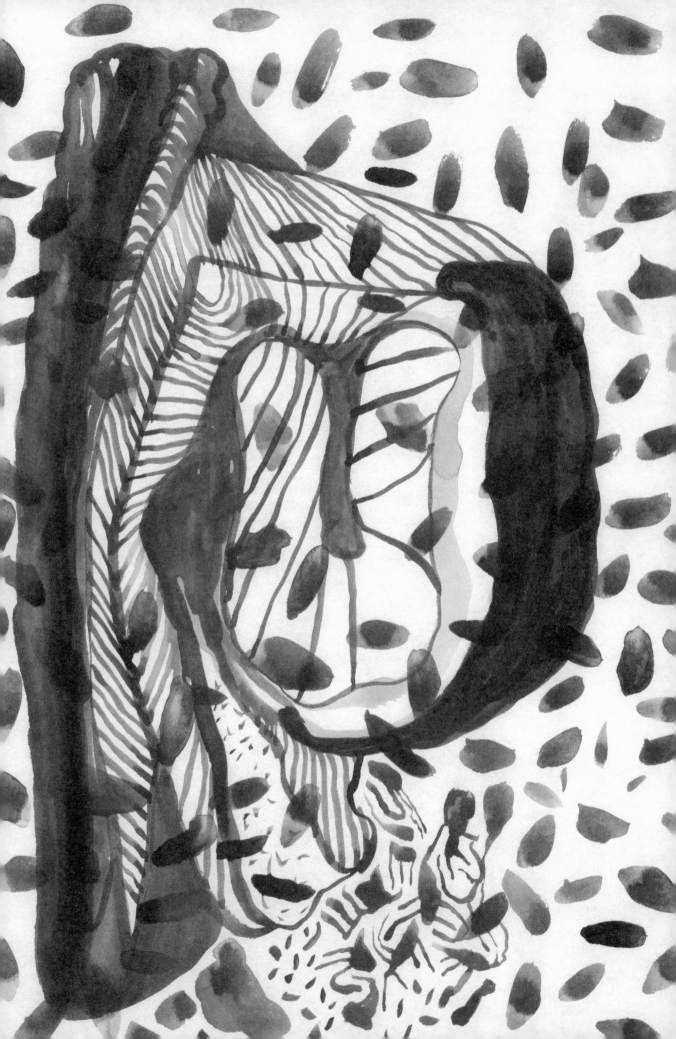

D15

lyKnn 2005. 09. 20

MC-D16

D-17

J. Shanaahin

D19 - MC

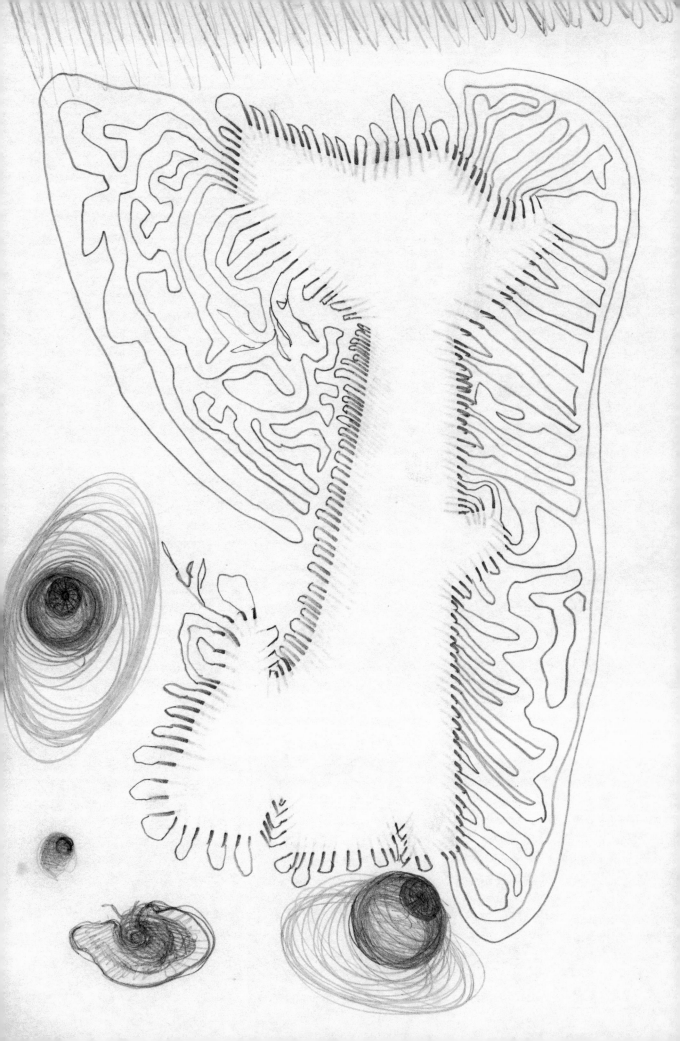

2003. 11. 12
2003. 11. 13

D20

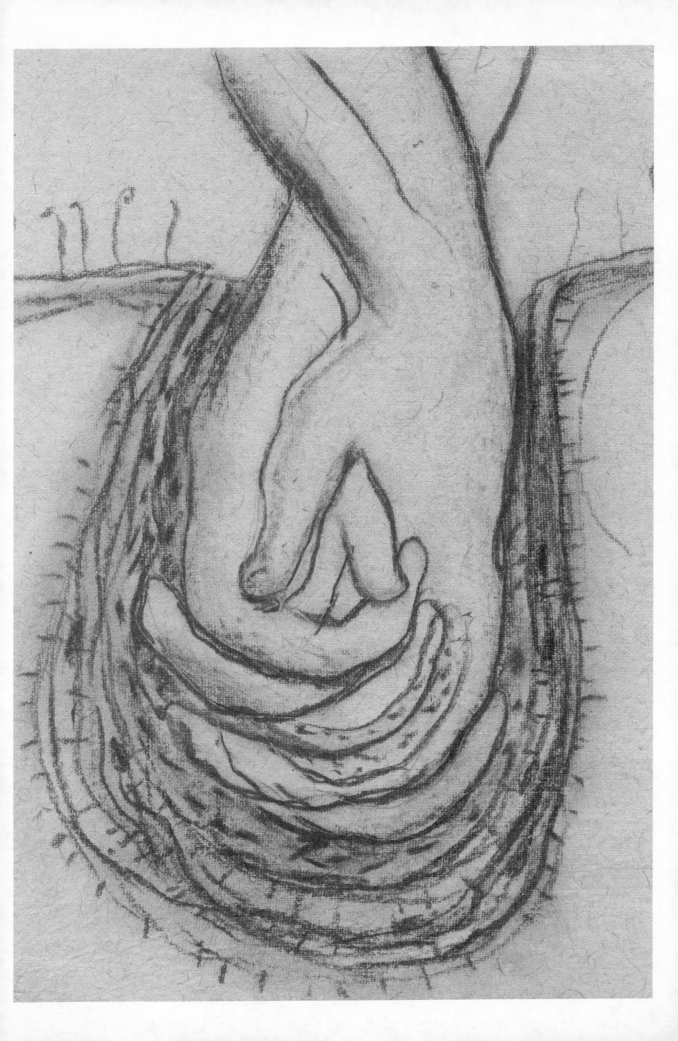

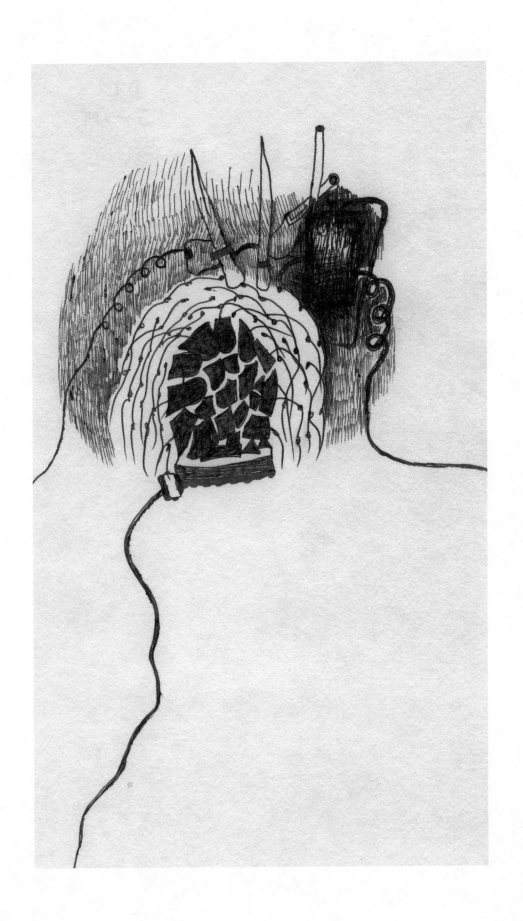

D22
J→M

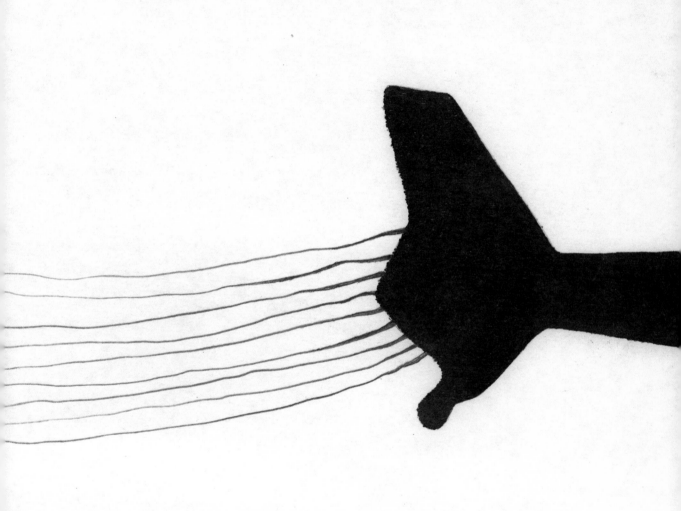

MC-D23

2006. 01. 01

D24

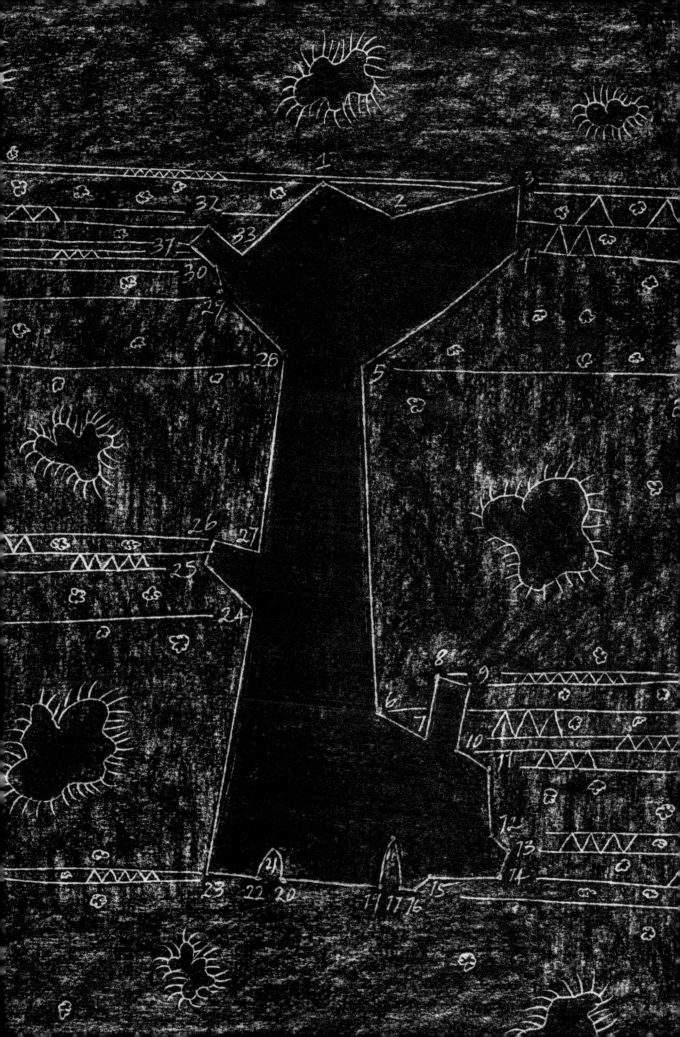

D25 → MC → J

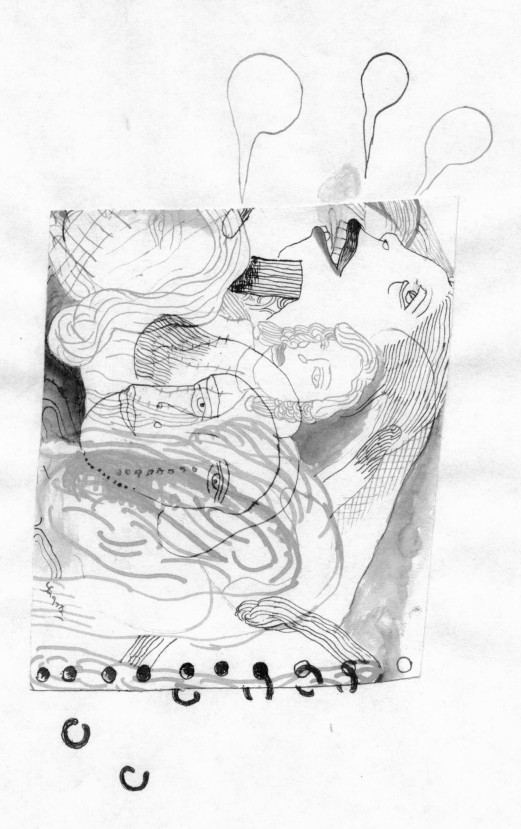

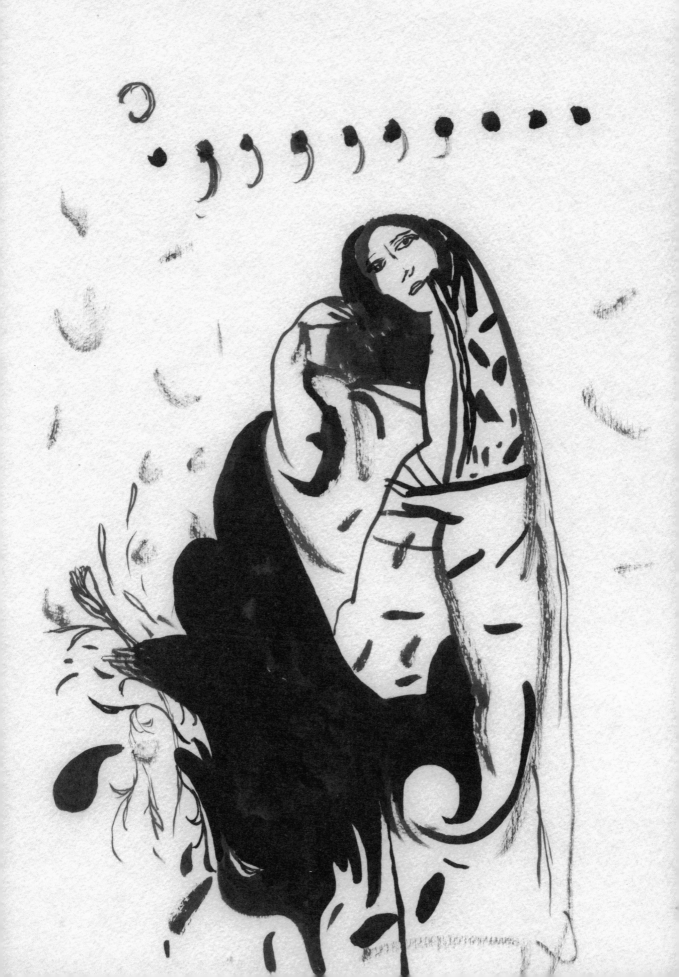

D27

少文 2006·02·01

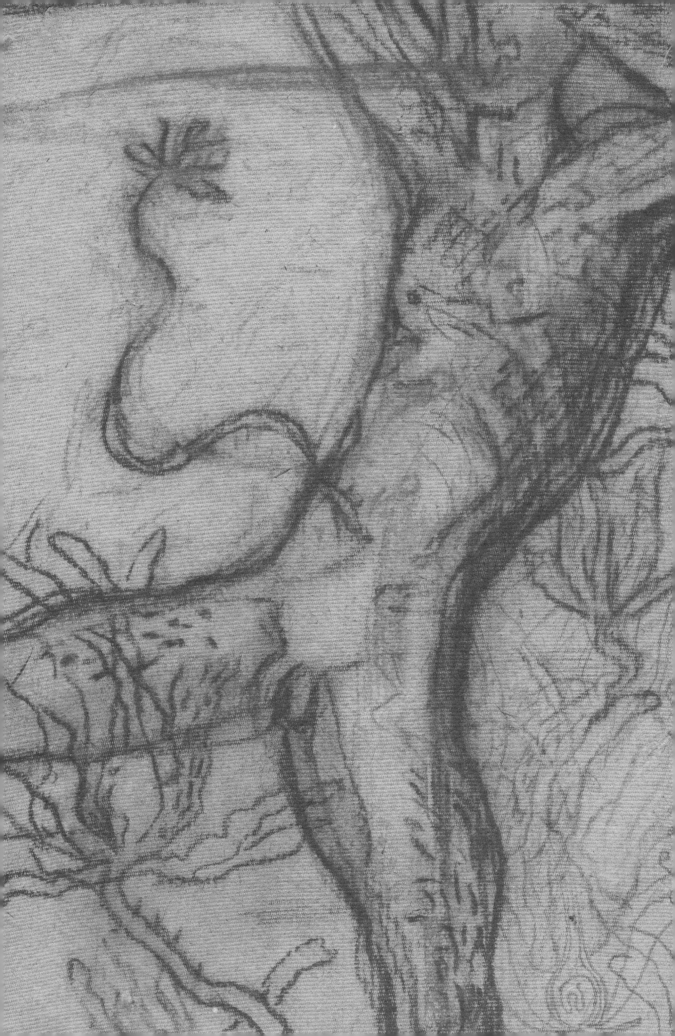

D-28

O. Strominger

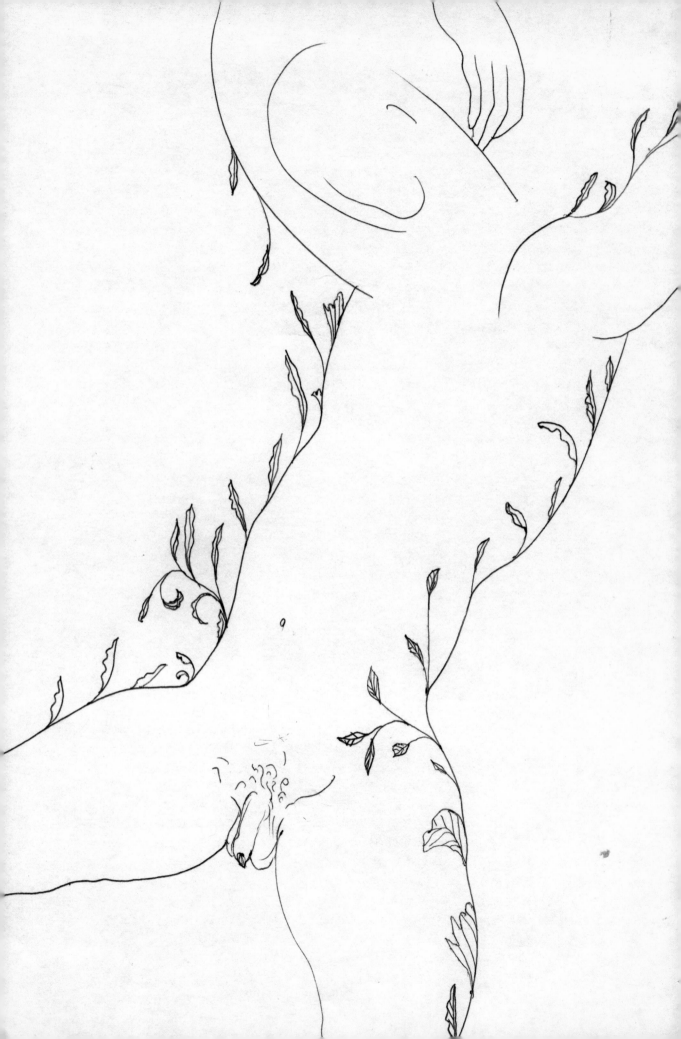

D 29

ら人 2006.03.20

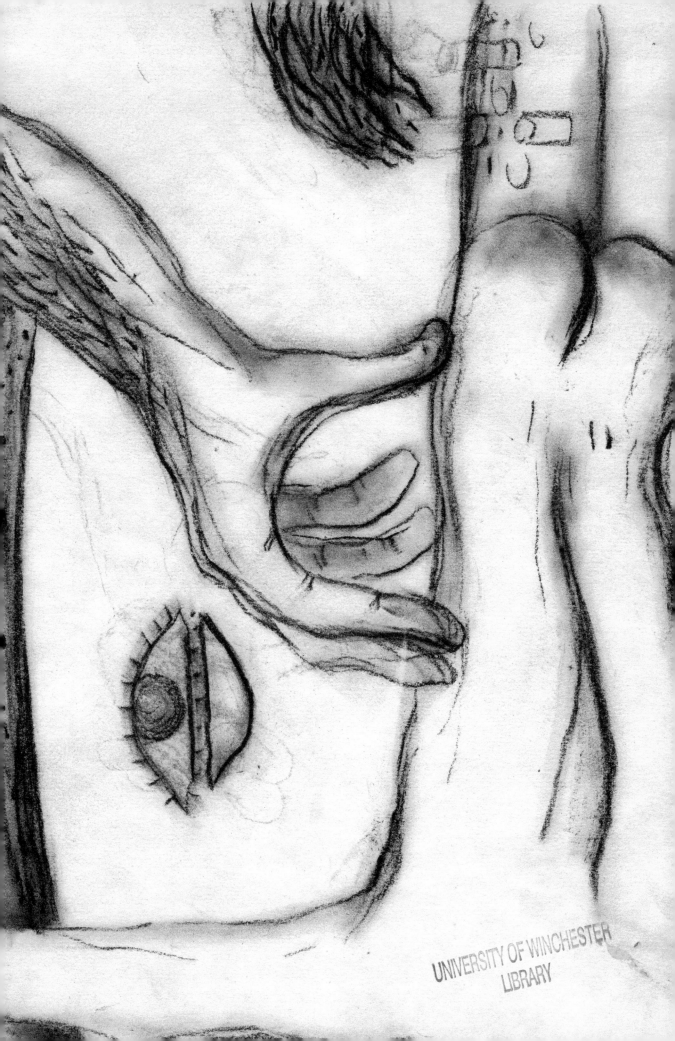

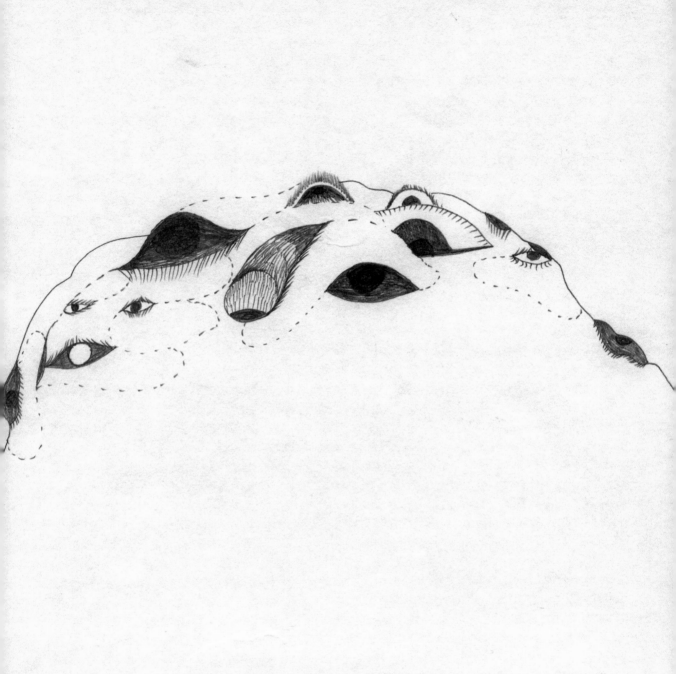

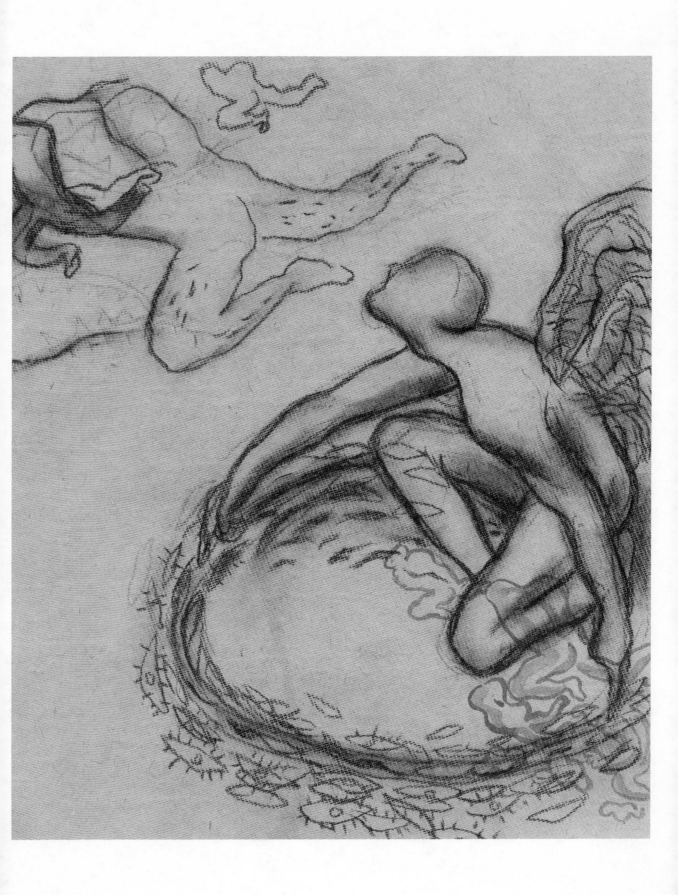

D-32

I Shawcross Heine

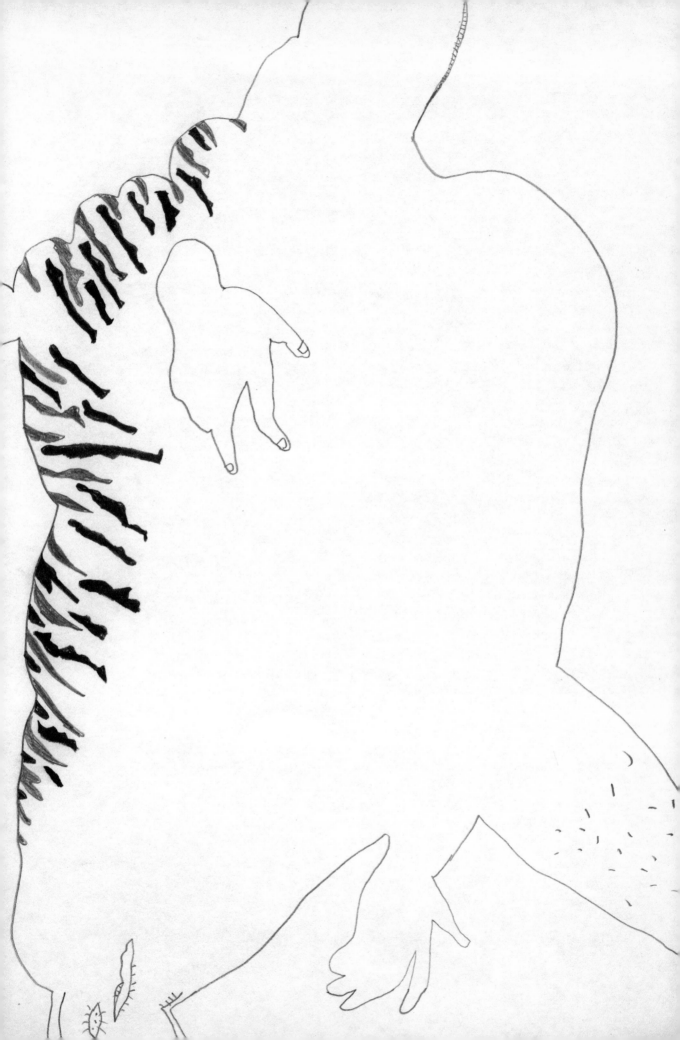

D 33

2006. 06. 01

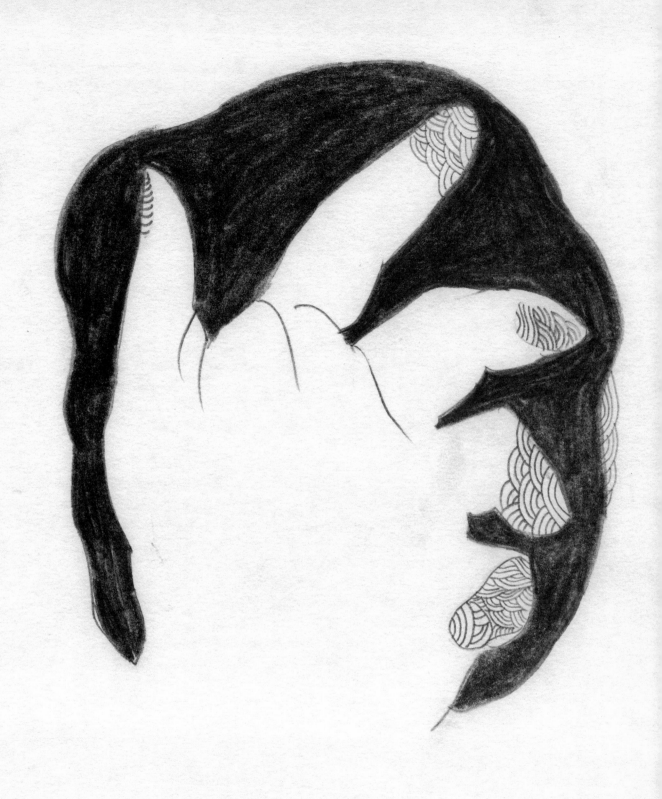

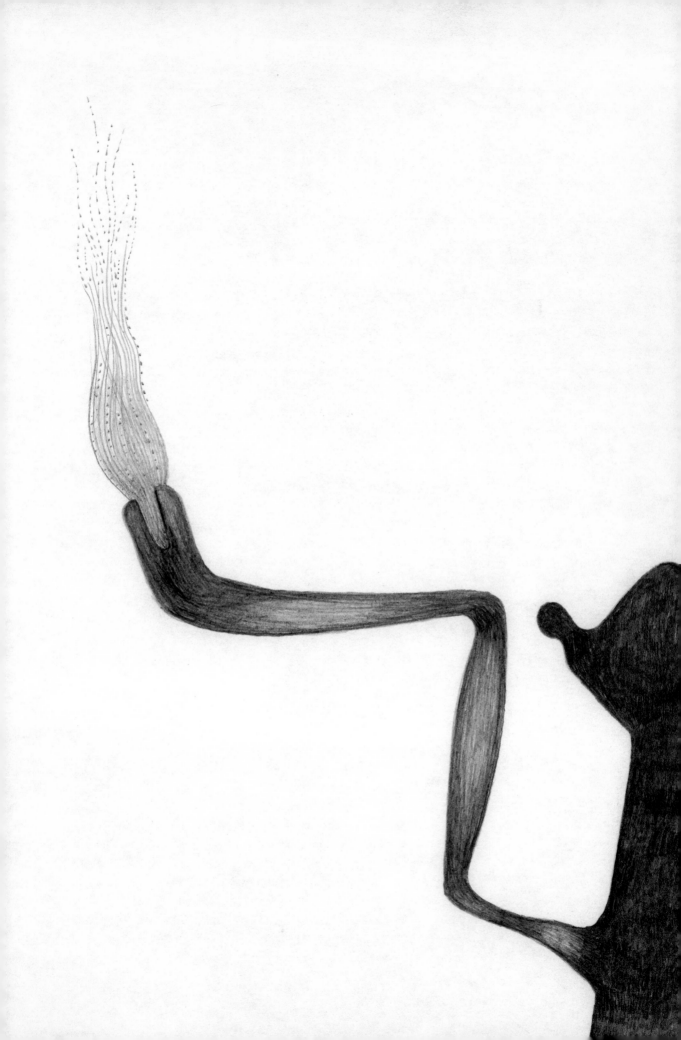

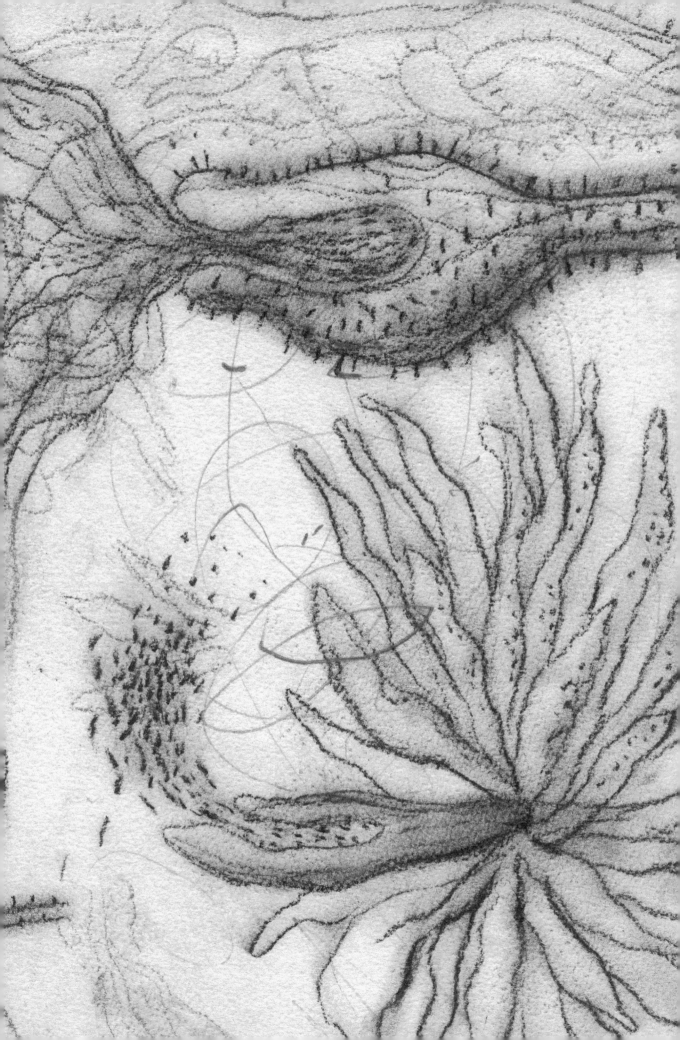

D 36

J. Shanahan

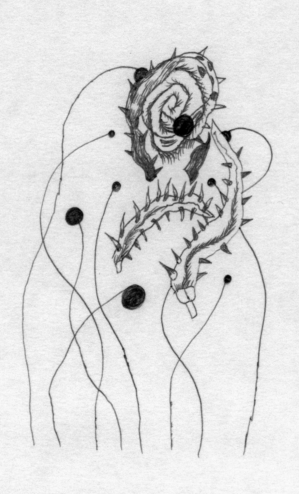

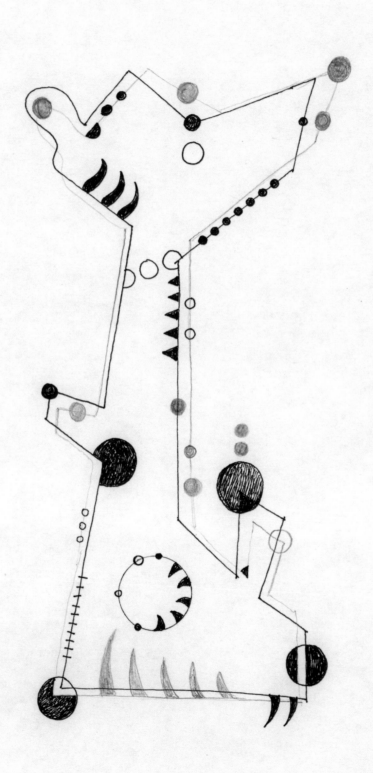

D38 - MC

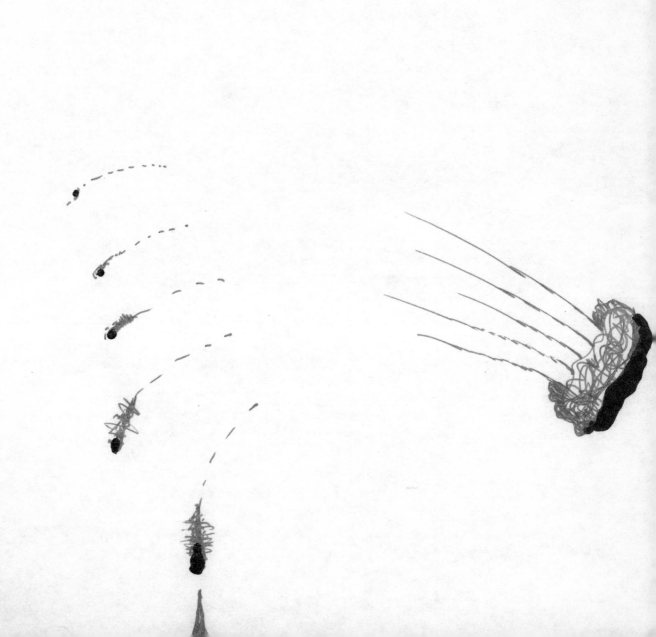

D 35
2006. 07. 15

MC D40

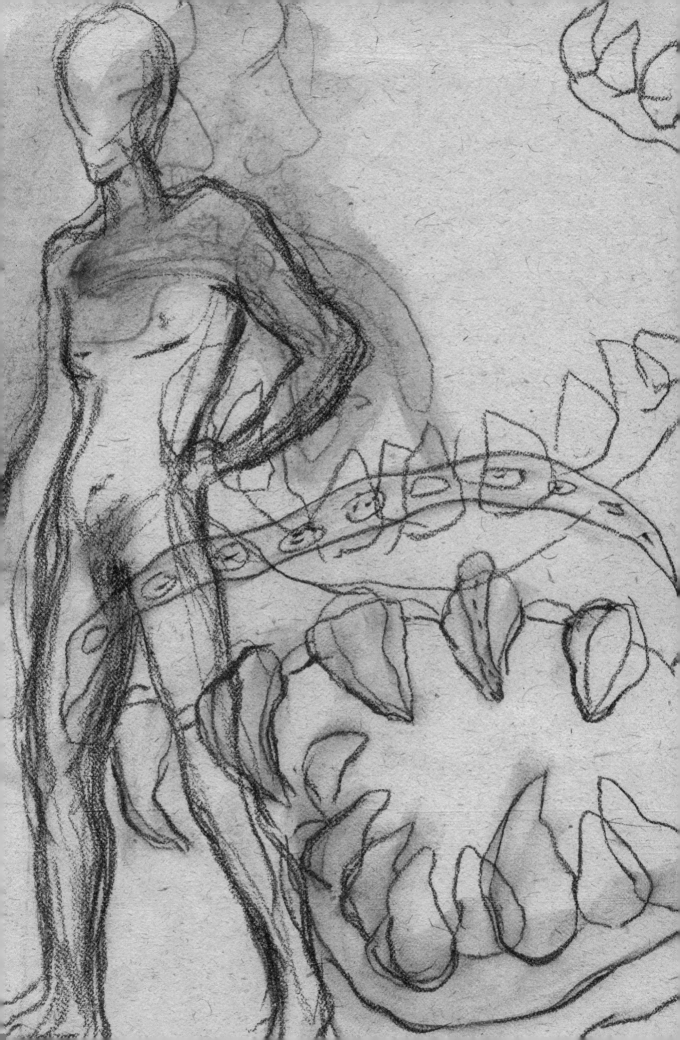

Top

↑

D-41

Bheeralhanan

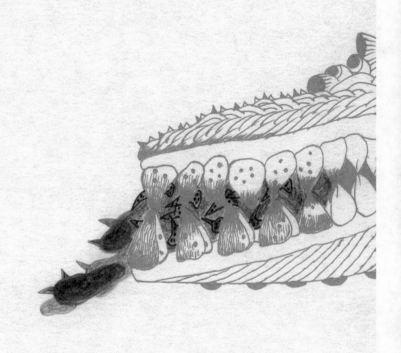

D44

2007. 07. 12

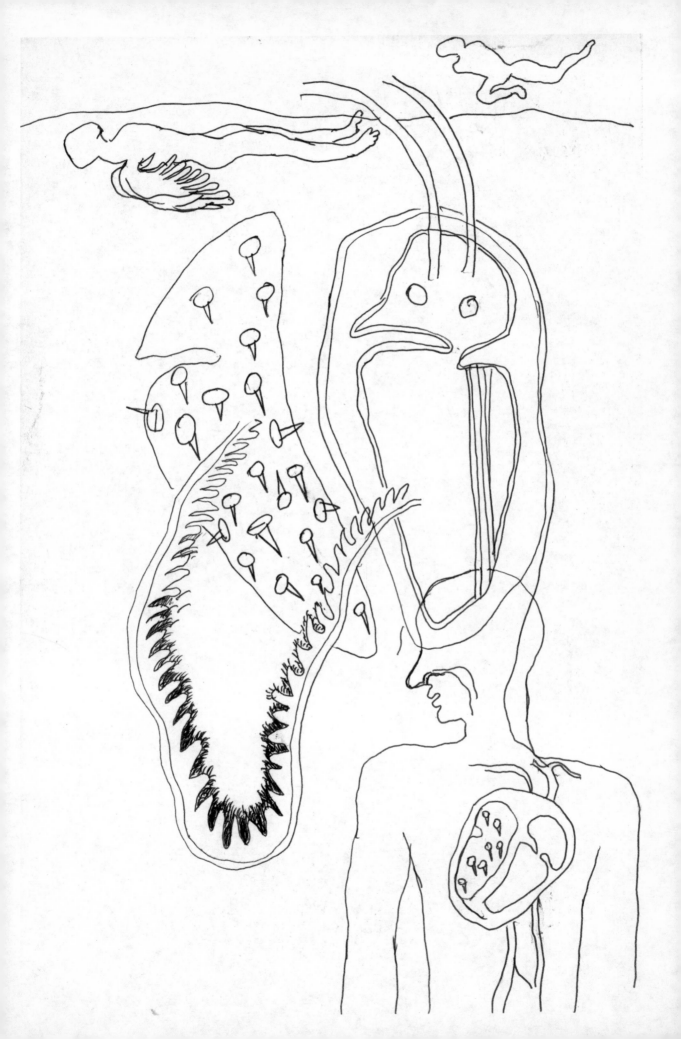

D 45

O. Shannatherine .

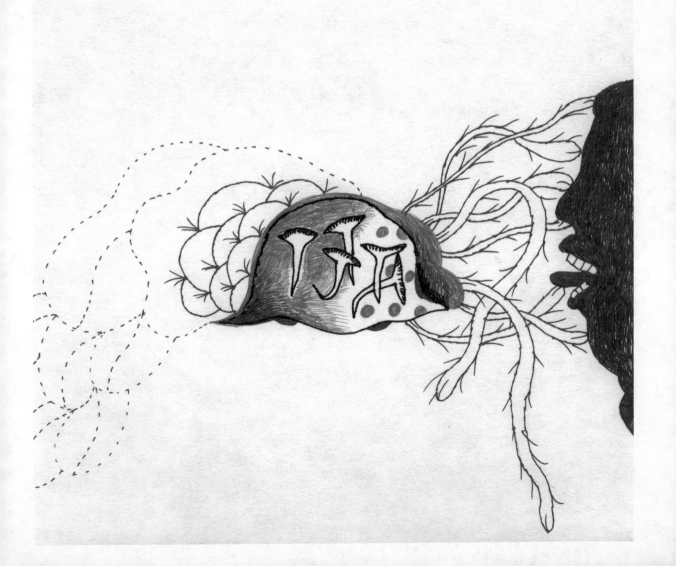

MCD47 → T

D 48

Lipták 2007. 08. 08

D50

J — Tenu

yearly

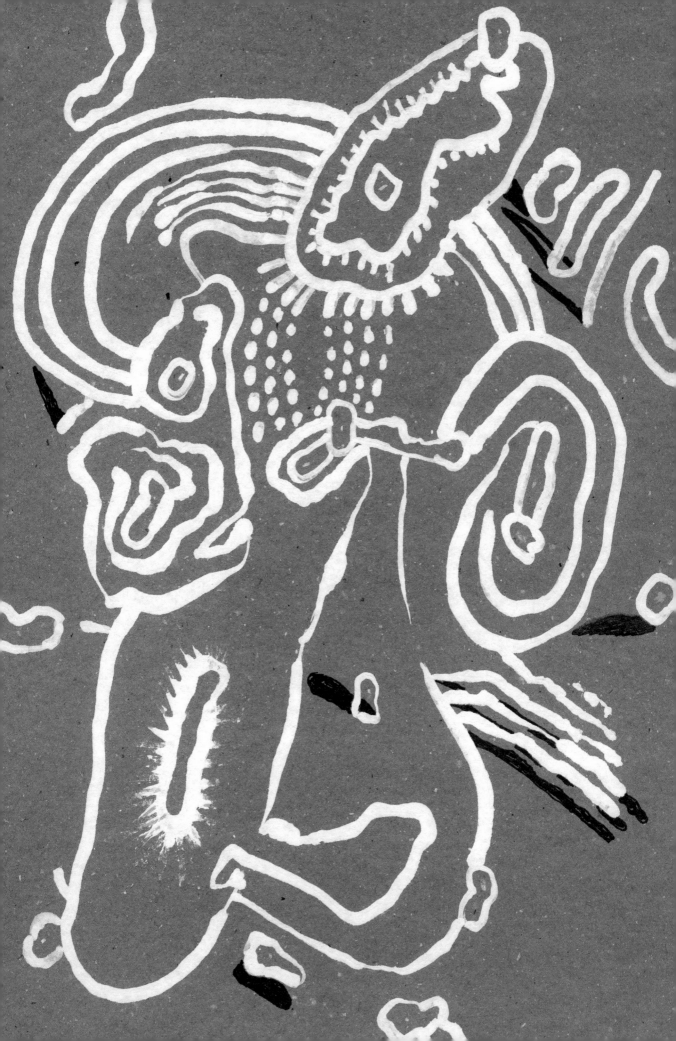

Cy Kuron
D.51
5.10.2007